CLIMATE REFUGEES

Cover photograph: Laurent Weyl, Munshiganj/Bangladesh,
On the hillside protected by the large dike.

© 2010 Massachusetts Institute of Technology
and Dominique Carré éditeur, Paris

This work originally appeared in French under the title *Réfugiés climatiques*
© 2007 Infolio éditions, Gollion, Switzerland

This book was photoengraved in Pictorial Service/Paris, France
and was printed and bound by Tien Wah Press, Singapore.

LIBRARY OF CONGRESS CATALOGING-IN-PUBLICATION DATA

Climate refugees / Collectif Argos.
p. cm.
ISBN 978-0-262-51439-2 (pbk. : alk. paper)
1. Human beings—Effect of climate on.
2. Climatic changes.
3. Environmental degradation.
4. Forced migration.
I. Collectif Argos.
GF71.C57 2010
304.2—dc22
2009038108

TABLE OF CONTENTS

→ HUBERT REEVES : Astrophysicist, Chairman
of the ROC league (www.roc.asso.fr)

INTRODUCTION HUBERT REEVES

Beyond the fight against greenhouse-gas emissions, one of the greatest challenges facing France, the rest of Europe and the entire world is the battle against the effects of global warming, which has already become a reality. Two struggles overlap: one to aid people currently in distress, and the other to stem the rising tide of climate refugees out of concern for the future. Will populations yet to be affected be moved by accounts of those victimized by 20th-century human activity? Will the compassion that impels us to donate money to help the victims of a tsunami for which we have no responsibility reach a point where we're willing to change our lifestyles, which are responsible for the migrations described in this book? Donating money is clearly easier than changing our way of life.

However, change we must
If we don't, disasters will not only affect people on the other side of the world, but could engulf our own countries as well. We have every reason to consider climate refugees as not merely a current reality limited to certain areas but rather as a future reality affecting many more regions if we refuse to change our ways. Our geographic maps will have to be redrafted, of course, which is only a matter of topographic surveys, but far more important is the fact that a greater number of people will have to crowd into a smaller amount of space. Current immigration patterns provide only a minor glimpse of the problems that will be triggered by climate-change migration.

To minimize the predicted worsening of the situation, we have to face it head-on. The projections of the Intergovernmental Panel on Climate Change (IPCC), are, to an extent, "average projections" or compromises, even though more dramatic outcomes are probable. At minimum, the inevitable rise in sea levels will also raise the levels of normal spring tides, and storms will become more terrifying than those that have at times ravaged our coasts. Will developed coastlines still be able to sustain human life? Europe will certainly not be spared.

We are all children of Earth and, faced with the peril of global warming, we must find a better way to organize our societies – and we must do so quickly, especially since another danger deserves serious consideration: the loss of biodiversity in all its aspects. The time for change is upon us, and we have no choice but to succeed.

→ JEAN JOUZEL : Research director at the CEA [French
Atomic Energy Commission], he is Vice President of
the IPCC Science working group and, in this capacity,
was co-awarded the 2007 Nobel peace prize.
President of the French meteorological society,
he is the author, together with Claude Lorius and
Dominique Raynaud, of *Planète Blanche,*
Les Glaces, le climat et l'environnement
published by Odile Jacob (Paris, 2008).

PREFACE <small>JEAN JOUZEL</small>

Every week, the media – newspapers, magazines, radio, television and websites – remind us that we're living on a planet whose climate is getting warmer, most likely because of an escalation of the greenhouse effect caused by human activity. They also warn us that if we're not careful, the 21st century will be marked by serious climatic upheaval.

The way that people perceive the changing climate varies considerably, however, based on whether they live in France, which enjoys a generally pleasant, temperate climate, or in a less clement region of the world already facing the initial consequences of climate change. Europe's 2003 heat wave gave us a preview of what our summers will be like in the middle of the century if no action is taken, but that seems so far off to us, and many have the impression – mistaken, in my opinion – that our children and grandchildren will be able to adapt to a climate 4-5° C warmer than the one we have today. Some regions, however, are already experiencing the initial effects of warming to such an extent that, from Alaska to the Maldives, populations are losing their native lands. The great value of this outstanding work is that it highlights the phenomenon in a very concrete fashion, accompanied by stunning photography.

As a researcher, I have been interested in climate change for nearly 40 years and have had an inside view of the public's gradually-developing awareness of the role played by human activity. There are still many sceptics who attribute warming to natural causes while refusing to see any human contribution, but their arguments are being whittled away year-by-year. As a result, the true believers' camp is inexorably gaining ground. In fact, the sceptics have largely yielded on anything concerning the scientific aspects of climate change and have gradually shifted the debate to the effects of warming: they believe that the warnings are too alarmist, and that the cost of controlling the greenhouse effect is prohibitive.

What is the current thinking in the relevant scientific community? In the late 1980s, the United Nations created the Intergovernmental Panel on Climate Change (IPCC), whose "role is to assess...the scientific, technical and socio-economic information relevant to...human-induced climate change...and options for adaptation and mitigation." The IPCC calls upon a wide range of experts, inclu-

ding physicists, chemists, mathematicians, economists, lawyers, sociologists, health-care providers and specialists in the marine and continental biosphere. It has just completed its Fourth Assessment Report after publishing reports in 1990, 1995 and 2001. The organization held meetings in Paris, Valencia, Brussels and Bangkok in 2007 to give government representatives an opportunity to approve the report's major conclusions, which highlight the problems we may have to confront.

The report confirms the diagnosis from a scientific standpoint. The man-made greenhouse effect has continued to increase in recent years, mainly attributed to the carbon dioxide generated by our consumption of oil, natural gas and coal. The second, unambiguous finding is that the climate is warming: "Warming of the climate system is unequivocal," the report states. Eleven of the past 12 years have been hotter than any of the previous years since 1850. Many other observations bear witness to this warming trend. The ocean, for example, is warming and expanding, leading to rising sea levels; maximum snow-covered surfaces are shrinking; and sea ice and glaciers are also affected. Determining the causes of this recent trend has been a long-term effort, but the acquisition of new data and the considerable improvement in climatic models enable us to conclude that the majority of the warming observed since the middle of the 20th century is most likely the result of human activity. In scientific terms, that means higher than a 90% probability.

Lastly, the climate projections are consistent with those published in the previous report: a rise of 1.1° C to 6.4° C for the same set of greenhouse-gas emission scenarios. However, we now have greater confidence in the essential values corresponding to these different scenarios: an increase of 1.8° C to 4° C (a warming of 3° C in one century would constitute major climate change), and we can now have greater confidence in projections concerning other climatic variables, including increased precipitation in high latitudes and decreased precipitation in subtropical regions, changing wind patterns, the likelihood of more intense tropical cyclones, heat waves, heavy precipitation, melting of the snow cover, reduction of sea ice and an irreversible rise in sea level. That is how our world will look at the end of this century and beyond if no steps are taken – and that is the shape our world has already begun to take.

With regard to impact, it is an established fact that over the past few decades global warming has had noticeable effects. Many natural systems have been affected by regional climate change, particularly higher temperatures. In future,

any impacts caused by rising sea levels and changes in the frequency and intensity of extreme weather events are very likely to increase in all sectors, affecting agriculture, sylviculture, ecosystems, water resources, human health, industry, housing and the development of our societies. The IPCC notes that hundreds of millions of people will be exposed to greater water stress and that millions more might be subject to flooding every year. Additional threats include the expansion of arid and semi-arid regions, lower agricultural yields in Africa, the disappearance of glaciers in the Himalayas with a corresponding impact on water resources, major changes affecting polar ecosystems and infrastructures, risks caused by ocean acidification as they relate to ecosystems and marine resources, and the vulnerability of certain coastal areas and small islands to rising sea levels.

There are many reasons populations may be forced to leave the regions in which they currently live, thus becoming "climate refugees." The Argos collective's spotlight on certain particularly vulnerable areas is fully supported by the conclusions of the IPCC working group that analyzes the effects of climate change.

We must not give up in the face of global warming. IPCC economists remind us, however, of the scope of the challenge, based on the objective set by every country on the planet to stabilize the greenhouse effect. All of these nations ratified the Convention on Climate Change following the Rio Earth Summit. The economists also draw our attention to the urgency to take action, given that climate change is already underway. The lower the stabilization level targeted, the earlier the temperature must peak and then decline. To ensure that global warming never rises more than 2° C over the current climate, carbon-dioxide emissions must start to fall by 2020 at the latest and must decline 30-60% by 2050 compared to their 2000 levels. Limiting global warming to 2°C over the climate we knew 200 years back entails that these emissions be divided by three by 2050. Stabilizing our climate is a huge challenge, but political leaders deserve credit for making this issue a centrepiece of their discussions at the international level, with the key Copenhagen deadline, and at the European and international levels. These objectives must be achieved if we hope to limit the number of climate refugees in coming decades and beyond.

→ GUY-PIERRE CHOMETTE, DONATIEN GARNIER,
AUDE RAUX : collectif Argos writers

FROM GLOBAL WARMING TO CLIMATE REFUGEES

The extensive media coverage of global warming these past few years reflects a profound and growing awareness of the issue. To varying degrees, knowledge of climate change has now penetrated all parts of society, including political decision-makers, environmental NGOs, journalists, public opinion and scientists, who are credited with being the first to sound the alarm.

A gradual awakening

The rapid pace at which society has come to accept climate change may lead to the belief that atmospheric warming is a recent discovery. Nothing could be further from the truth. In the late 18th century, Swiss naturalist Horace Bénédict de Saussure discovered the greenhouse effect and developed the hypothesis that the atmosphere, like glass, traps the sun's rays and heats the Earth. In 1824 and 1838, French physicists Joseph Fourier and Claude Pouillet proved him right. Fourier demonstrated that the atmosphere keeps the soil temperature warmer than it would otherwise be. Pouillet went even further: he believed that water vapour and carbon dioxide were responsible for the greenhouse effect, and that any variation in either one could lead to global climate change.

In 1896, Swedish chemist Svante Arrhenius, who would go on to win the Nobel Prize in 1903, dramatically proved this theory true. He calculated that a doubling of the atmospheric concentration of carbon dioxide would result in an average temperature rise of 4° C. A century ahead of his time, he even predicted that the use of fossil fuels would eventually lead to global warming. The scientific pieces of the puzzle were thus in place 100 years ago, allowing us to understand and anticipate a phenomenon that took hold throughout the 20th century.

In 1955, American physicist Charles Keeling built an observatory for monitoring atmospheric carbon dioxide levels on the summit of Mauna Loa volcano

in Hawaii. That year, he recorded a CO_2 level of 315 parts per million (ppm). Based on studies of polar ice, we now know that the level was 280 ppm in 1750, the baseline year traditionally chosen by climatologists as the beginning of the Industrial Revolution. Every year, Keeling recorded the increase in CO_2 levels until the scientific community in the early 1970s began to seriously investigate the climate change theory, which was becoming a reality at global level. In 1972, the subject was discussed at an international environmental conference in Stockholm. In 1979, the first international climate conference took place in Geneva. The same year, the National Academy of Sciences in the United States conducted the first major, serious study on global warming. Its results were so alarming – at such an early date! – that President Jimmy Carter asked Academy scientists to continue their research. One of them, NASA researcher James Hansen, had no qualms about solemnly telling the U.S. Congress in 1988 that global warming was already underway.

Meanwhile, a conference of scientists and public officials was held in Villach, Austria, in 1985. The conference concluded that, *"[A]s a result of increasing concentrations of greenhouse gases, [...] in the first half of the next century a rise of global mean temperature could occur which is greater than any in man's history."* Moreover, the conference called for the creation of an international working group to study the issue.

The U.N. heard the call. In 1987, the World Meteorological Organization (WMO) and the United Nations Environment Programme (UNEP) jointly created the Intergovernmental Panel on Climate Change (IPCC) to review all scientific studies on global warming published worldwide. By bringing together thousands of scientists from around the world affiliated with a wide variety of research institutions, the IPCC, a one-of-a-kind organization, is designed to remain as independent as possible from business lobbies. Its first report, published in 1990, concluded that there was a strong probability of human impact on the climate. This conclusion led to the adoption of the Convention on Climate Change at the Rio Earth Summit in 1992. Its second report, published in 1995, forecast an average warming of 1° C to 3.5° C by 2100 and shortened the timeframe for drafting the Kyoto Protocol. In 1997, 159 countries agreed to reduce greenhouse-gas emissions by 5.2% by 2010 compared to the level recorded in 1990.

A hundred years after Arrhenius's indisputable results, the international community, with the notable exception of the United States, modestly embarked on

its long, laborious fight against a man-made phenomenon that seriously threatens humanity.

What we know about global warming

The planet is warming, as evidenced by the average global temperature curve, which rose between 0.6° C and 0.8° C over the course of the 20th century. The 20 hottest years ever recorded were all concentrated between 1980 and 2005. And France has not been exempt: since 1850, the country's average temperature has risen by 1° C. The cause of this 'fever,' which has developed with an intensity and speed never before seen, is the greenhouse effect, itself caused by human-induced pollution.

This phenomenon can be compared to a garden greenhouse. Light passes through the Earth's atmosphere, which also traps heat. Solar rays cross the atmosphere and heat the Earth. Our planet, in turn, radiates part of this energy in the form of heat, which is then stopped by a layer of gas made up primarily of water vapour as well as carbon dioxide, nitrous oxide, methane and other artificial 'greenhouse' gases. Because it prevents heat from escaping into space, this layer of gas acts like a roof in a garden greenhouse. While the greenhouse effect is generally a beneficial natural phenomenon, without which the average temperature would be −18° C instead of the current 15° C, any man-made artificial increase is dangerous.

According to the IPCC's fourth report, published in 2007, there is no longer any doubt about the link between the enhanced greenhouse effect and anthropogenic pollution, i.e. pollution caused by human activity. The hypothesis of a change in the Earth's tilt that is modifying its distance from the sun has been refuted, because this cyclical variation takes place in astronomical time. A variation in volcanic activity has also been ruled out. Based on the analysis of air bubbles trapped in polar ice for thousands of years – a sort of climatic archive – we know that the concentration of carbon dioxide has risen from 280 to 377 ppm, a 30% increase since the start of the Industrial Revolution. This gas, which accounts for 60% of the increase in the greenhouse effect and remains in the atmosphere for 120 years, is mainly generated by the use of such fossil fuels as coal, oil and natural gas for industrial, energy-production, transport and residential needs (heating, electricity and cooking). At the same time, the concentration of nitrous oxide, largely the result of intensive farming practices – particularly the use of fertilizer – has grown by 15%. Furthermore, the

concentration of methane, primarily produced by cattle-breeding and rice-growing, has more than doubled. There's nothing natural about any of this, and the worst is yet to come.

Despite everything, it's not too late to act, because the greater the increase in temperature, the more costly and harmful the consequences for the environment, plants and animals. As an example, while the oceans have been rising since the 1990s at the rate of 3 millimetres per year compared to 2 millimetres over the previous 50 years, this rate could reach 10 to 90 centimetres by 2011 or even more, thus wiping many areas off the map. This phenomenon can be explained by the thermal expansion of surface waters (with constant mass, when water heats up it takes up more volume than cold water) and the accelerated melting of the Antarctic and Greenland icecaps. Because of these many worrying climate disruptions, 200 million men, women and children will be forced into exile worldwide by the end of the century.

Urgent need for international cooperation
As it gains awareness of its responsibility for global warming and the related impoverishment of biodiversity, humanity is discovering that it is more vulnerable than ever, its diversity, if not its very existence, threatened. It has initially sought to limit the causes of the problem by reducing greenhouse-gas emissions, as evidenced by the Kyoto Protocol. This joint effort, still under negotiation, is likely to intensify, but it will not be enough to stop the warming process currently underway. The international community must prepare to confront major impacts, particularly those affecting vulnerable populations, some of which have already been affected.

The rise in the average temperature directly threatens populations living near arid regions and in Arctic areas traditionally covered by permafrost, and people residing on low-lying islands or in deltas and coastal areas are imperilled indirectly by the rise in sea level and increasingly strong cyclones. These are often poor populations that were already living in precarious balance with their environment and for whom global warming is the last straw, the factor that topples them from poverty to destitution, from a rooted existence to exile.

According to an estimate published by the United Nations University in 2005, migration related to global warming could involve 50 million people in 2010. Such migration will have two major consequences. The first is cultural in nature, involving native populations and all those to whom knowledge of philo-

sophy, social organization and the environment has been handed down over the centuries while preserving their unique traditions. When forced to move far from the ecosystems to which they have adapted, scattered throughout a city or country and deprived of any real or imaginary possibility of returning to their native land, they fear losing their identity. They emphasize the injustice of losing their way of life when their greenhouse-gas emissions are infinitesimal compared to those of developed countries. For these men and women, as well as certain independent countries like Tuvalu that are suddenly shorn of their self-determination, it is clearly a question of human rights – and for humanity as a whole, it is a matter of irreversible loss of ethnodiversity.

The second consequence is demographic in nature. As population displacements become increasingly massive and originate in different parts of the world, it will be necessary to transport, house and settle hundreds of thousands – even millions – of people in nearby or distant lands that may themselves be fatally harmed by a side effect of global warming. If these displacements are not organized in advance or negotiated with receiving and transit countries, they could lead to violent disturbances and humanitarian disasters.

Well aware of the climatic, anthropological and geopolitical forecasts produced by the IPCC and a growing number of reports (for example, those published by North American military think tanks), the international community must urgently address the migration issue for two major reasons: firstly, legal and logistical tools must be developed; and secondly, the world community must provide the necessary political and financial tools for effective international action, which will undoubtedly require the creation of a new global organization or the significant broadening of an existing agency's mandate, such as that of the United Nations High Commission for Refugees (UNHCR).

At the present time, the UNHCR only takes care of refugees as they are defined by the 1951 Geneva Convention, i.e. any person who, *"owing to well-founded fear of being persecuted for reasons of race, religion, nationality, membership in a particular social group or political opinion, is outside the country of his nationality and is unable or, owing to such fear, unwilling to avail himself of the protection of that country; or who, not having a nationality and being outside the country of his former habitual residence as a result of such events, is unable or, owing to such fear, unwilling to return to it."*

Too often, countries hide behind this restrictive definition to refuse asylum to individuals who, according to the Petit Robert French dictionary, *"had to flee the place they lived to escape danger."* It is therefore essential to extend refugee status to persons displaced by global warming as the consensus grows that a real danger exists due to human-induced climate change. This could serve as the impetus for international action and as the legal incubator for climate justice sought by populations on the frontline of global warming.

The time has come for political leaders and economic players worldwide to follow the lead of IPCC scientists and organize an international effort, one not limited to reducing greenhouse-gas emissions but one that immediately begins planning for the mass migrations of climate refugees that will mark the 21st century.

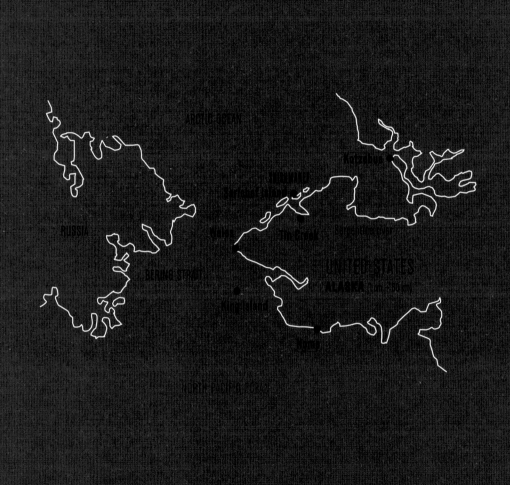

ARCTIC OCEAN

Kotzebue •

YUKUK?
Serpentine(?)

RUSSIA Wales Tin Creek Serpentine River

BERING STRAIT UNITED STATES
 ALASKA 1 cm = 50 km

• King Island

Nome

NORTH PACIFIC OCEAN

TEXT: GUY-PIERRE CHOMETTE
PHOTOGRAPHY: HÉLÈNE DAVID

UNITED STATES
Alaska, the Kigiqtaamiut in jeopardy

Since our arrival three days ago, nothing has really changed along the shore. Under the effect of heavy snowfall, the waves look starched, weighed down as they are with thick grey slush. The sea is oily with melted snow that refuses to harden. This situation, however, should have rapidly changed three weeks ago. In the span of a few days, the snow should have turned into a thick layer of ice, flattening, immobilizing and cooling the sea until it became pack ice – but it is now late October, and this has yet to happen.

In Shishmaref, all eyes, full of impatience, are turned to the sea. Autumn seems to drag on forever, and a vague sense of unease has taken hold. Unseasonably high temperatures prolong this unsettled, in-between period, which is susceptible to violent storms that could break off whole chunks of shoreline without warning, and as long as there is no pack ice encircling the island, protecting it like a cocoon, the risk remains high. For the Inupiaq of Shishmaref, this wait – longer and more worrying every year – stirs up a nightmare that many others have already seen come true: a huge wave swallowing the whole village all at once.

It's now early November – and still no pack ice. Fierce gusts of wind threaten to pummel the village at any moment.

"When I saw the semaphore station plunge suddenly into the sea, I knew my house was going to be next. I had this strange feeling; I felt panicky and calm at the same time. We had to act fast. We had no time to waste because of the wind and waves. Within a few minutes, a human chain formed to help me clear out my house despite the cold and the gusty wind. People really support each other in Shishmaref. They think nothing of helping out because they know we're all facing the same fate. It only took an hour to find a safe place for most of my belongings. Meanwhile, the sea had swallowed up the last 6 feet (2 metres) of land separating it from the house, and below, the waves were already hollowing out the permafrost..."

On that morning in mid-October, Joe Braach had been working calmly at the village school, where he's the principal. The weather report called for moderate winds on the Seward Peninsula, but in recent years the weather in Alaska had changed so much that storms no longer forewarn of their approach. The storm suddenly struck Shishmaref in the middle of the afternoon. In only five hours, it devoured a 20-foot-wide (6-metre) strip of coastline, thus brutally shrinking the little island of Sarichef – 3 miles long by 1,300 feet wide (5 kilometres by 400 metres) – on which the Shishmaref community has been living for centuries.

Despite his natural composure, reinforced by the physique of a master mariner for whom the sea holds no secrets, the 50-something Joe acknowledges that he had a narrow escape. The storm vanished as fast as it had roared in, and his house was spared, but it now lives on borrowed time perched 3 metres above the Chukchi Sea, standing directly over the little beach on what remains of Shishmaref's small sand bluff. Three weeks have come and gone, but still no ice. *"Long live the pack ice,"* murmurs Joe, gazing absently out to sea.

Alaska is getting warmer at an ever-quickening rate, with one of the fastest-rising temperatures in the world. The Shishmaref Inupiaq say they can now hunt seal by boat in early December. At the same time, storms have increased in frequency and strength – another known effect of global warming. In addition, Shishmaref's permafrost (permanently frozen Arctic ground) is thawing and no longer has its usual rock-like strength; it thus cannot withstand the battering of waves and wind during storms. Instead, large chunks of permafrosted land break off and fall into the sea. Erosion is spreading as well: Joe remembers that when he moved to the island in 1987, several dozen metres of shoreline separated him from the sea when he looked out his window, and he could see a semaphore station, the school's basketball court and sand dunes; all of these are now gone.

Over the past 20 years, four levees were built in an attempt to contain erosion, but the effort failed; the levees quickly sank into the fine sand. Traces of the levees can be found here and there entangled among the piles of old, broken-down equipment that make Shishmaref's beach highly unattractive. In desperation, islanders threw anything on the beach that they no longer needed – snowmobiles, quads, and obsolete construction equipment – to stem the assault of the voracious waves, like making sacrifices to a demon god.

Early that morning, someone came to warn Mina Weyiouanna. Her house ended up falling: it had long perched precariously on the bluff above the sea, and that night it toppled over the edge. In another few days, it would undoubtedly be torn apart by the next storm and washed away by the sea. Mina shyly walks through the village with an impassive look on her face. She brings a photograph of her grandparents so she can pose with them, but she wants to do it quickly – she doesn't want to attract a crowd of people. Mina is modest, and knows how painful it will be to see her half-collapsed house. *"I have so many memories,"* she says.

Mina was born 47 years ago in one of the last traditional huts made of canvas and whalebone. Adopted by her grandparents at age one, she grew up with them in the house that fell on the beach that night. *"I can still see myself playing dominoes with my grandfather,"* she says with dignity. *"At the time, the house was still over 300 feet (100 metres) from the shore."* In 1982, after the birth of her first daughter, Mina moved to a new house right next to her grandparents; 20 years later, her house would be one of 18 that the Shishmaref community moved to the other end of the village, setting in motion the first retreat from the advancing waves.

A naturally cheerful person, Mina is quickly overcome with emotion when she talks about the move, recalling the house suspended in the air by a crane specially shipped over by barge from the city of Nome. Placed on giant skis, the house was pulled far from the threatening waves. *"It was so sad I could barely watch. It was almost night, and it had to be done quickly. When we returned to our house, now far from the shore, everything was upside down...I just wanted to cry."* What's more, Mina is having trouble getting used to her new neighbourhood, which is located on an old runway that had become too short due to erosion. *"Over there, we're far from the village centre and relationships in the community have drastically changed."* Furthermore, Mina had to leave behind her grandparents' house where she grew up, long abandoned to the ocean's inexorable ad-

vance – until the night when the shore, eaten away by the waves, yielded under its weight.

Wearing his usual yellow earmuffs to protect him from the biting cold, Jimmy Nayopuk has come down to the beach, which is covered with still-soft snow. With a melancholy look on his face, he points vaguely at the sea and the nearby shore. *"That's where it was,"* he says. *"My house was 100 feet (30 metres) from here, maybe 150. During the storm of 2000, we couldn't do anything about my house. It broke apart when it fell, and I lost all my belongings. Since then, I've been living with my mother – I can't afford to build another house."* Johnny and Roberta Weyiouanna join us. They are also trying to describe Shishmaref's old western neighbourhood, which no longer exists. They were luckier than Jimmy; their house had been moved to the other side of the village. Like Mina, Roberta is having trouble adjusting: *"I miss the sound of the sea; I don't like the silence at night. But the island is shrinking. Other houses have since been moved and more will be, too. We have no choice."*

<p style="text-align:center">*</p>

No choice. As the island shrinks at an ever-increasing pace, the 600 inhabitants of Shishmaref have no other solution than to retreat. In 2001, most of them voted to relocate the village by 2015, their last chance before Sarichef becomes uninhabitable, according to the geologists, meteorologists and other experts who have flocked to the aid of these climate refugees living on borrowed time. Relocate, yes – but to where?

The future of the Shishmaref community has yet to be determined, but two possible solutions have emerged. The first involves moving it to small towns around Nome and Kotzebue, 200 miles to the south and east, respectively, to take advantage of their urban infrastructure. With an estimated cost of $100 million (€74 million), this is the less expensive alternative and the one favoured by the state of Alaska and federal funding agencies. The second alternative, estimated to cost $200 million, would involve relocating the village to the mainland only 12 miles from Sarichef. The village would be fully recreated in an uninhabited area called Tin Creek that would be safe from erosion. *"The state will never pay the extra cost,"* says Jonathon Weyiouanna, Johnny's father-in-law. *"We'll have to find other funding. If we fail, we'll disappear. Our special culture, our community traditions like sharing and respect for our ancestors, our subsistence economy – everything*

that makes us a unique community will perish in a city like Nome, which is foreign to Inupiaq culture." The community's struggle can be summed up in these words: relocate to Tin Creek or disappear.

Jonathan puts his gun on the seat of his snowmobile. Since sunrise, he has been on the lookout for seals that venture into one of the two natural canals separating the two ends of the island from solid ground. He can stay like this for hours, standing on the snow, his head wrapped in his furry hood, silently scrutinizing the flat landscape, seeming to take in the entire panorama before him. Slightly to his left, at the other end of the lagoon that extends 9.3 miles (15 kilometres) inland before disappearing into the mainland, he points towards Tin Creek, in the direction of Ear Mountain, the only geographic feature visible on the horizon. *"Over there,"* he says, *"I could continue to live off hunting and fishing. What you see around you is the cradle of our culture – the ocean on one side, the lagoon on the other, and the rivers that flow into them. Tin Creek is still part of this area. If we move there, we'll be able to preserve our culture, which is so closely connected to this specific environment."*

Like most of the men in Shishmaref, Jonathan earns the bulk of his income from hunting and fishing year-round. His wife, Barbara, also earns a subsistence living by making traditional clothing from the sealskins that Jonathan brings her. *"Nature is our pantry,"* she tells us when we have tea at their home after returning from the hunt. When the entire community spends the long summer days picking berries, both Jonathan and Barbara stock up on blueberries, blackberries and salmonberries, which they preserve in seal oil and eat in the winter. And while they may occasionally order a couple of large hamburgers in Shishmaref's only (and tiny) snack bar, subsistence living is a lifestyle they have no intention of giving up.

Between two gulps of steaming tea that he keeps in a Thermos, Johnny expresses agreement; this is how he lives as well. He and Jonathan usually hunt as a team. *"They tell us we'll still be able to hunt in Nome and Kotzebue,"* he notes, *"but that's not true. Alaska's Inupiaq communities live far from each other so they can divvy up their resources. It would be the same as if you forced a farmer to let another farmer onto his land – the two of them would not get along well. Our ancestors settled here precisely because the Shishmaref lagoon is so productive. Why would we go looking for game elsewhere?"*
In addition to dispersal, assimilation is another risk that could deal a fatal blow

to the community. As evidence, Jonathan cites the sad story of the Inupiaq of King Island, located in the southern part of the Bering Strait. Threatened by a landslide in the 1960s, this small community was moved to a neighbourhood in Nome set up especially for them. For 10 or perhaps 15 years, the community remained cohesive by cultivating its cultural distinctiveness and intra-communal ties, but how much longer could it withstand the inevitable assimilation of some 100 Inupiaq in a city of several thousand North Americans?

Johnny empties his Thermos and gets ready to go home, but he's not very happy with the two seals he killed during the morning. *"It's not much, but it's normal now,"* he says. *"Seals use the ice to rest – so no ice, no seals!"* Even though large chunks of ice formed overnight, the pack ice has yet to make an appearance. The hunters grumble, and Shishmaref remains defenceless.

<p style="text-align:center">*</p>

Even when the ice covers the lagoon and links the island to the mainland like a bridge, the village remains isolated from the rest of the world. No road leads there, nor will there ever be one; it would make no sense to build such a road given the Arctic weather conditions. The only daily link to the outside world is the plane from Nome to Shishmaref, where the insular mindset has a profound impact on the residents. Furthermore, their family, social and professional ties form a distinct community with its own customs, beliefs and celebrations. No one explains it better than Clifford Weyiouanna. At age 62, his face sculpted by Alaska's icy winds, Clifford is considered a respected elder by the community, which listens with deference to his calm, serious voice whenever he has something to say, because Clifford is a man of few words, not given to small talk. His broad experience includes breeding reindeer, hunting game and serving as an education advisor to the regional government. He is now retired, but as an elder he remains involved in important decisions regarding Shishmaref's relocation.

"We have a very old tradition of community life," says Clifford, gently swaying in his rocking chair, his usual cigarette in his hand. *"When we hunt and fish, a portion is always shared with the elderly and those in need. Just like a corporation, people work together for the needs of the community. That may be what gives our community the strength and vitality to hand down our culture from generation to generation – what gives us our economic vitality, too, as we try to preserve our sub-*

sistence lifestyle in a world where we could easily rely on goods brought in from the city. And it's what gives us our artistic vitality as well – on that subject, you should go and see John Sinnock."

In the school's handicrafts class, John is bending over a young student's work – a rough sculptural shape carved out of walrus tooth. John is one of Shishmaref's most highly regarded sculptors. He has been passing on his expertise and knowledge with great passion to younger generations for some 30 years. His course is optional, but most of the students take it. *"They are enthusiastic about the idea of learning our traditional art,"* says the sculptor, whose tallness lends him a calm, natural authority. *"Some of the students become true artists. I get great satisfaction out of that, because I've noticed that by learning the art of their ancestors they're also learning to value themselves. They gain a better understanding of themselves through the work they create. At the same time, they learn that their community is unique, that it's fragile and that they'll have to defend it."* On that issue, John is adamant: each Inupiaq community in Alaska has its own form of artistic expression based on its history, traditions and environment. *"In Shishmaref, many of our sculptures depict scenes of daily life related to seal hunting, because it's the basis of our diet and subsistence. In Wales, a town on the Bering Strait, they're more likely to depict whale hunting, in other places caribou hunting, and so on."*

While John moves from workbench to workbench, advising students, we can hear a pack of dogs barking outside. Koozye Ningeucook, one of Shishmaref's last dog mushers, is preparing to hitch them up to his sled to get them into shape. No one uses dogsleds in Shishmaref anymore to get around, but Koozye, like John, is struggling to preserve the community's traditions. He's even trying to earn a traditional living, because the most stalwart dogs sell for a good price in southern Alaska, where this Inupiaq custom is practiced as a sport [sled-dog racing].

<div align="center">✳</div>

Since the decision to evacuate Sarichef was made, the Shishmaref Inupiaq have been haunted by the thought of relocating to a city. They are convinced that such a move would be tantamount to burying their culture, soul, uniqueness and future. However, far from being paralyzed by this eventuality, the community has taken its fate into its own hands. It founded the Shishmaref Erosion and Relocation Coalition, an organization whose slogan, *"One People, One Voice,"* sums up its objective: to attract the attention of the public, American media and especially

government authorities to the serious and urgent nature of the situation. In 2004, Luci Eningowuk, chairperson of the coalition, testified at length before a US Senate hearing held in Anchorage, Alaska, speaking on behalf of her community and some 200 other Inupiaq villages, all facing the same problems as Shishmaref to varying degrees.

"The ultimate goal," says Clifford, one of the organizations' founders, *"is to raise enough funds to relocate the village to Tin Creek."* In the coalition's offices, located in the basement of the village church, Clifford's cousin Tony elaborates: *"The cost studies conducted by state agencies all came to the conclusion that moving to Nome or Kotzebue would be less expensive, but they never take into consideration the social and human costs! Those are obviously harder to estimate so they ignore them, but in reality, they're enormous. In addition to losing our culture and lifestyle, we'd be hit by a wave of unemployment and crime. They'd have to expand the prison in Nome!"*

In Shishmaref, over 100 people are salaried employees working for the school, city or private firms – two food stores and the small airline companies. Frank, 55, an employee of Bering Air, is responsible for receiving and distributing merchandise shipped in by air. *"In Nome and Kotzebue, this job is already filled,"* he says. *"I would suddenly find myself unemployed – and that would be the case for nine out of 10 jobs! Unemployment would slowly but surely kill all of us."* Yet another threat hangs over the community if it moves to the city: *"Over there,"* says Frances, Frank's wife, *"alcohol is readily available. For that reason alone, I could never live there. Ask the women in Shishmaref; they're all afraid of the same things – alcohol, idleness and violence. Since the community voted to ban alcohol in Shishmaref about 20 years ago, alcohol and the havoc it wreaks are but a memory. Alcohol would destroy us just as much as unemployment and the loss of our traditional way of life."*

＊

That night the mercury suddenly dropped, and at sunrise the temperature stood at -13° F (-25° C). The snow had stopped falling and the glacial wind was sweeping the surface of the sea – ideal conditions for the freezing of water and thus the formation of initial pack ice around Sarichef. For hunters, this is a period when time stands still, when the ice is already too thick for pursuing seals by boat but not yet solid enough for using snowmobiles. Settled comfortably in his rocking chair, Clifford tries to be reassuring: two or three more days like this and the pack ice

will return, but that doesn't stop him from deploring the fear that has been creeping into the trusting relationship the Inupiaq have always had with the ice. In recent years, some Inupiaq have felt the ice suddenly crack under their feet, and owe their survival only to the presence of their hunting companions. Such an accident never would have happened in the past, when the thickness of the pack ice left no room for doubt. These events have led to wariness, a loss of traditional orientations and changes in customary behaviour. Even the elders' knowledge has been called into question, undermining their status as wise men.

Seated on the floor of her house, Clifford's wife Shirley is working with the skin of a seal that Clifford killed several weeks earlier. A special-education teacher for troubled children, she likes spending her free time making traditional fur clothing that will be sold at high prices in Anchorage or in big cities in the 'lower 48' states. Wearing small white walrus-bone earrings in the shape of bears, Shirley says she doesn't really need the money, but is eager to preserve their traditions. *"Our four children are all grown now,"* she says, motioning with her chin to the dozens of family pictures that line an entire wall, as in all Shishmaref's houses. *"I'll be retiring in two years. For Clifford and me, it will be time to prepare for Shishmaref's relocation. There will be nothing to keep us here, so we'll be going to live in Serpentine."*

Located near Tin Creek on the other side of the lagoon that separates Sarichef from the mainland, Serpentine River is accessible by boat in summer and by snowmobile in winter. It's a popular place for fishing, hunting caribou and picking berries. Like many Shishmaref families, Shirley and Clifford own a sparsely furnished cabin. *"We'll fix it up so we can live there year-round,"* she says. *"It'll be hard in terms of water and heating, but we prefer that a thousand times more than going through the uprooting of our community."* Above all, Shirley likes to fish at Serpentine: *"I daydream while I'm fishing. I think about my children, their future and our life. At the same time, I never feel as happy as when I'm here, outside, in this environment."* At Serpentine, Shirley beams with joy, her face lighting up every time she catches a fish, while Clifford scans the horizon searching for caribou.

Clifford and Shirley are far from being the only community members to envision this future. A number of Shishmaref Inupiaq say that, sooner or later, the community will have to take the initiative and start relocating to Tim Creek by moving several houses on a voluntary basis or by occupying Serpentine River cabins all year. The idea is to call the state's bluff and make it fund the development of

Tin Creek. *"It's a way to force the issue,"* says Clifford. *"In any case, Shirley and I have already made our decision. If we're told to move to Nome or somewhere else, we'll go by ourselves and end our days in Serpentine. I hope that the rest of the community follows – simply to stay together and be happy. This shore, this lagoon, these rivers – this is our home, you understand? We have deep roots here. And, as you well know, there's no place like home."*

<div align="center">*</div>

Late November. This morning, Shishmaref awakens to an endless white expanse stretching to the four corners of the compass. The pack ice encircles the village and protects it from those powerful storms that might have the strength to devour it. For a few months, the community can breathe a sigh of relief. On the beach, Mina sadly contemplates her childhood home, which is frozen in place by the ice and will remain like that, half collapsed on the beach, until the ice breaks up in the spring. *"What's going to become of us?"* she asks. "I'm having trouble imagining a future for myself. I can't believe we have to leave." From the top of the small permafrost bluff, a few people gaze at the breathtaking white vastness spread out before them. *"In our language,"* says Mina, *"we're called the Kigiqtaamiut, which means the people of Shishmaref. Whatever happens, we will always be the Kigiqtaamiut."*

∫

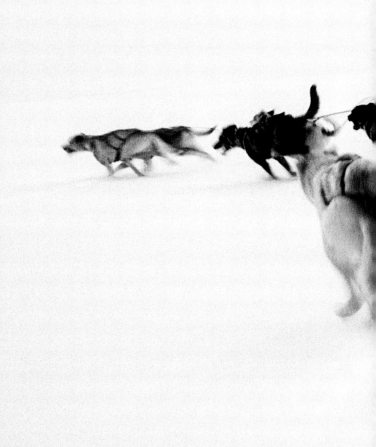

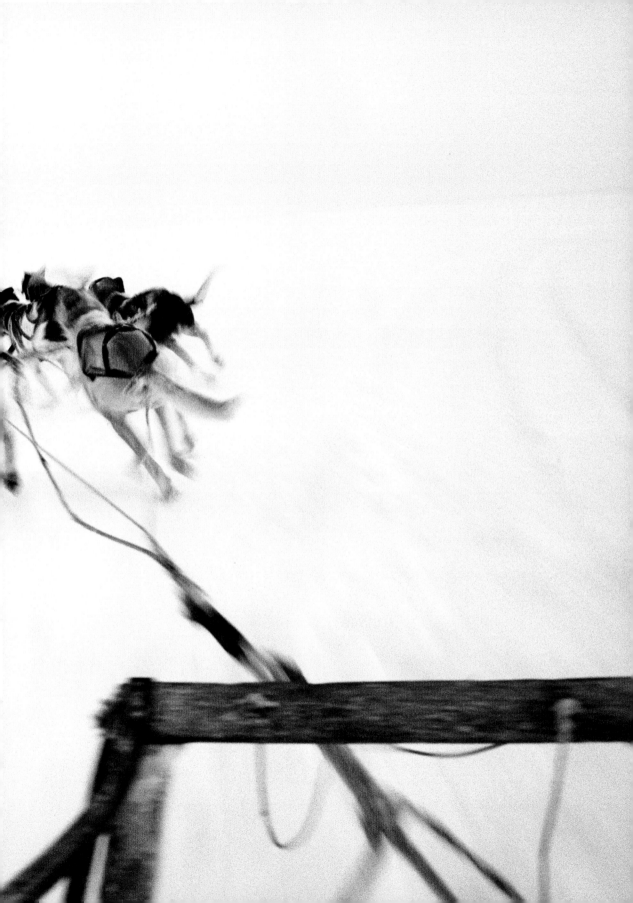

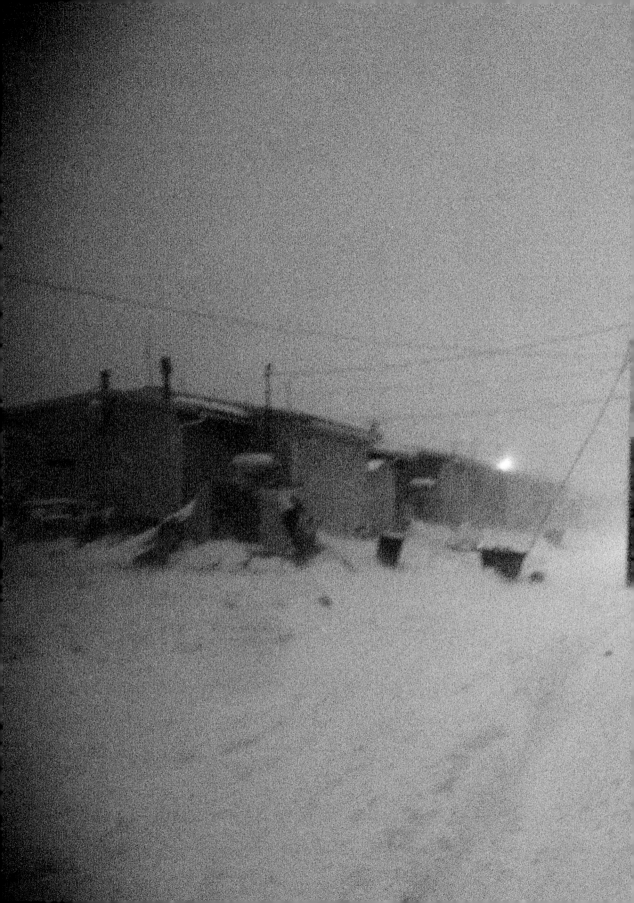

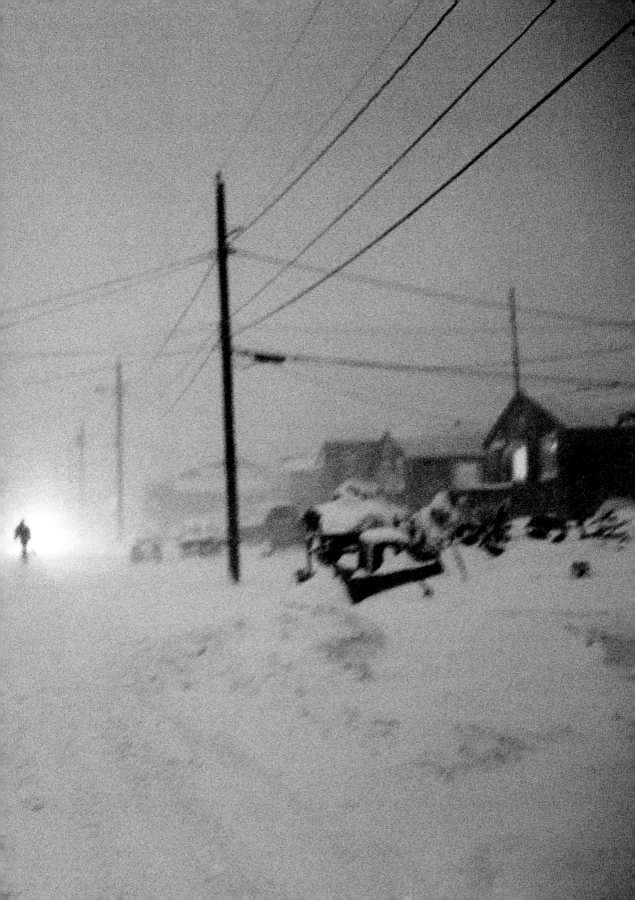

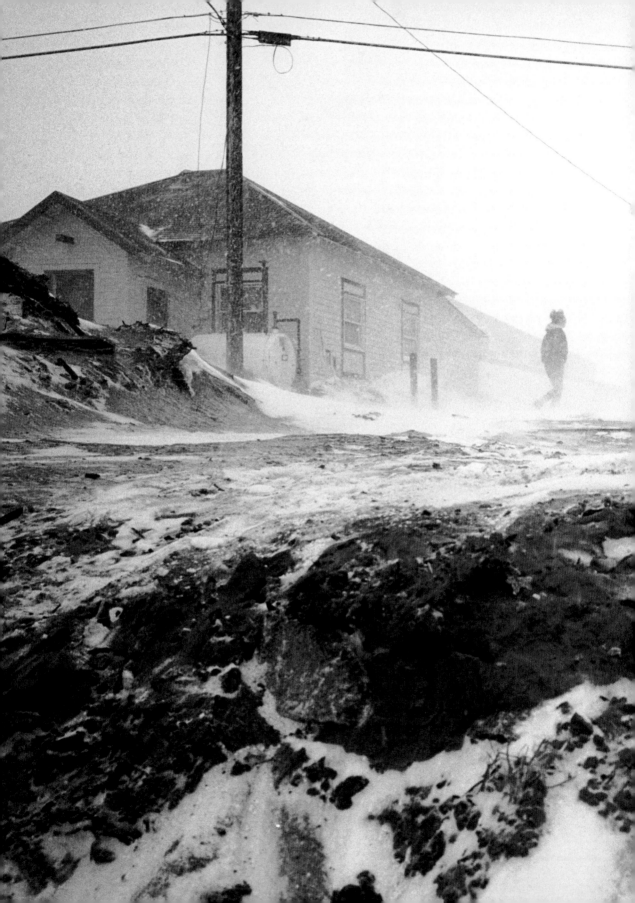

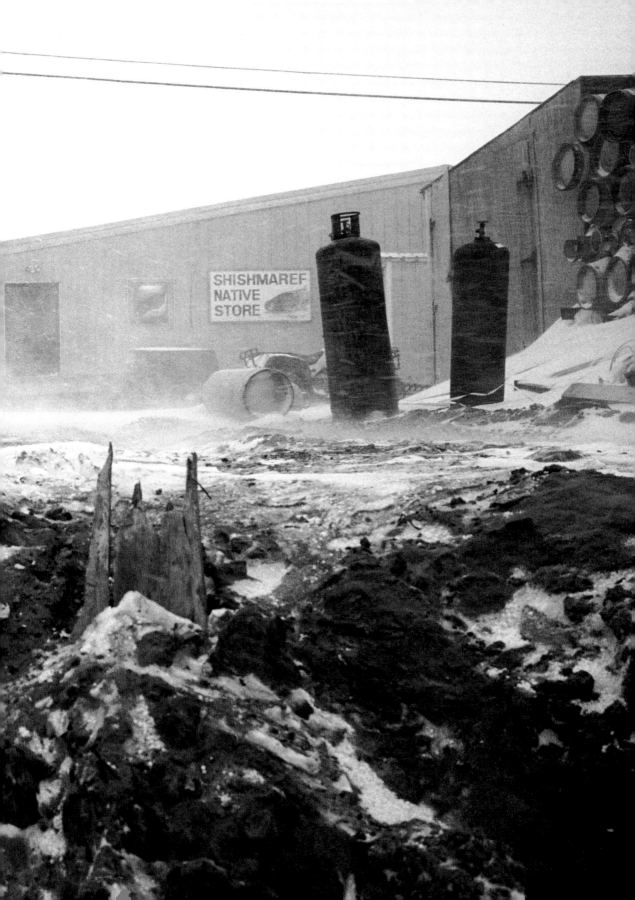

→ *(Previous pages)*
In Shismaref, the permafrost
is thawing due to global
warming. The erosion is
so serious that the Inupiaks
are doomed to exile.
The community is threatened
by the loss of an identity
based on an ancestral
territory and on subsistence
economy.

→ *The Shishmaref Inupiaq face*
an uncertain future.
If they are relocated to Nome,
they will lose their identity.
Only a move to the virgin
lands of Tin Creek, not far
from their ancestral home,
will ensure their survival as
a community.

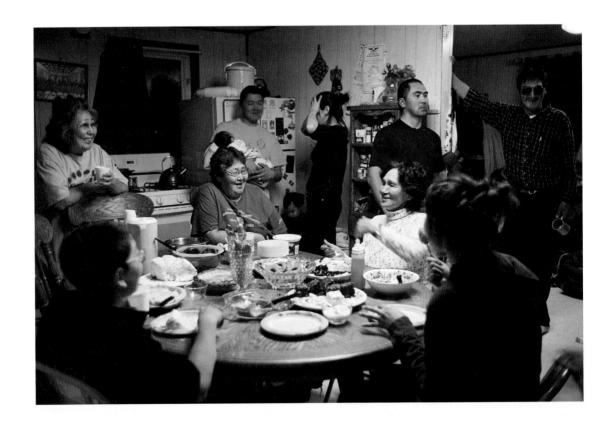

→ *The Shishmaref school helps maintain the community's close cultural and social ties. The teachers strive to preserve their culture by offering courses in Inupiaq music, dancing, sewing and sculpture..*

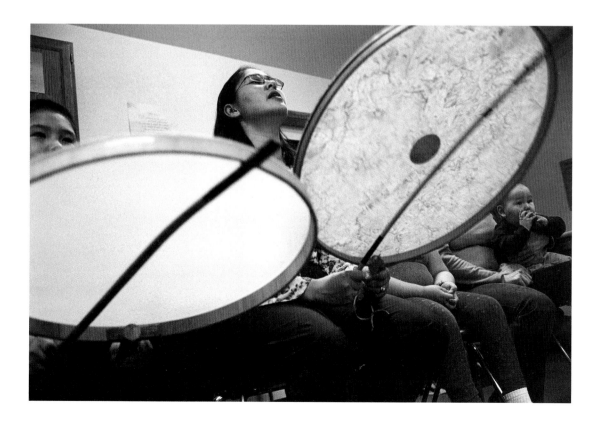

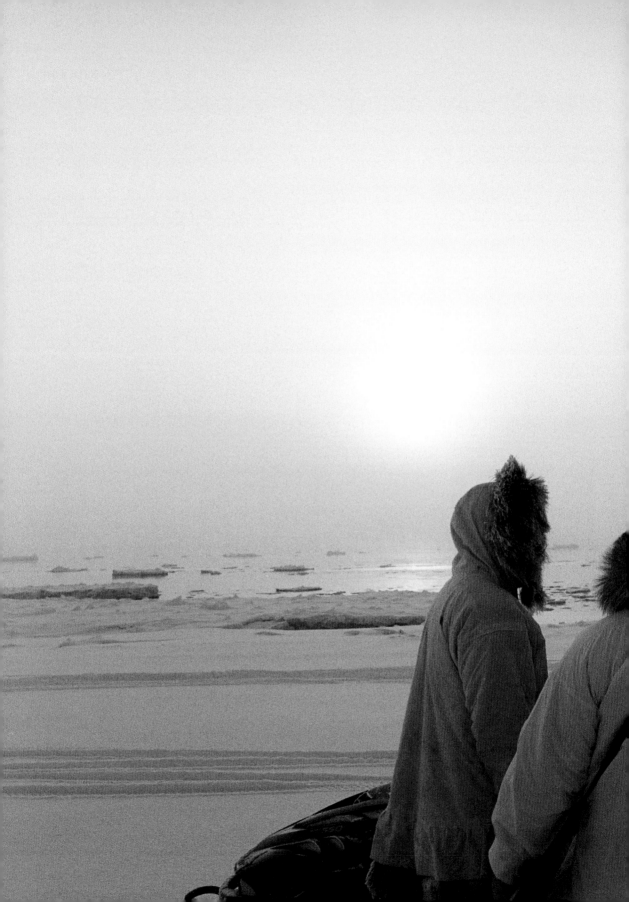

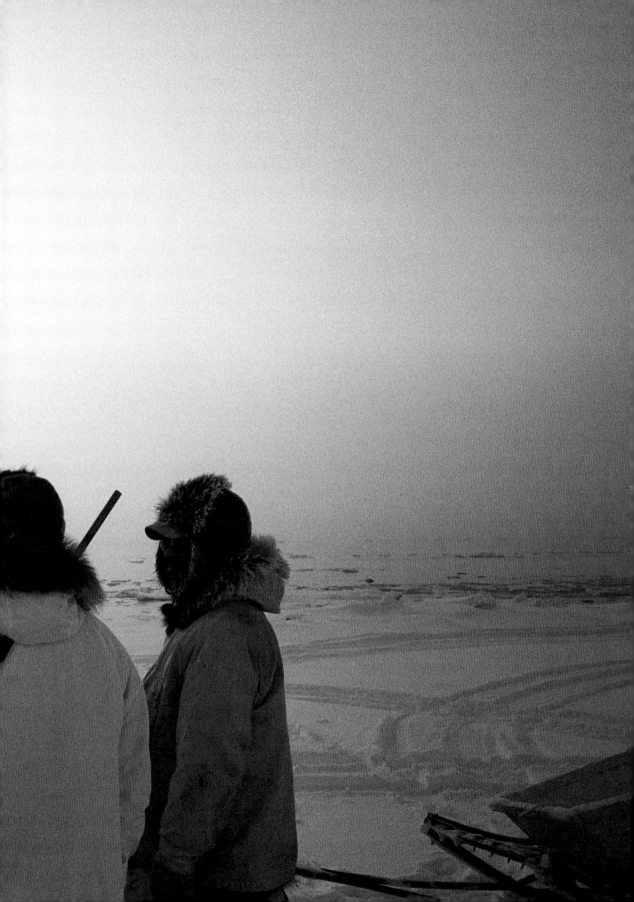

→ *(Previous pages) In Shishmaref, the seal hunt is one of the pillars of the subsistence economy and thus of Inupiaq culture and identity. The hunters always share a portion of the kill with elders who can no longer take part.*

→ *Hunting, fishing, and berry-picking in the summer: "Nature is our pantry," say the Shishmaref Inupiaq, who have no intention of giving up their way of life, which is largely based on subsistence.*

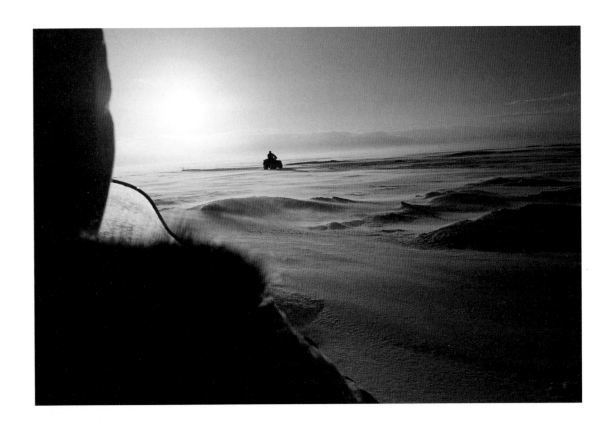

→ *Snowmobiles -although their weight is more likely to cut through the thinning pack ice- have long replaced sled-dogs. Koozye Ningeucook, one of the last sled-dog mushers of shishmaref, is trying to perpetuate one of the most ancient traditions of his community.*

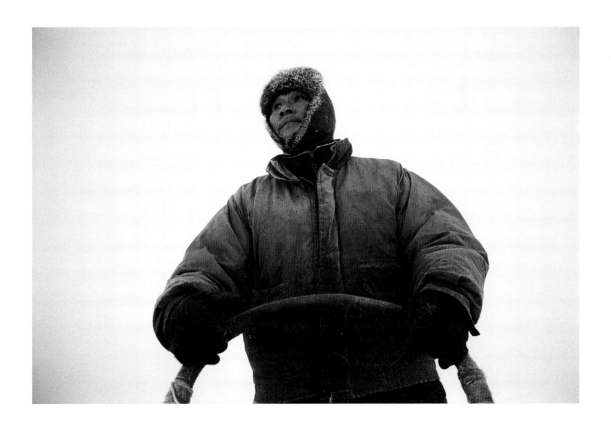

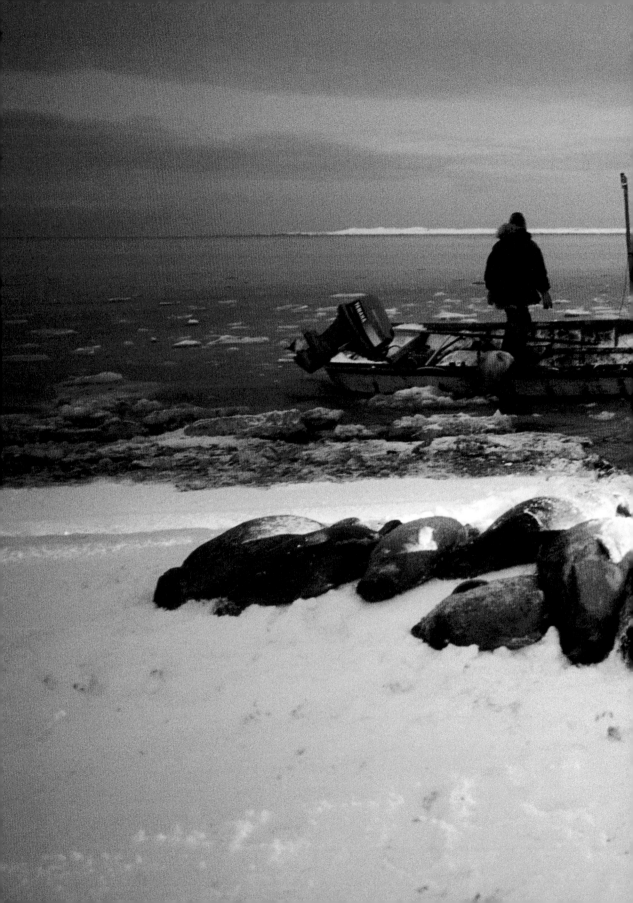

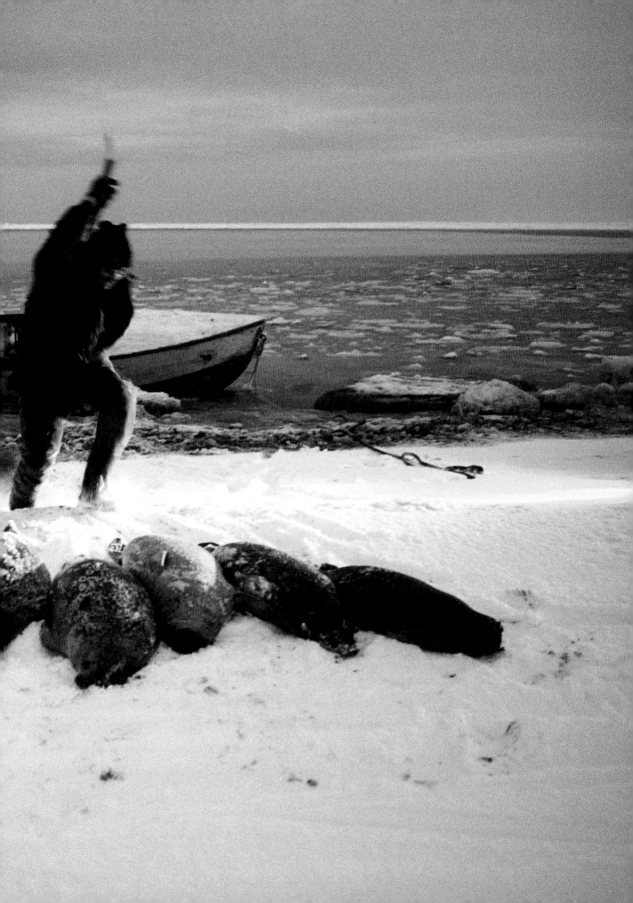

→ (Previous pages) "Our special
culture, our community
traditions like sharing and
respect for our ancestors, our
subsistence economy –
everything that makes us a
unique community will
perish in a city like Nome,
which is foreign to Inupiaq
culture," says Jonathan
Weyiouanna.

→ There have been regular
efforts to restore
Shishmaref's eroded
beachfront. Over the past 20
years, four levees have been
built in an attempt to contain
erosion, but the effort failed;
the levees quickly sank into
the fine sand.

→ *Long abandoned, Mina Weyiouanna's childhood home has just fallen onto the beach. "I can still see myself playing dominoes with my grandfather," she says with dignity. "At the time, the house was still over 300 feet (100 metres) from the shore."*

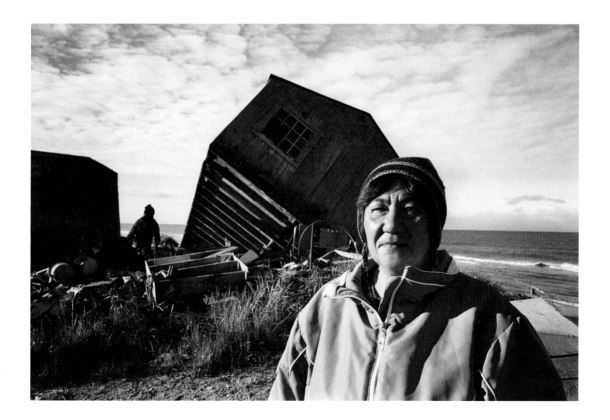

→ *Illustrating the respect paid to elders and the close family and social ties that bind the community, dozens of pictures line the walls in Shishmaref's homes.*

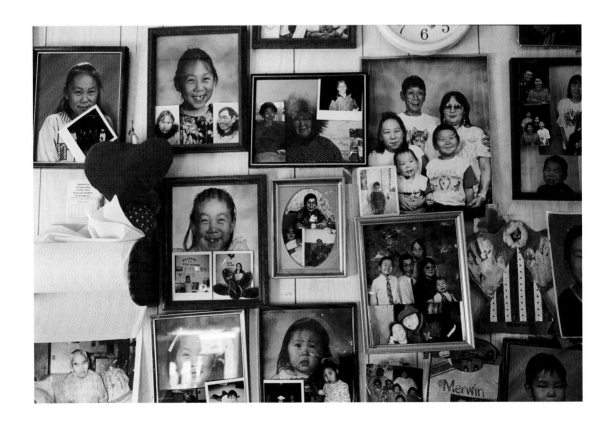

→ *Many families own a cabin along the Serpentine River. To avoid being relocated to Nome, some Inupiaq are thinking about sparsely furnishing their cabins to live there year-round, preferring this extreme solution to an uprooting they view as being fatal to their community.*

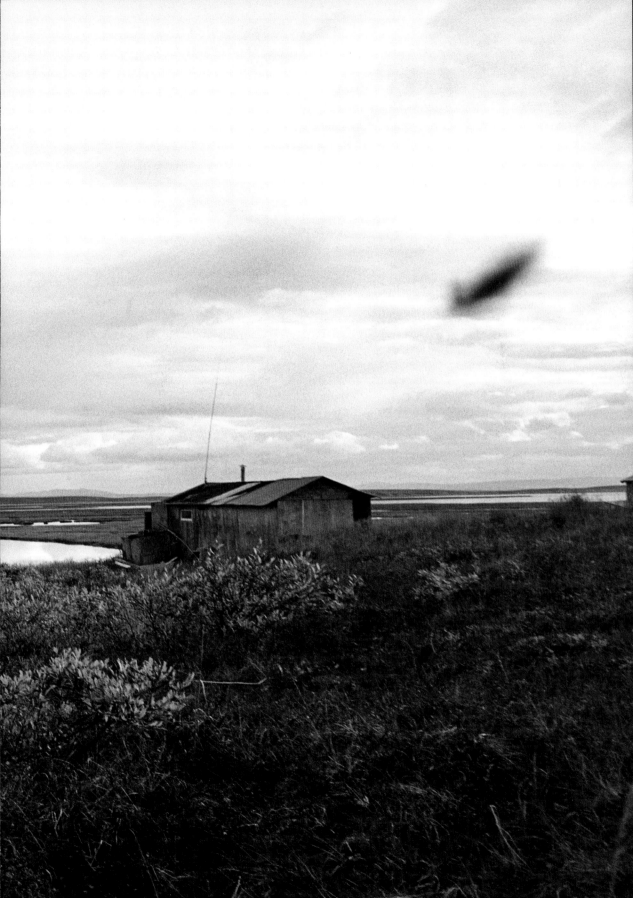

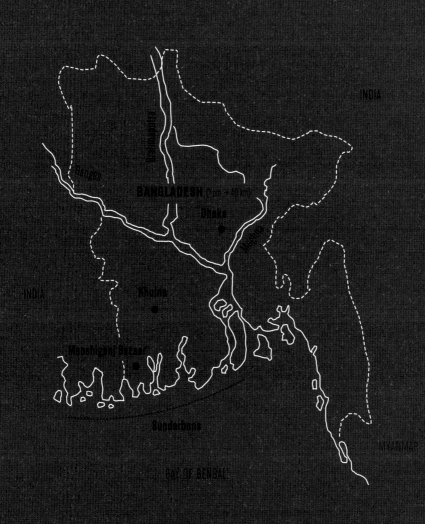

TEXT: DONATIEN GARNIER
PHOTOGRAPHY: LAURENT WEYL

BANGLADESH
Sundarbans, the great overflow

1. A flat country

Munshiganj is a 12-hour bus ride from Dhaka. After several days of making en-
quiries in the capital, we've decided to head for this small municipality in the
southwest corner of Bangladesh, not far from the Indian border and the Bay of
Bengal. We're a team of three: photographer Laurent Weyl, Tihami Siddiquee, a
brilliant Alliance Française student who has agreed to serve as our interpreter,
and myself, the author of these lines.

We travel in relative comfort during the first part of the trip. The bus's suspen-
sion is a bit stiff, but the air conditioning works and the seats are equipped with
an unbelievable massage device. We soon desactivate this ineffective gadget and
gaze out the window at an unvarying landscape of rice paddies and ponds borde-
red by trees and interrupted by waterways. We savour our tranquillity since, as
Tihami has warned us, the level of luxury will decline appreciably once we pass
the city of Khulna.

Here's what we have to look forward to: we'll be squeezed inside a crowded, di-
lapidated bus piloted by an exhausted driver who – clearly unaware of how the
brakes function, with pedal to the metal, pounding freely on the horn – will sla-
lom down the road amid buses going just a hair slower than ours, tricycles loaded

with bundles of jute, log-jammed pedestrians and, worst of all, his dangerous alter egos bounding at full speed in the opposite direction. The four hours of trepidation will bring back memories of the anguish I once experienced on the precipitous roads of Bolivia.

But Bangladesh is as flat as the Andes are mountainous. We'd just seen this for ourselves crossing the chocolatey immenseness of the Ganges. The ferry was not particularly high, but when we stood on its third bridge we felt as though we were looking down over the infinite flatness of the Bengal region. It even seemed that, if the boat had had one more level, we could have seen the entirety of this liquid country, the delta of three of the largest Himalayan rivers: the Ganges, the Brahmaputra and the Meghna.

2. The cup and the drop of water

The total absence of topographical features and the enormous amount of water converging towards Bangladesh – which receives 92% of the water from Tibet, Bhutan, India and Nepal – predispose the country to flooding. Each year during monsoon season, floods cover one-third of the country on average. With 147 million inhabitants concentrated in an area slightly smaller than one-quarter of France, Bangladesh is one of the most densely populated places on the planet. Until recently, however, the annual floods weren't such a problem for its inhabitants, because – with the exception of a few rare, particularly destructive 'floods of the century' – people were accustomed to the flooding and used it to their benefit.

The fragile balance achieved over generations between humans and a capricious environment, however, is now threatened by an unexpected additional factor: global warming. A few days before our departure for Munshiganj, we met with Ahsan Uddin Ahmed, head of Bangladesh Unnayan Parishad (BUP), an independent, multidisciplinary research organization. He explained the threat with the paradoxical enthusiasm of those impassioned by the most dramatic issues. *"Global warming is causing floods of increasing scope and duration. In the space of 20 years, we've already seen five that have equalled or exceeded previous 'floods of the century.' This can be attributed to several factors: glacial melt and heavier monsoon rains abnormally increase the amount of water that has to drain down to the Bay of Bengal, and then rising sea*

level act as a brake on river flows, especially during high tide. In a country as flat as ours, a few centimetres of water can result in significant expansion of flooded areas." At this point, I mentioned a projection made in the third IPCC report: for Bangladesh, a 45-centimetre rise in sea level would mean the loss of 10.9% of its area (one metre would lead to a 17% loss), and 5.5 million people would have to leave their land. Ahmed smiled. *"It will probably be even worse, since global warming has so many different effects. During the dry season, for example, rising temperatures combined with significantly reduced rainfall will cause drought in the northwest of the country; and with the flow of waterways substantially reduced, the tides will drive saltwater farther north, contaminating fields and groundwater along the way."*

Ahmed was careful not to take a position on the probability of hurricanes increasing in intensity, but he noted that if this turned out to be true – as indeed it seems to have done already – there would be serious implications for vulnerable coastline populations. We remarked that, according to his analysis, very soon no area of Bangladesh would be spared the consequences of global warming. *"Correct! And all of these transformations are already underway – you only have to go to the southwest to see that. By increasing the salinity of the soil there, global warming has considerably impoverished the region's ecosystems and jeopardized its inhabitants."*

There was something triumphal in the professor's tone as he reached the end of his talk. We were confused. Ahmed's opinion was, however, consistent with that of most of the NGO heads and specialists we had spoken to: the southwest was one of the regions most affected by global warming, so that was where we had to go.

3. Munshiganj Bazaar

It's impossible to go any farther than Munshiganj. The small road leading to it stops abruptly, bumping up against the Malancha River, which, although not impassable, acts as a kind of border between a densely populated, intensively utilized space and an untamed world devoid of dwellings and farmland. Across from us on the other bank lies the Sundarbans, one of the most extensive, richest mangrove forests on the planet. Bordering the Bay of Bengal and shared

between India and Bangladesh, the Sundarbans has been named a UNESCO World Heritage Site. Fresh water and saltwater meet in this forest, which is a complex ecosystem and refuge for numerous endemic and endangered species. Night has just fallen. The village is lit by oil lamps and light bulbs powered by motorcycle batteries. Exhausted from our journey, we stretch our stiff legs in the hot, humid air, which feels refreshingly cool compared with the overheated, dusty, deafening hell from which we have just emerged. We can hear bicycle bells ringing and, in the distance, the enchanting chirping of frogs. One by one, our senses return to normal and we gradually open up to our surroundings.

Munshiganj Bazaar, its full name, is the market town for all the local villages. It has a main street perched on an earthen levee that's supposed to protect the area from tidal bores and high tides. The street is lined with shops, small businesses of all kinds and teahouses. The houses and mosque are located on a lower level, as is the primary school, which has been lodged in a multi-storey cyclone shelter – more to protect the children from unexpected floods than excessive winds, the principal tells us later. A tall pole dominates the village. We're informed that it's a telephone antenna erected by Grameen Phone, the nation's leading mobile telephone service provider, which is owned in part by the micro-credit bank set up by Nobel Peace Prize recipient Muhammad Yunus.

We use this brand-new network to phone our contact Mohon Kumar Mondol, the young founder of a local NGO who had confirmed that the area was heavily affected by global warming and promised to put us in touch with a family that has felt its effects directly. We will meet them tomorrow. In the meantime, Mondol directs us to some accommodations not far from the terminus, where we'll be able to sleep in beds and take showers – for the last time in quite a while.

4. Uncle Mannan

All night long, we heard rain drumming on the sheet-metal roof of our lodgings. This year, the monsoons have come late and with redoubled intensity. Some districts in Dhaka were flooded for several days, paralyzing traffic and slowing down business. Here, explains the friend Mondol has asked to take us to our host, the rains have delayed the sowing season, which is a big problem for rice farmers in the region – but, as we will soon discover, these farmers are now few and far between.

We take advantage of a lull in the downpour to get moving. Pulling our wheeled suitcases, bending under the weight of our equipment, we join the crowd headed for the market. Men are dressed in the traditional lunghi, a skirt of light cotton that is reminiscent of the sarong of the Pacific Islands, along with a usually threadbare button-down shirt. Women wear colourful saris. Most everyone goes barefoot or wears plastic sandals. Those without umbrellas are soaked but continue their shopping and conversations as if nothing were amiss. Suddenly someone makes a joke. Several passers-by laugh and, a moment later, we find ourselves at the centre of everyone's attention – and that's just where we stay until our departure eight days later. It must be admitted that we do stand out, and with his parka and clunky hiking shoes, Tihami hardly blends into the crowd any better than we do.

"That's him!" Our guide points out a stocky man with thin legs who's meant to accommodate us at his family home. He hasn't seen us and continues his shopping, buying spearhead-shaped leaves the size of a man's hand and then some shaved nutmeg and powdered lime, the ingredients necessary for making paan, a bitter chewing that's very popular in the countryside. I observe him as he bargains for his purchases. His fine moustache, well-groomed white beard and grey hair are those of an old man, but his full face, thick features and ample head of hair give him a somewhat youthful quality. Is this a middle-aged man who looks older than his years, or an old man still full of vitality? It's hard to tell. The sale is finally made, the purchases are stowed in a lightweight basket and, with an air of triumph at once candid and facetious, Abdul Mannan Molla turns in our direction.

Introductions made and our agreement ratified, we load our baggage and fresh-water reserves onto a tricycle equipped with a plank platform, and, escorted by a group of curious villagers, we set off on foot with our host. Uncle Mannan, as we will call him from now on, informs us with a bit of embarrassment that his house is three kilometres away on one of the many earthen dikes that crisscross the region. We smile, undaunted – we like walking, and a little exercise won't do us any harm after our long day on the bus. Our enthusiasm quickly fades, however: the path we set forth on is so sodden that we sink into the mud at every step, and our shoes are soon heavily caked, which hampers our progress yet doesn't prevent us from slipping. We become obsessed with our feet. When we look up, we discover that we're the only ones thus afflicted, the only ones huffing and puffing, the only ones encrusted with

mud. The people accompanying us seem to be walking on concrete. Uncle Mannan's agility is so amazing, we decide that, despite his white beard, he must be in his 50s. When we find out he's actually 70 we feel a bit depressed.

A century later, we reach the village of Pankhali, with its impoverished earthen houses plastered up against the dike. In a rather pitiful state, we enter the shack belonging to Uncle Mannan and his wife, Zohura, where we are greeted by their two sons, Rhaman and Gafar, their respective families, and a great number of neighbours.

5. Disappearance of a landscape

The adaptation of a group of people to their environment can be measured by how easily they move about in it. The Tuareg cross sand dunes quickly; the Inuit balance perfectly on ice floes; and the Aymara demonstrate incredible endurance on Andean plateaus. We've been staying with the Molla family for three days now and have decided that we will never make good mud trekkers. To move through this substance with dignity, you need to have been born here and swung on your mother's or sister's hip as she walked along unstable paths. You have to have played football in silt. And, before you return to this waterlogged earth for good, you have to have at least modelled it with your hands, built a house or plugged up a hole in a dike. Uncle Mannan has done all of these things in his time.

Even today, our aged but nimble host is a foreman at various dike maintenance and repair worksites, in particular the large construction project aimed at keeping water from the Sundarbans mangrove forest at bay. We've just come back from one site, where we saw workers taking advantage of an ebb tide – and a break in the monsoons – to scoop up large amounts of silt with hoes from the bed of the Malancha River. Laurent spent a good part of the morning sunk in the mud up to his knees, photographing the day labourers as they transported heavy clumps hand-to-hand up four metres to the top of the levee. They increase its height by several centimetres every year for better tide resistance, the foreman tells us as we watch the water rising. By the time we left, the water was already well above the level of the fragile huts on the other side of the large dike.

As we make our way back to Pankhali, where a lunch of seasoned rice garnished

with a few small bony fish awaits us, another subject preoccupies our host. He pays less attention than usual to the friendly waves that never fail to greet his arrival in the village and points at the landscape surrounding us with a hint of sadness. Huge basins where shrimp will be raised for export extend as far as the eye can see. Everything is dull and grey. *"When I was young,"* Uncle Mannan tells us, *"this was all rice paddies and herds of cattle. It was beautiful. But ever since the 1988 tsunami, the soil has gotten more and more saturated with salt, and crops have been replaced by shrimp farms."*

Was this adaptation to environmental changes a success? *"It has brought us a lot of money,"* Uncle Mannan says. *"There was no bazaar before."* But someone from the small group that has inevitably formed around us corrects him: *"Money, yes, but only for the rich. The poor are just getting poorer."*

Opinions are volunteered from all sides. *"There are far fewer jobs at the shrimp farms than in the rice paddies,"* says one neighbour. *"There's no more work."* Another speaks up: *"We used to burn dried cow dung as fuel, but now most of the cattle have died and we have to cut wood in the Sundarbans."* A third man joins in: *"There used to be six seasons, now it seems like no more than three."* The group hasn't become any more optimistic by the time we reach Uncle Mannan's home. *"Just send us a bomb and we'll put an end to all this,"* a diminutive, emaciated man concludes with a straight face.

There's no question of stopping the discussion there. Most of the villagers who have accompanied us follow us into the single room of the house. Once our feet have been washed and dried (so as not to track dirt from the house's earthen floor), we take our places on mats that serve as both tables and beds. We're about to begin our meal when a magnificent song, a kind of rhythmic wail, rises up from somewhere in the neighbourhood. It's soon joined by a harmonium. We listen in admiration. *"It's a love song,"* explains Tihami.

After lunch, Uncle Mannan's wife Zohura offers us paan. A small woman withered by work, she's 62 but seems 10 years older than her husband. Someone brings her up to speed on the conversation. *"Everything's changed,"* she agrees with her unusual irreverent, tragicomic style of humour, which makes her so endearing. *"Every garden used to have its own fresh-water well, but now the water is salty and we can't use it anymore. We have to walk to the bazaar or take a boat across the river to get drinking water. It's exhausting."*

6. Shrimp and tigers

Listening to Zohura, I remember the words of the scientists we met with in Dhaka and I reconstruct the cycle of deterioration that's killing the area little by little. The tsunami that devastated the region in 1988 was the trigger. Salt contamination has been increasing since that time due to rising sea levels and reduced river flow during the dry season. This has created a vicious cycle. With saltwater penetrating further inland and deeper into the groundwater, global warming is gradually poisoning the population and destroying rice farming and jobs.

Prospects for survival seem grim. Anywhere else, leaving would be the only solution, but the mangrove forest offers a temporary respite. Peasants unable to find jobs at the shrimp farms increasingly turn to fishing, hunting or scouring the Sundarbans for wood and wild honey. Uncle Mannan's youngest son, 30-year-old Abdul Rhaman Molla, who fishes in the mangrove forest (Gafar, the eldest, resells fish hatchlings to the shrimp farms), has noticed this. *"There are more and more boats on the water. For five years now, people from the north have been making the three-day trip to fish here. It's God's will – I don't hold it against them. But because of this, there are fewer shrimp and fish hatchlings. There are places where I used to catch 10 kilos a day, but now I get only 500 grams. To cope with this situation, I'm forced to go farther into the forest."*

The men who venture into the Sundarbans run serious risks. The mangrove forest is infested with pirates who beat fishermen and kidnap them for ransom. It's also the refuge of the fearsome Bengal tiger, to which a rising number of victims is attributed.

Everyone here has a frightening story to relate. We listen to the villagers give testimonials populated by memories of panic-stricken terror. Some of them show off impressive scars left by crocodile teeth or tiger claws. Yet hunger remains stronger than danger, and human overexploitation of the mangrove forest continues. It's sums up with global warming's more direct effects such as salt contamination, rising ocean levels and increasing water and atmospheric temperatures. All of these changes are happening too fast for the mangrove forest to adapt. The biggest trees are disappearing, as are many animal and plant species. Without the forest's biodiversity, the delicate balance that allows humans to survive in the southwest will be destroyed, forcing hundreds of thousands to migrate. As Ashan Uddin Ahmed told us in Dhaka, *"Over 8,000*

families depend directly, and at least five million indirectly, on the Sundarbans for their livelihood."

"Go? Go where? I'd rather climb up a tree and die here," exclaims Zohura, prompting laughter from her neighbours, when I ask her if she could imagine leaving her village because of global warming. *"I'll take my family to Dhaka. There's no other choice,"* her son Rhaman says half-heartedly. But the Molla family's departure is not yet on the agenda – *"except perhaps for a season, as we have always done during difficult times,"* corrects Uncle Mannan, who doesn't appear to realize that this isn't a temporary crisis but an inevitable decline.

7. To stay or to go?

The days go by, and, as we learn more about the detrimental cycle into which global warming is dragging Munshiganj and its surrounding areas, it's as though we can physically sense the landscape's extreme fragility. This sensation grows more vivid as we come to understand the strength of the bond linking the inhabitants to their region. They practice a moderate Islam under which music is tolerated, women are not oppressed and a peaceful coexistence with the Hindu population is allowed. The two groups even share the cult of Bono Vidi, the goddess of the forest. The region is marked by the richness and beauty of the Sundarbans, and the area quite simply belongs to them. This morning we finally met Mohon Mondol, the man who put us in touch with the Molla family. We were already familiar with his determined voice but were surprised by his youth – he's only 30 – and his steady demeanour. Via his own tiny NGO, Gana Unnayan Sangstha (GUS), he has set up ecological clubs in neighbouring villages, where people meet to discuss changes in the environment and implement solutions such as planting trees, raising houses, managing drinking water and introducing varieties of rice less vulnerable to salt. Uncle Mannan is a member of the Pankhali club. This means that he is able, despite his illiteracy, to make regular presentations to his neighbours and host the small theatrical troupe that GUS supports.

"People here notice the changes," Mondol explains, *"but they are too ill-informed to understand them and they worry a great deal. So, together with a troupe of local actors and musicians, we've set up travelling shows to explain what's happening at*

global level using representations of our culture. If we want to avoid a massive mi-
gration into the cities, we must help people understand what's happening and offer
them ways to adapt."

Yet despite his efforts and the attachment the inhabitants of Munshiganj feel for
their region, a growing number of people who cannot find work at the shrimp
farms or in the mangrove forest have been forced to leave – and others will fol-
low, for, as Mondol carefully avoids mentioning, these adaptive measures are
only stop-gaps.

An acquaintance of Uncle Mannan's has provided us with the address of a group
of young men who've moved to Dhaka to work as rickshaw wallahs, pedalling
passengers around in three-wheeled vehicles. The time has come for us to conti-
nue our journey. *"You're leaving already? Then why did you even come?"* asks a
tearful Zohura when we bid them farewell. With lumps in our throats we em-
bark in Rhaman Molla's pirogue, which we've chartered to avoid the ordeal of
another trudge through the mud.

8. Dhaka

"Khilgaon. Maradia. Nazrulramman's garage." In the immensity of Dhaka, this is
the only information we have to go on to locate the Munshiganj migrants among
the growing masses of people relocating there. With its current population of 13
million expected to rise to 21 million by 2015, making it the fourth most populous
city on the planet, the capital of Bangladesh is also one of the fastest-growing
megalopolises. Buildings – skyscrapers of glass, villas, blocks of flats still uncom-
pleted but already shabby, shantytowns and more – are rising everywhere, often
in a slapdash manner and amazingly close together.

The task did not promise to be easy, and I hoped that I'd noted down the three
names correctly. But Laurent soon found Khilgaon and then Maradia to one side
of our map. According to Tihami, who had never been there, it was an impoveri-
shed district with a dubious reputation. We had to get there soon; night had al-
ready fallen, and we didn't want to risk finding the place closed. We had to
convince the driver of a baby taxi, a three-wheeled affair powered by compressed
gas, to take us there, and then we had to beg him to turn on his metre. Once en

route, it was impossible to hear each other over the cacophony of the traffic without screaming, so we just sat back and watched the compact flow of cars, buses and baby taxis. Surrounded by all these vehicles, the rickshaws seemed like fragile insects without shells or any other means of defence.

After more than an hour, our sputtering, shaking vehicle finally stopped at the end of a badly lit blind alley. A sizeable sheet-metal shed pierced with large openings stood before us – Nazrulramman's garage. A passing shadow answered our queries: yes, there were some drivers from Munshiganj here. We followed the shadow through a narrow back street, and then filed into a small room lit by one light bulb. A dozen men were there, each crouching or stretched out on the concrete floor. Tihami quickly uttered the magic word, *"Munshiganj,"* and we immediately received a very warm welcome. This is how we met Mohammed Abdul Hamid.

9. Hamid

Hamid, age 25, is lean and muscular, though he says he's much skinnier now than he was a year ago when he decided to leave his village. At great length, in a voice made hoarse by pollution, he tells us of the difficulties of his job as a rickshaw driver. After 10 hours of work each day, he washes up with a bucketful of water, eats a meal of spiced rice and chats awhile with friends from the village, and then collapses on a mat for a dreamless night that barely restores his energy. Imagine it: 10 hours of braving the dangers of crowded roads and blows from traffic cops' billy clubs; 10 hours of transporting bad payers and excessive loads; 10 hours on a seat with projecting bolts that cause painful wounds in the crotch area; 10 hours of trying not to think too much about his old life, or about his wife and two children, who stayed behind in his beloved home region. *"When there's a full moon, I can't help thinking of the Sundarbans. That's the best time for fishing in the mangrove forest. I loved that. I still feel it calling to me."*

As he reminisced, Hamid's melancholy gaze gained a bit of sharpness, a little more vigour, but his empty look of resignation soon returned. *"I had to stop fishing because the tigers were getting more aggressive and attacks were increasing. I was too scared. There was no work outside the mangrove forest and I wasn't able to feed my family, so I followed my brother-in-law to Dhaka. I'm not the only one; there are more and more of us here. A year ago, there were 11 of us, and now there are around 50."*

Hamid and his companions, who range in age from 17 to 40, pool their resources to buy food and rent a dormitory and a common room from the man who also owns the rickshaws. When we later meet the owner, a nonchalant 40-year-old, he tells us that he never misses the days – not so long ago – when his garage was part of a farm in the middle of a field and his only lodgers were cows and ducks. True enough, his business is a prosperous one, endlessly fuelled by migrants arriving from all over the country in search of work they expect to be temporary. Hamid confirms this when he explains that he's working as hard as he is in the hope of saving enough money to set up a small shrimp business – back home, at the edge of the Sundarbans.

10. The geographer's view

From his simple, modern office in a conspicuous high-rise on the campus of one of the private universities prospering in Dhaka, light-years away from the Khilgaon district where the rickshaw drivers live crowded together, Maudood Elahi, a geographer and specialist in domestic migration, predicted a different future for Hamid. *"It's the classic scenario. The head of the family arrives first. At the outset, he sends money back to his family, thinking that one day he'll return and settle with them, but usually the opposite happens."*

The professor confirmed that Dhaka, the main destination for migrants, has increased in area by 40% over the past 20 years. If, as the most recent IPCC report predicts, climate change continues to put pressure on Bangladesh, we must expect massive population migrations, both from the southwest and the rest of the country. Dhaka simply cannot absorb such a large-scale rural exodus, especially since the capital is itself threatened by major floods like the ones it experienced in 2004. Bangladeshi refugees fleeing to neighbouring countries would most likely lead to violence. Elahi explained the situation to us in a dispassionate tone: *"Migration to India or Myanmar would be very difficult. India has enough population problems of its own, and, in any case, both countries will be hit hard by climate change themselves – not to mention the political issues. This is why it's vital that we begin looking for cooperation outside southern Asia. International organizations like the UN and the HCR will have a decisive role to play in preparing for the massive migrations we anticipate. In my view, there's no other solution, since Bangladeshis will not be able to relocate to neighbouring countries. Quite frankly, I think that countries with larger land areas will have to change their immigration*

policies. If we believe climate change is a global problem, then we must look for glo-bal solutions. Trying to solve it at national level is a mistake."

11. Global approach

The founder of the Bangladesh Centre for Advanced Studies (BCAS), a multidisciplinary research centre located in the posh Gulshan district that has led the study of the socio-economic impact of climate change. Dr Atiq Rhaman has spent the past 20 years campaigning for just such a global approach. He is very knowledgeable in the scientific field and has much to say about the relationship he sees between global warming and issues of international justice. Political correctness does not seem to concern him. *"For Bangladesh,"* he told us, *"which is already suffering from the effects of political negligence and numerous natural disasters, global warming is the final critical factor, the straw that breaks the camel's back. Although our country produces only 0.3 to 0.4% of total worldwide greenhouse gas emissions – less than the city of New York – we must work to reduce them. It's our moral duty. But at the same time, if the rest of the world does nothing, a major humanitarian disaster will be the result. Who will be to blame for that?"*

The answer seems clear, well as the solution to the global injustice he spoke of. *"For a long time now, I've been proposing the following solution. Each country must take responsibility for – in other words, transport and accommodate – a quota of climate refugees proportional to its past and present greenhouse gas emissions."*

The restrictive status of 'refugee' as defined in the 1951 Geneva Convention has yet to be extended to people displaced because of climate change. As we leave Dr Rhaman's office, we understand how essential this will be for the future of the Bangladeshis.

12. Epilogue

The announcement was barely audible, but we did hear *"Dubai"* several times. We get out of our seats and prepare to board. We're jostled and pushed as other passengers try to get ahead of us. These men dressed in thin, ragged clothing have grown impatient, and resort to reflexes acquired on crowded buses in the

countryside of Bangladesh. Their expressions are blank; their bodies, restless. The stewardesses don't seem to know what to make of these uncommon passengers who throw themselves and their tattered bundles into the first empty seats they find. They're labourers heading for the United Arab Emirates, travelling to join Indonesians, Pakistanis and Filipinos – all the cheap labour of Asia – at immense construction sites in the Persian Gulf. We speculate as to how long they'll be there: Six months? Nine? Longer? At least they have the hope of returning home. This will no longer be the case when they become climate refugees.

∫

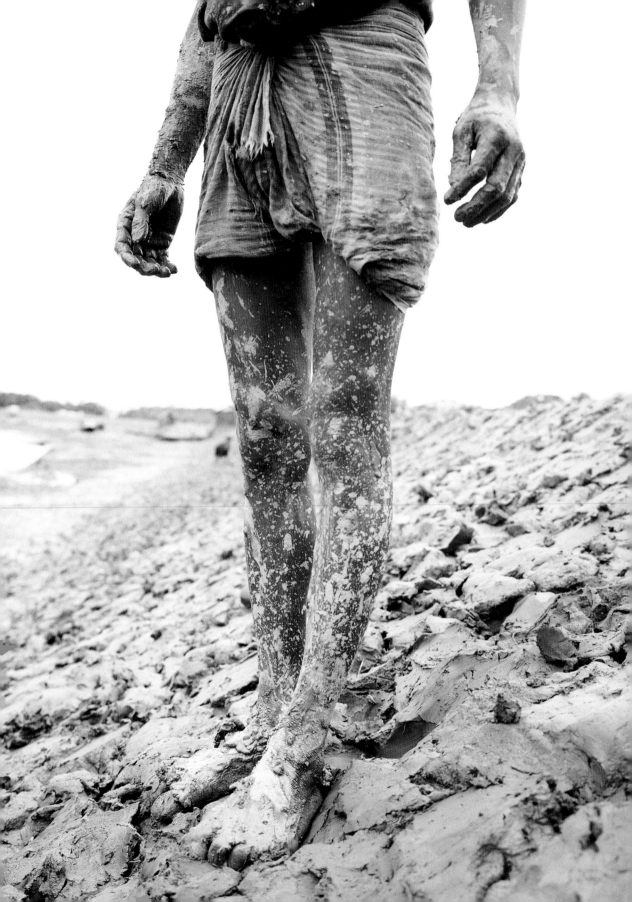

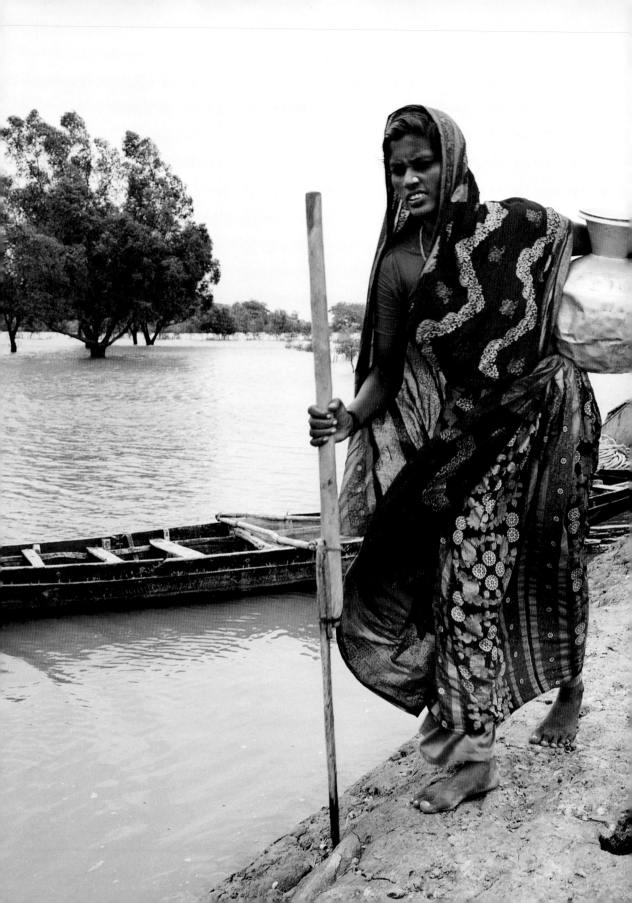

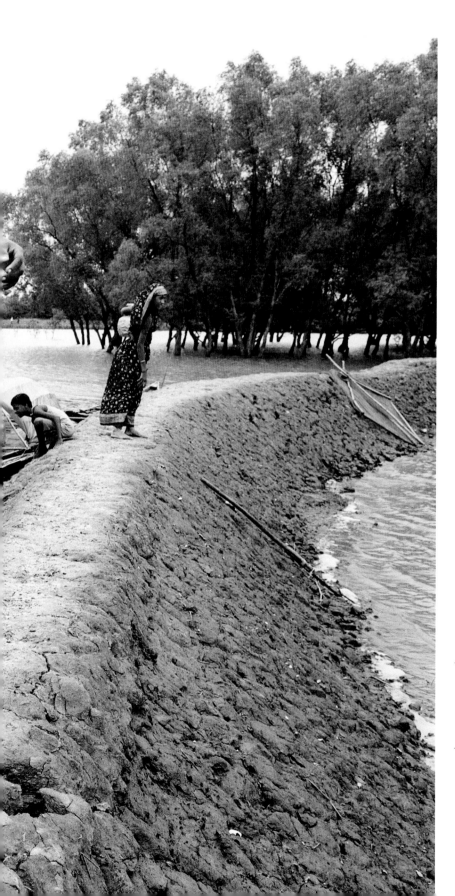

→ (Previous pages)
Munshiganj. Workers
on the large dike.

→ Village of Pankhali.
Mojinah Parvin
returns from her
daily chore of
fetching water.

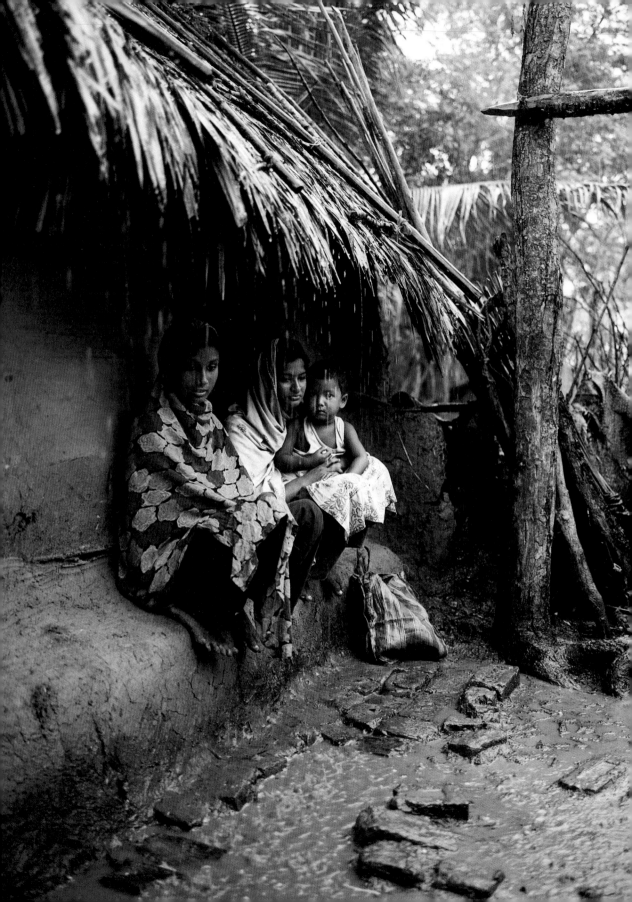

→ *Village of Pankhali. At the entrance to Mannan Molla's home.*

→ *Village of Pankhali. Mojinah Parvin repairs a wall damaged by monsoon rains.*

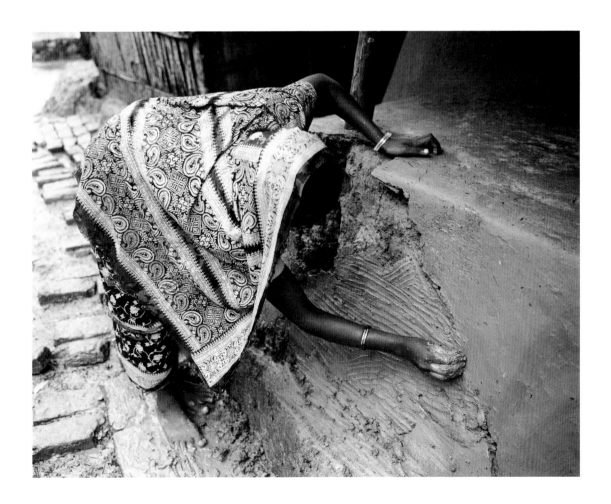

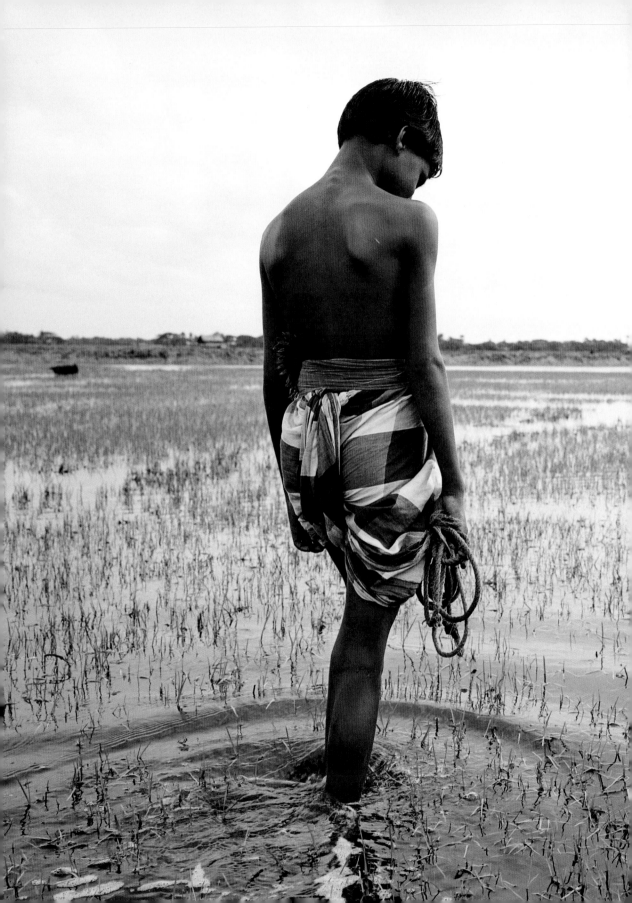

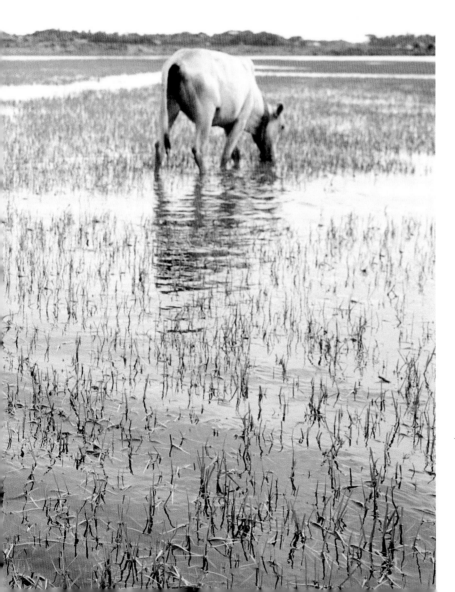

→ *Village of Pankhali.*
Moinur Gazzi, 12,
looks after the
family's last cow.

→ *Village of Pankhali. Wood*
 from the Sundarbans
 replaces dried dung as fuel
 for cooking.

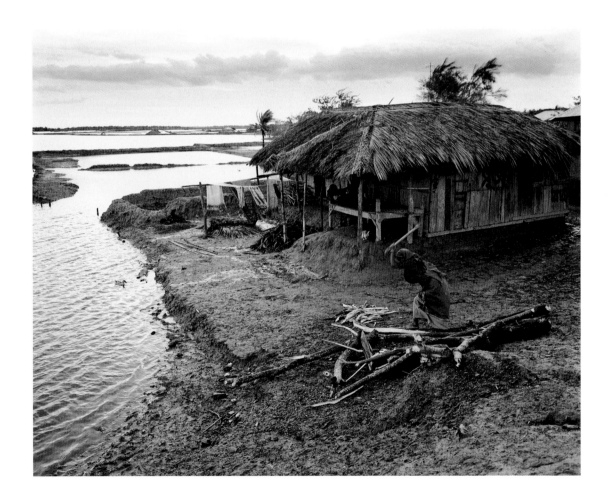

→ *Village of Pankhali. Mojinah and Fatema must either cross the river or walk three kilometres to find drinking water.*

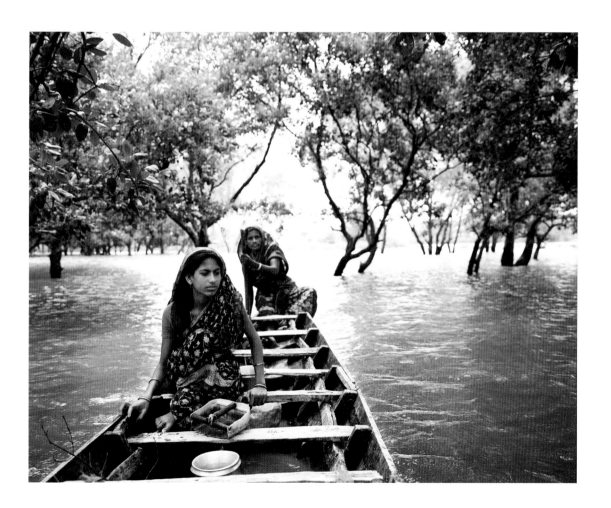

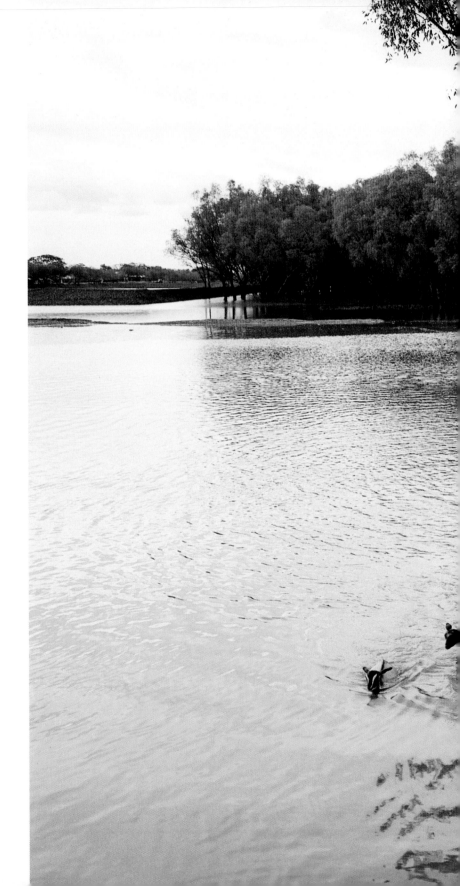

→ Village of Pankhali.
Dwarf goats are the
best replacement the
villagers can find to
cover their meat and
milk needs as cows
die off in increasing
numbers.

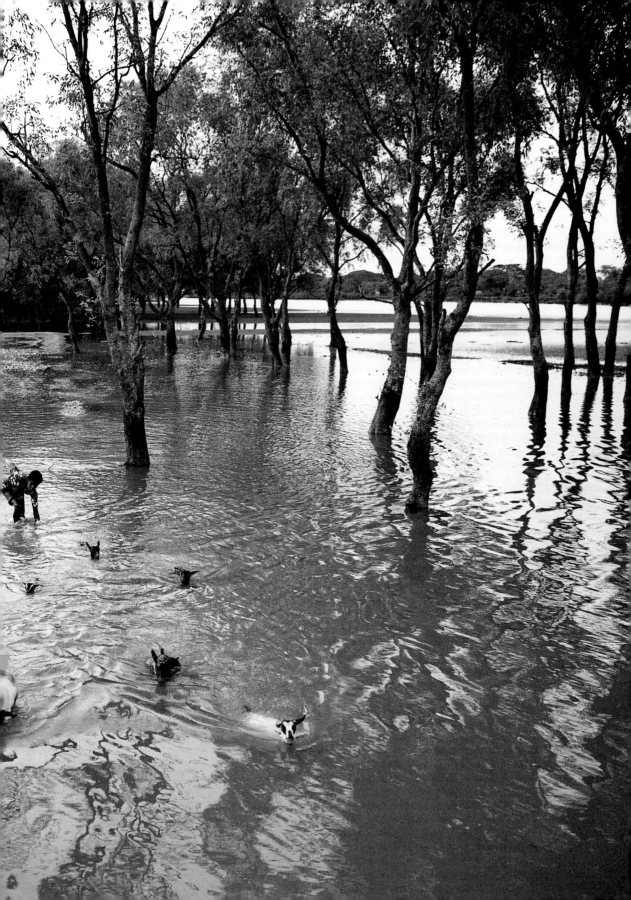

→ *Village of Zelekhalee.*
 A large audience has gathered
 to watch a local theatre
 troupe performing a skit
 about global warming.

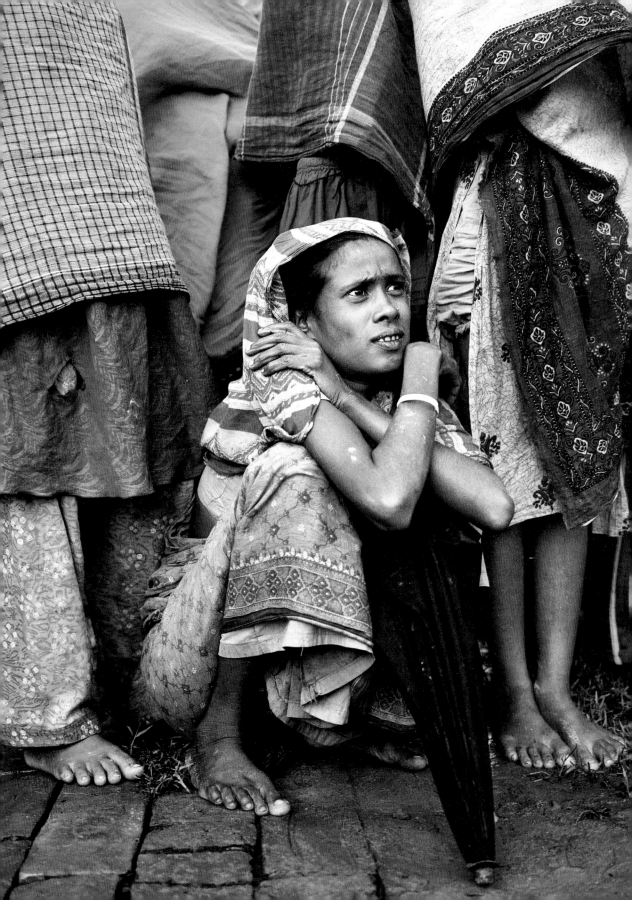

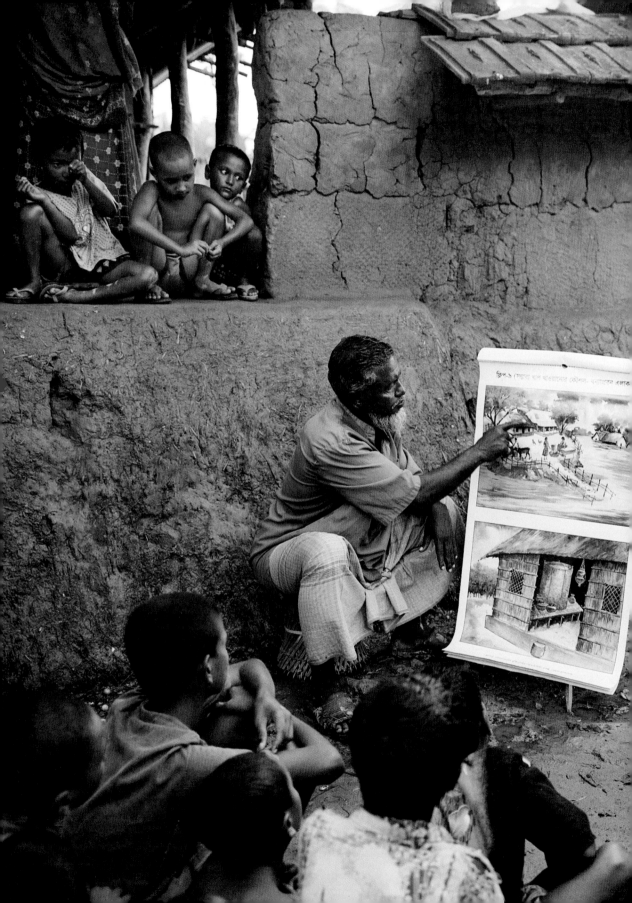

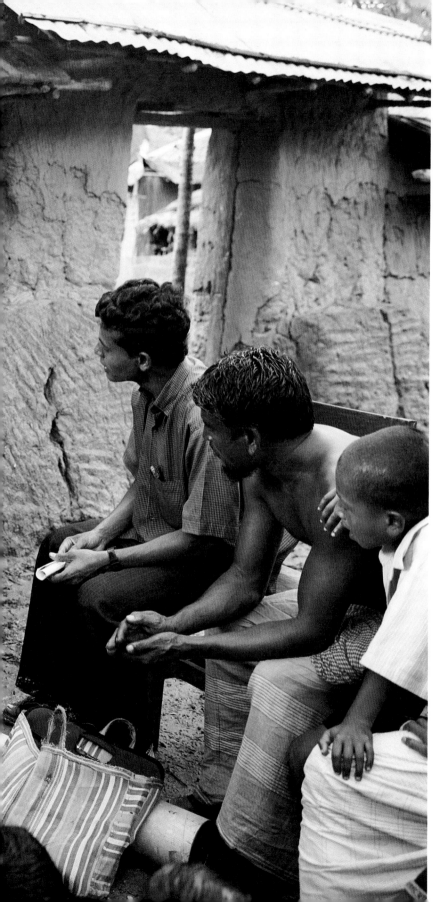

→ *Village of Pankhali.*
A lesson on global
warming by Mannan
Molla.

→ *Munshiganj. On the hillside*
protected by the large dike.

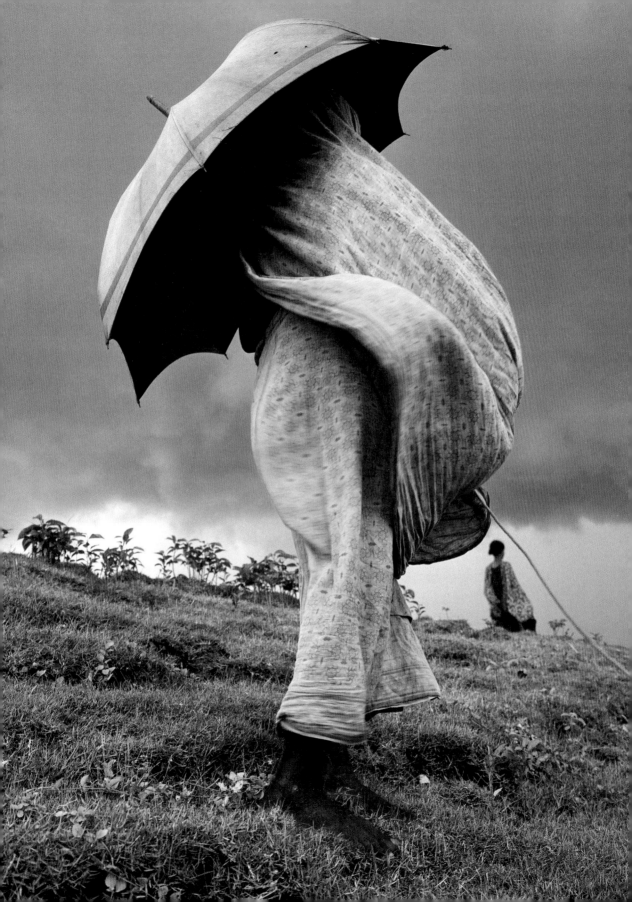

→ *Sundarbans mangrove forest.*
 Rhaman Molla begins fishing.

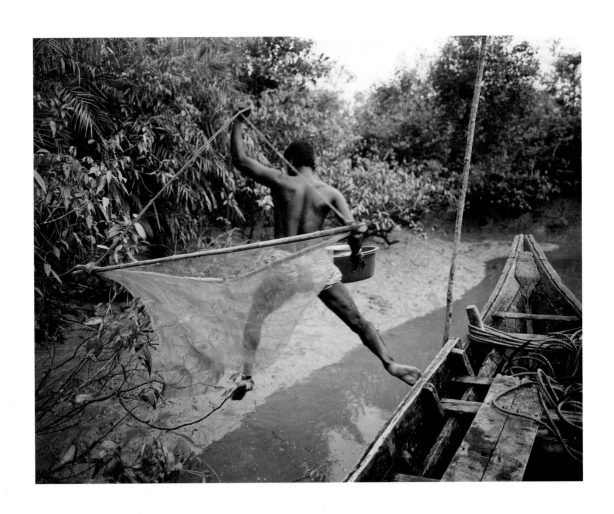

→ *Village of Pankhali. Female day labourers at a shrimp farm.*

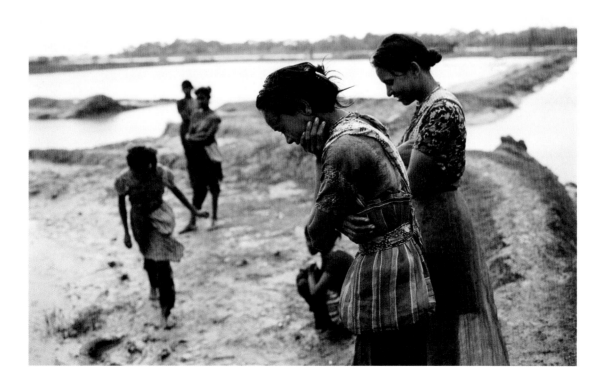

→ *Dhaka. Mohammed Abdul*
 Hamid on his rickshaw.

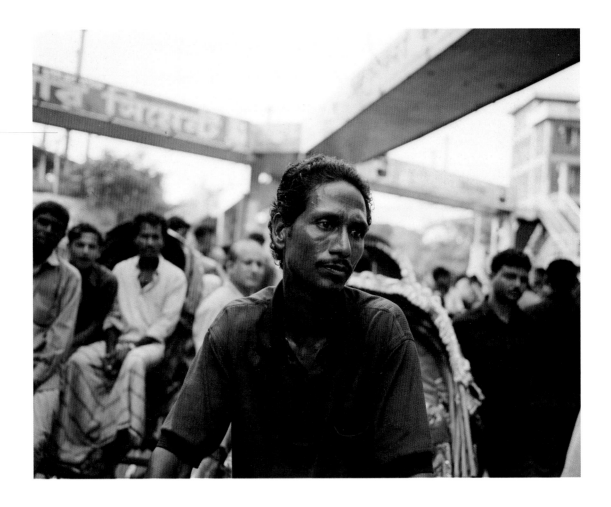

→ *Dhaka. In the Munshiganj*
rickshaw drivers' dormitory.

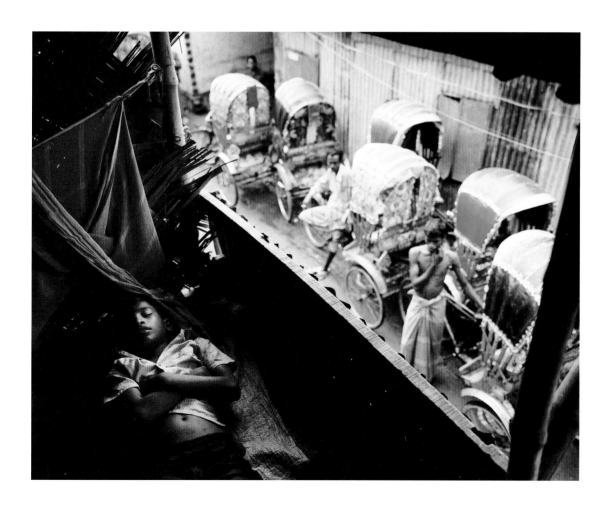

→ *Dhaka. The dikes built around the capital are no longer sufficient to protect it from flooding.*

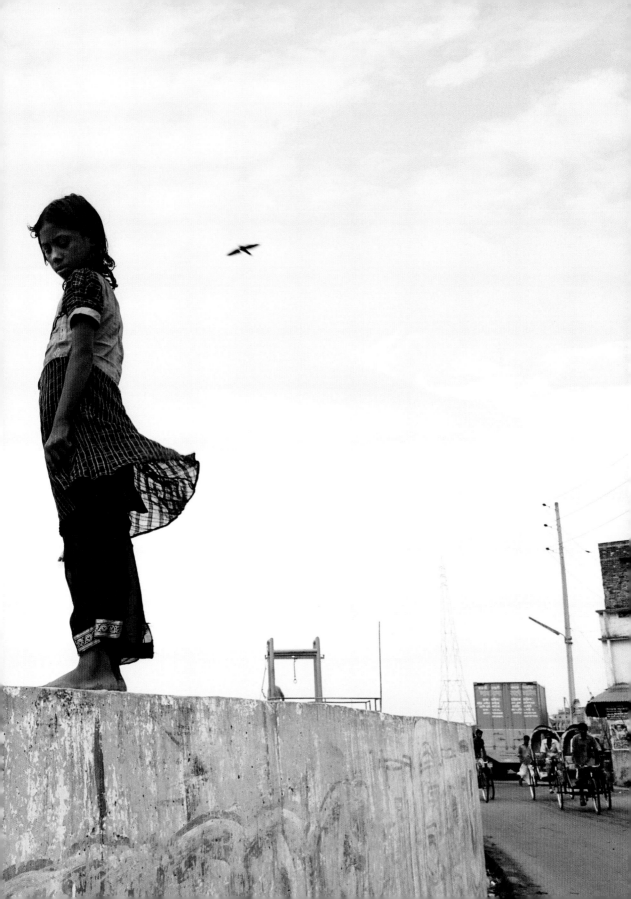

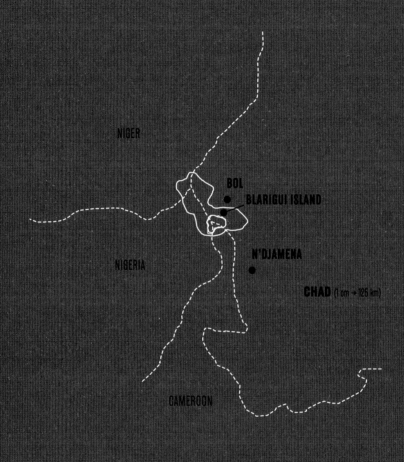

NIGER

BOL

BLARIGUI ISLAND

NIGERIA

N'DJAMENA

CHAD (1 cm → 125 km)

CAMEROON

TEXT: AUDE RAUX
PHOTOGRAPHY: CÉDRIC FAIMALI

CHAD
Blarigui, low tide in Lake Chad

Ocean

During the 1960s, people living around Lake Chad used the word "ocean" to refer to this vast expanse of water.

Phantom

The water in the lake is stagnant, murky and muddy, yet men fish, women wash clothes and children play in it. To the general indifference of the West, Lake Chad, the fourth-largest body of fresh water in Africa, is disappearing – and taking life along with it. Over the past 40 years, it has lost 90% of its area, shrinking from 25,000 square kilometres to just 2,500. Not long ago, the lake was bordered by four countries: Chad, Niger, Nigeria and Cameroon. Today, it touches no more than two. According to NASA, *"Lake Chad is now just a shadow of its former self because of climate change and human overuse. If nothing is done, it will be gone in 20 years."* African monsoon rains have decreased to the point that the lake no longer reaches the borders of Nigeria and Niger. These countries are now cut off completely from access to the water. *"Before, when we would go to Niger to sell our fish, the pirogues could unload their cargo on Niger's shore,"* Chadian fisherman Didina Diathé tells us. *"Now, since there's no more water, trucks come to pick it up."*

Carcasses

Men are working on the swampy banks of the lake, salvaging iron from the carcasses of rusted boats – vestiges of bygone days when it used to rain.

Creation

People have no control over the rain, so they leave. They search for a sky full of clouds, but in vain. *"I left Niger 16 years ago. I was a livestock breeder,"* says fisherman Moussa Gao. *"There was no longer enough water in the lake to push the fodder onto the bank and feed the animals. So I came and settled on Blarigui Island, in the Chadian part of the lake, and learned on-the-job how to fish. But over the past several years, I've been finding far fewer fish in my traps. Now, at age 60, I think I might return to my country, where I left my wife and our five children."* He picks up his machete and deals a fatal blow to a wet, flopping carp, then places it onto a tarp to dry. The air is scorchingly hot. *"Life is hard here, but I mustn't get discouraged. God created the lake, and you should never get discouraged by any of God's creations."* Never get discouraged – even if life is reduced to survival. Or when it's turned upside down by a teenage boy dying of yellow fever after a bleeding performed by his distraught family.

Nassara

Village chief Al Hadjil Kanë stretches out in the shade on his colourful mat at the entrance to the island's only house built from heavy materials. He lists off his wishes as he fingers the beads of the rosary clasped in his calloused hand: *"We lack everything in Blarigui. I need a well so that the 500 inhabitants can drink clean water. I need a clinic so that the sick can receive care and a school to educate the children."* Seated near him is Babanguida Chari, the representative of the Patriotic Salvation Movement, President Idriss Déby's party. He leaves these problems to be solved by *"the white men,"* saying, *"After God, who is all-powerful, it's up to the nassara to take action. That way, the water will come back."*

Sharing

Children walk back and forth in front of the spot where the two nassara have settled down with their notebooks and cameras. They're sitting on mats that have been unrolled right on the ground, a thatched roof above their heads. The children are intrigued and venture closer; then, frightened, they back away. After a few hours, the braver ones come and stand around them, touching them, taking hold of their hands, shouting and giggling. The others wait for nightfall to take a furtive look at this girl and boy with the strangely white skin. A few days later, the nassara offer to share their meal of boiled fish and rice with tomato sauce accompanied by glasses of very sweet tea with several 'squares' of sugar melting in them. Five of the children kneel with them around the large platter. They take a little fish, a little rice, roll them together into a ball and gulp it down. They do this

three or four times, then get up and leave. A few minutes later, one of them returns with another group of children, pointing out the dish to them so that they can eat, too.

Good luck charm

The families of the fishermen on Blarigui Island fill their water jars directly from the now-unsanitary lake, and drink the water even though it gives them diarrhoea. Mothers hang good-luck charms around their children's necks to ward off such childhood diseases as measles and chicken pox. Boys who reach the age of five take off with their fathers in long pirogues with paint flaking off their sides to sell their meagre catch at the market and bring back something to survive on. Yesterday was a Saturday. Hundreds of men landed on the dusty, sandy shore of the island. For the occasion, their pockets bulged with wads of nairas, the Nigerian currency that is used everywhere around the lake. Some make a stop at Zara Mahamat's little restaurant. On the menu: fish with rice or vegetables cooked in large cast-iron pots with flies hovering above. *"When I came to the island four years ago,"* she tells us, *"I set my restaurant up right at the edge of the lake. People were practically eating with their feet in the water. And now look: the lake has shrunk back more than 100 metres."* At nightfall, there are a few minutes of pitch-blackness, and then the generators start up, filling the dark silence with their mechanical sounds. Torches are lit, fires crackle and musicians tipsy on corn alcohol beat on percussion instruments while fishermen dance. They're 'ambiancing.'

Market day

It's early morning. Under makeshift straw shelters, alongside pyramids of batteries, soap and salt, lie sacks of carp, catfish, brown bullheads and sardines – fresh, dried and smoked. They were caught using such traditional methods as fishing baskets and nets. *"About 40 years ago,"* says Sali Oumar, the author of a report on fishing prepared for the Ministry of the Environment, *"the holes in the mesh of fishing nets measured 10 fingers, with a finger corresponding to one centimetre. They use this unit of measurement since most of the fishermen are illiterate. Now the standard size is no more than three fingers."*

Without borders

"A fisherman doesn't trouble himself about borders; he has free access to the water regardless of his nationality. So fishermen from Nigeria, Niger and Cameroon all group together on the islands in Chadian waters, where fish are to be found, to catch,

sell and buy them. The lake's basin is home to 22 million people, and about 300,000 people from all four countries make their living directly or indirectly from fishing. Among them are a large number that we consider environmental refugees."
Zakara Anza, fishing industry advisor to the Lake Chad Basin Commission (LCBC), an interstate development agency.

Conflict
"The more the water disappears, the more the risk of conflict will grow." – Sali Oumar

Miracle
Life is far from easy here. Fisherman Samuel Ngargoto, 35, looks to God for help. *"Not only are the fish smaller, but there are also fewer of them,"* he says. *"And as the lake transforms into a marsh, the hogfish, a rare and valuable fish that fetches a high price at the market, is becoming harder to find. We aren't able to compensate for this loss with other species, like carp and catfish, which have succeeded in adapting to the changes in the lake but aren't worth much. God needs to send us a miracle because there's too much suffering involved in living on this lake."*

Odours
The air is thick and carries an acrid, stale, fermented odour. It comes from the stands of dried fish, the putrid water of the lake and the herds of emaciated goats. This odour enters your nose, invades your lungs and can never be erased from your memory.

Climate refugees
"In this region, not only fishermen but also livestock breeders and people who come to farm the dry lakebed because there isn't enough rain where they hail from are all climate refugees. The presence of this body of water in the Sahel is in fact exceptional. And the Chari River, which provides 90% of the lake's water, feeds it at a rate two times lower than the rate observed in the 1960s. Severe droughts hit the region hard in 1972 and 1984, but, at the same time, the brief return of the rains at the end of the 1980s transformed the lake into a huge marsh. As the water allowed seeds to germinate, islands of papyrus and reeds formed pretty much everywhere."
Jacques Lemoalle, hydrobiology researcher at France's Development Research Institute and international Lake Chad specialist.

Mirage
When Samuel Ngargoto sets off to raise his fish traps, he always brings a long

stick to clear himself a path through the reeds, papyrus and clusters of vegetation that sprout up everywhere in the lake. He often has to get into the water to push his pirogue out of the mud. From the shore, this sight is like a mirage: even kilometres out in the lake, he never reaches a depth over his head. With the water evaporating at an average rate of 2.10 metres per year and rainfall of only half the amount observed prior to 1970, the lake is now very shallow. This has led to yet another problem: the water is increasingly muddy.

Monsoon

"In the 1960s, the lake was an average of six metres deep, and the water was clear. Today, the monsoon has diminished and arrives later, during the month of June. Now the depth is only 1.5 metres, and the mud is making it very dirty."
Koundja Mbatha, topographer at the LCBC.

Drought

"Lake Chad's stability is being threatened by several changes in the climate – low amounts of rainfall, evapotranspiration from high temperatures and a series of severe droughts. The gradual drying up of the lake is the most spectacular example of the effects of climate change in tropical Africa." – Source: UNESCO.

Poison

LCBC driver Abakar Diguira has just arrived from N'Djamena, the capital. He is worried. Five times a day, he performs ritual washing in preparation for his prayers to Allah, and each time, he sighs: *"I'm not able to pray very well after performing my ablutions in the water of this lake."*

Prison

"I'm isolated, cut off from everything – from my family, from my 15-year-old daughter. I can't write to her or call her. Feelings are difficult, aren't they? But I have to hold on for three to five months, long enough to make some money fishing. Then I can go back home, but when I do, I'll try to keep from thinking about the time when I have to come back." – Samuel Ngargoto

Time

Hours, minutes, the hands and dial of a clock, time cut into portions, time computed. For Chadians, time doesn't exist; people are all that matter. It is people, in their submission to God, who create time. When a nassara asks the rational, objective question, *"What time are we leaving?",* a Chadian does not answer, *"at*

11:32," like a train timetable, but rather, *"When everyone has gotten into the 4x4. Inshallah."* Chadians take their time, even though their time is limited. Chadian life expectancy is only 48. People here greet each other at great length with a ritual of questions and answers about each other's health and then the health of fathers, mothers, children, brothers, sisters, uncles, aunts, cousins and so on. Men slowly count the wooden beads of their rosaries, women slowly pour steaming tea into glasses, fishermen slowly draw their fish traps out of the water and farmers slowly plough up the earth. So we learn to be like them. We stop looking at our watches. We learn to live in the present.

Trek

To get to N'Djamena from Bol, the largest village on the Chadian side of the lake, you have to endure over eight hours on a sandy, dusty, dirt road. There are 17 of us crammed into a 4x4, and every square centimetre – from the boot to the roof – is occupied by a passenger. Along the way, we pass one, two, then three trucks stranded at the side of the road. Their drivers are sometimes forced to stay put for as long as five days waiting for a spare part to arrive. This road becomes even more difficult with the arrival of the harmattan, the wind that blows down from the Sahara and spreads dusty sand everywhere, even obscuring the sun. When the Grand Sultan of Bol, the city's member of parliament and traditional chief, is obliged to travel to N'Djamena for a parliamentary session, he chooses a different itinerary. He crosses the lake aboard an old, overloaded pirogue that threatens to tip over with the slightest wave. A dozen men take advantage of this trip made at the Sultan's expense and pile in amid sugarcane, colourful rugs, chickens and cases of Coca-Cola. During the trip, we notice that the pirogue is taking on water. With an air of resignation tinged with irony, the Sultan comments: *"An overloaded pirogue sank last month. The 21 people on board drowned. None of them knew how to swim."*

Chirac

In the village of Bol, a woman with hair tied up under a red scarf is wearing a brown-and-yellow boubou printed with the words 'France' and 'Paris' plus images of Jacques Chirac. For most Chadians, the former French president is *"the friend of Africa."*

Belief

Never tell a Chadian that you don't believe in God. He won't believe you. He doesn't care if you're a Muslim, Christian, Jew, Animist or Buddhist. What mat-

ters to him is that you believe. Without belief, you're open to despair. You'll never come close to the truth, in spite of all your knowledge and learning. Knowing without believing amounts to knowing nothing at all.

Faucet

Sunday morning in the village of Bol. Mass has just ended, and as the men, women and children emerge from the church decked out in their Sunday best, a heavy, intense rain begins to fall. The long-awaited monsoon has finally come, at the end of June. Rather than heading for shelter, the crowd stays outdoors in the rain. People stretch their palms skywards and wash their hands under this imaginary faucet. Some tilt their heads back, mouths open wide, eagerly drinking in the precious drops of water.

Fever

It's 40 degrees Celsius outside, and yet a man is shivering. He's bundled up in a boubou and a parka with the Coq Sportif logo, but is still chilled to the bone. His teeth chatter, his whole body trembles and quakes, and he retches, but nothing comes up. His eyes are expressionless. He cannot eat, drink or swallow any medicine, however, because he's fasting for Ramadan, so he just prays that the arbitrary moment signalling the passage from day to night will arrive soon and deliver him from his suffering.

Cholera

In spite of the increasing frequency of cholera, the people who live around Lake Chad will not boil their water before drinking it, for fear of killing it.

Black gold

The Lake Chad Basin Commission is a development agency created in 1964 by the four countries that bordered it at the time together with the Central African Republic and Sudan. For the past few years, it has been working on an ambitious project to help improve the lives of these men and women. The plan is to dig a 300-kilometre canal from the Oubangui River in the Central African Republic to feed a tributary of the Chari River. However, negotiations with various African banks to unfreeze funding are advancing at a snail's pace, and in 2006 the World Bank suspended 90 million euros in loans to Chad in protest against several unilateral decisions by Idriss Déby's government. These included eliminating a special fund earmarked for infrastructures to benefit the population, to which 10% of the country's oil revenues were to have been dedicated, and financing the war

against the rebellion in the northern region of Tibesti. With such moves, Déby effectively reneged on a 1999 agreement between Chad and the bank on the country's use of oil revenues that aimed to guarantee *"sound governance and management."*

Hollow horns

Research is being conducted on the effects the canal's construction will have on biodiversity as well as soil drainage and stability. But due to the dramatic decrease in monsoon rainfall, many animal species – such as the Kourie cow, whose hollow horns allow it to float from one island to another – are already endangered. Other species at risk include the hippopotamus, crocodile and otter. According to UNESCO, Lake Chad ranks second among African lakes in terms of richness in biodiversity. It is home to over 350 species of birds, and every year thousands of migratory birds pass through the area.

Hope

Spirulina, an effective remedy for malnutrition and vitamin deficiency, has been consumed for centuries by the Kanembou, an ethnic group living on the banks of Lake Chad. The blue-green algae, named for its spiral shape, is exceptionally rich in protein, which represents more than half of its dry weight. Spirulina is also a good source of beta-carotene, iron, calcium and magnesium, and, best of all, it's one of the few species able to live in warm, shallow, brackish water – like the water of Lake Chad.

Sweet potatoes

Another organization, another project. The Lake Chad Development Agency, founded by the Chadian government after the first big drought, has created a 1,800-hectare polder in Bol. *"These lands are very fertile since they're rich in organic material,"* project development head Djerakoubou Dando tells us. In this initiative, known locally as Mambi, each family receives a half-hectare of floodplain land. In exchange for a share of its harvest, the family can grow crops like manioc, sweet potatoes, carrots and cabbage. Not everyone shares Dando's enthusiasm, however. Ministry of Environment and Water fishing and aquaculture specialist Dara Laobeul offered the following criticism:

"In the long term, this project will end up killing the fishing industry, since we are decreasing the water's area and these lands will always need to be irrigated. I think it would be better to focus on projects aimed at developing these waters. In any case,

while we cannot survive on grains alone, we can very easily eat only fish, which is rich in vitamins, phosphorous and iodine."

Urgent

How can people 'take the long view' when they're confronted with such an urgent situation? How can they do so when time is no longer counted in generations but reduced to a short stay on earth where each day is an obstacle, and the past no longer has a future?

Dream

Alhadje Mamat Salé, 55, once a fisherman and now a farmer, stands in the middle of his plot of land, his feet anchored firmly on the ground. He puts down his spade, takes off the brown scarf tied around his neck and wipes his forehead. Overwhelmed by the sun's brilliance, Alhadje returns to musing on his dream: *"If the lake ever gets its water back, I'll go back to fishing."*

∫

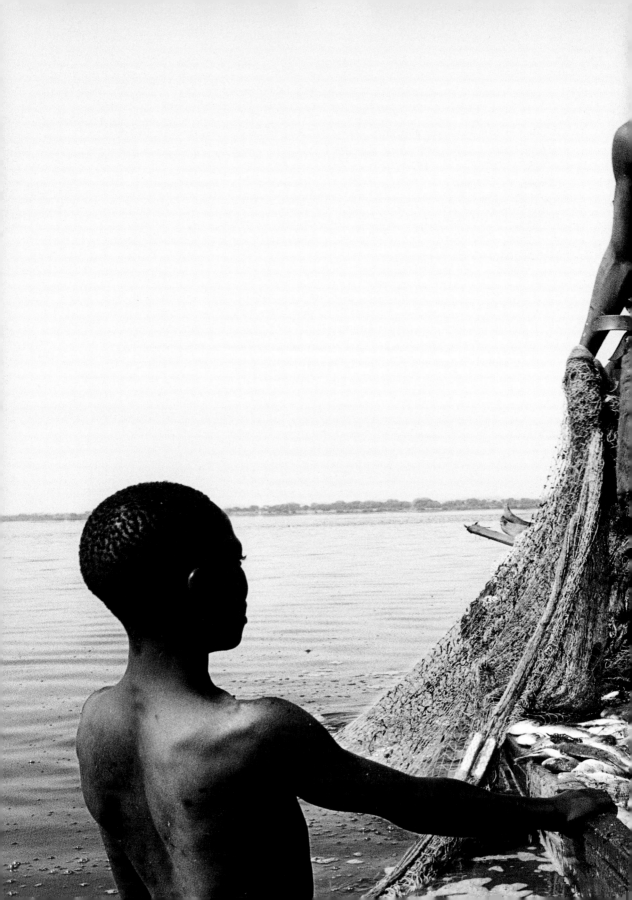

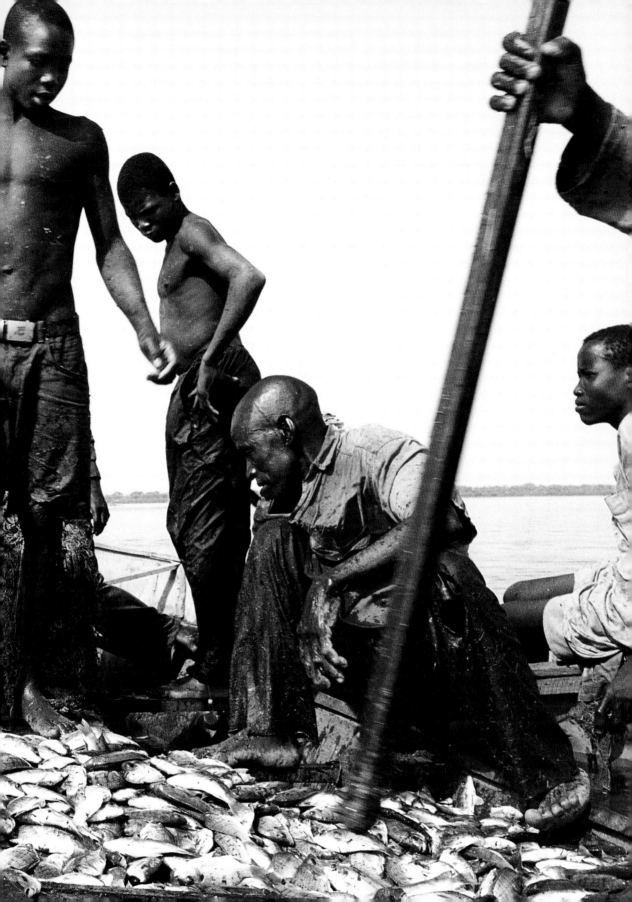

→ *(Preceding pages) The Lake Chad Basin is home to 22 million people, and some 300,000 inhabitants of the four surrounding countries (Chad, Niger, Nigeria and Cameroon) make their living directly or indirectly from fishing.*

→ *Pirogues abandoned on the lake's marshy banks bear witness to a past when rain was not an uncommon occurrence.*

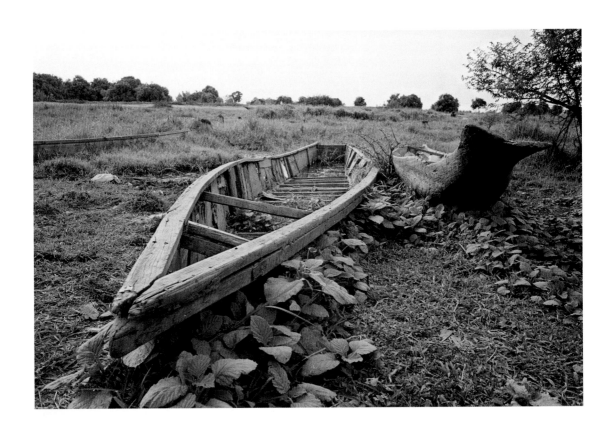

→ The African monsoon has diminished so greatly that the continent's fourth-largest body of fresh water has lost 90% of its area over the past 40 years.

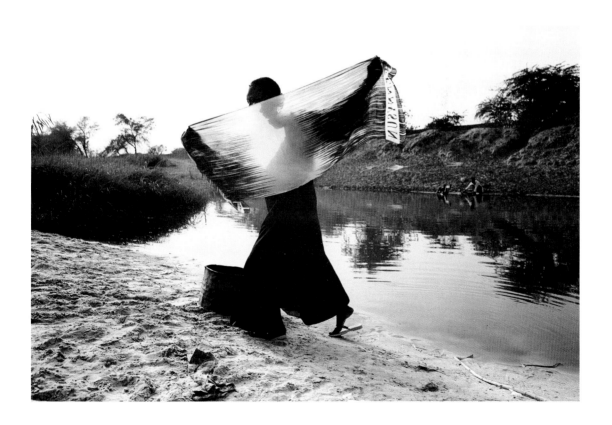

→ *Lake Chad no longer reaches the borders of Nigeria and Niger. These countries are now cut off completely from direct access to its waters.*

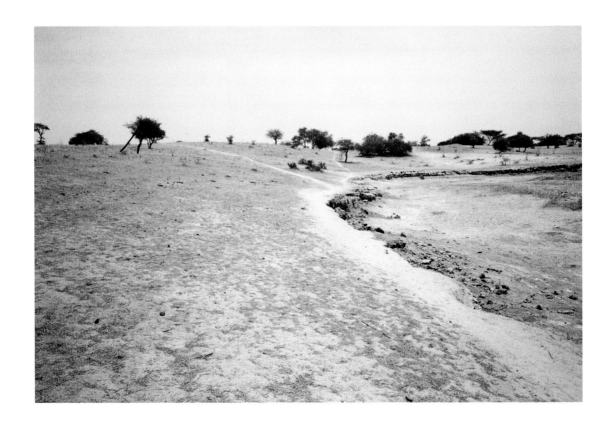

→ *Lake Chad has shrunk from 25,000 square kilometres to just 2,500.*

→ *(Following pages) According to a NASA report, Lake Chad is now just a shadow of its former self. If nothing is done, it will be gone in 20 years.*

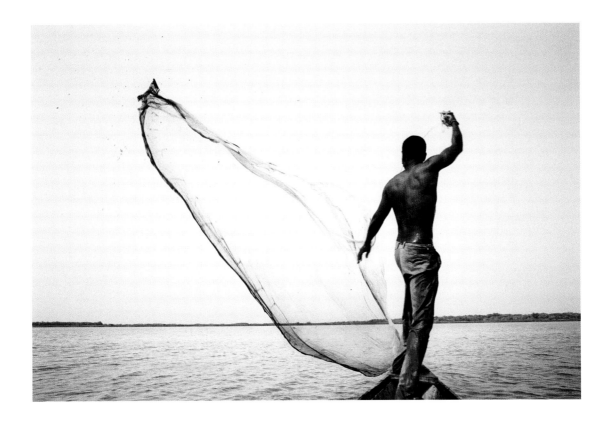

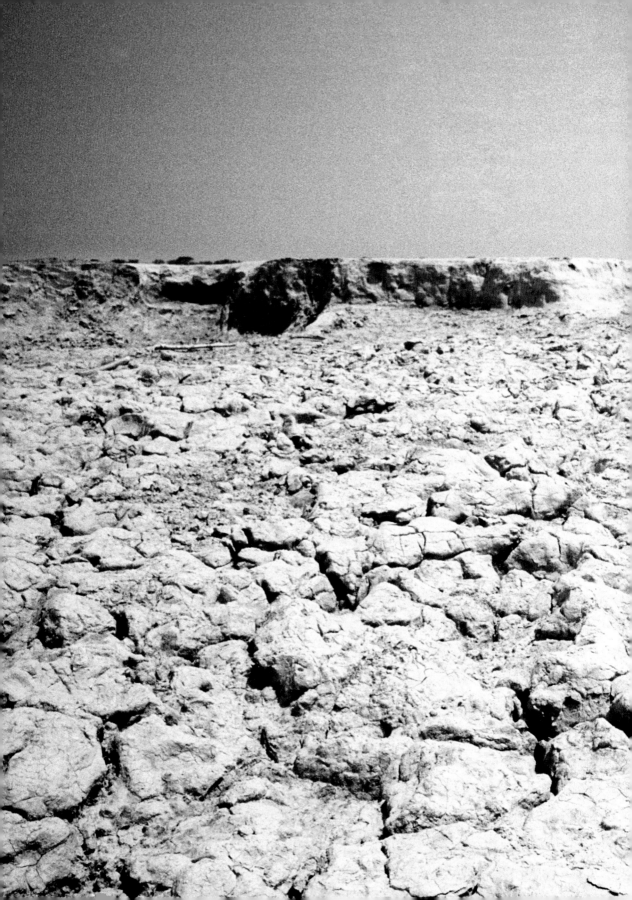

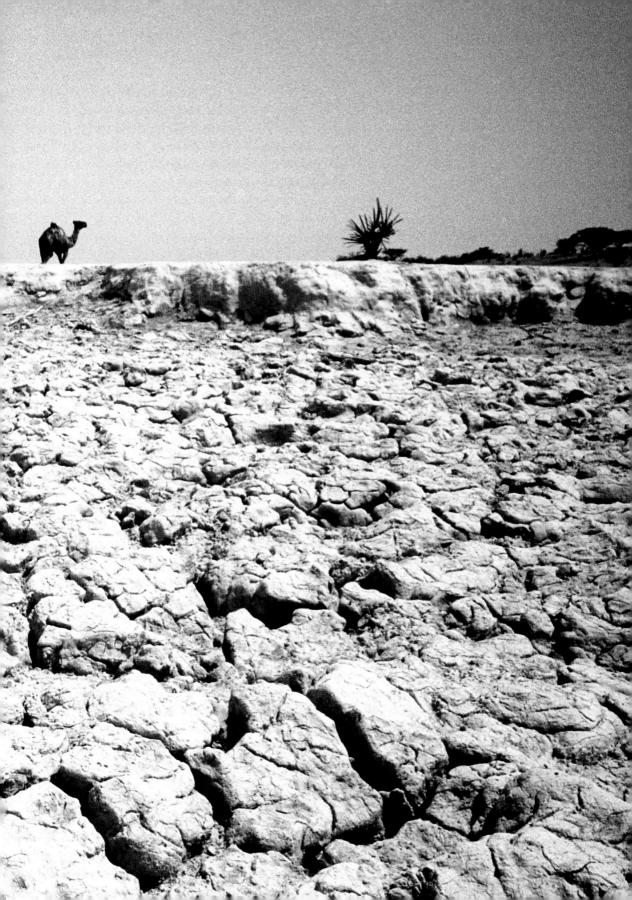

→ *Fish are now smaller and
there are fewer of them.
Noble species, such as the
Capitaine (or Nile Perch),
have become rare. Only
marsh-dwelling fish have
managed to adapt to the
lake's new ecosystem.
But carps and catfish fetch
much less on the market.*

→ *The holes in the mesh of fishing nets used to be ten fingers in size, with a finger corresponding to one centimetre. Today, the standard size is no more than three fingers.*

→ *(Following pages) Even several kilometres from the shore, the lake is never over head-height.*

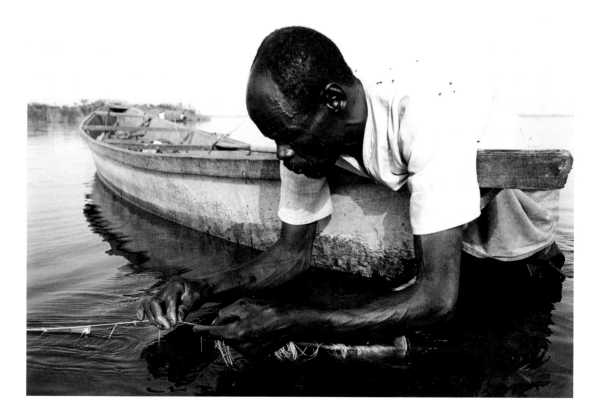

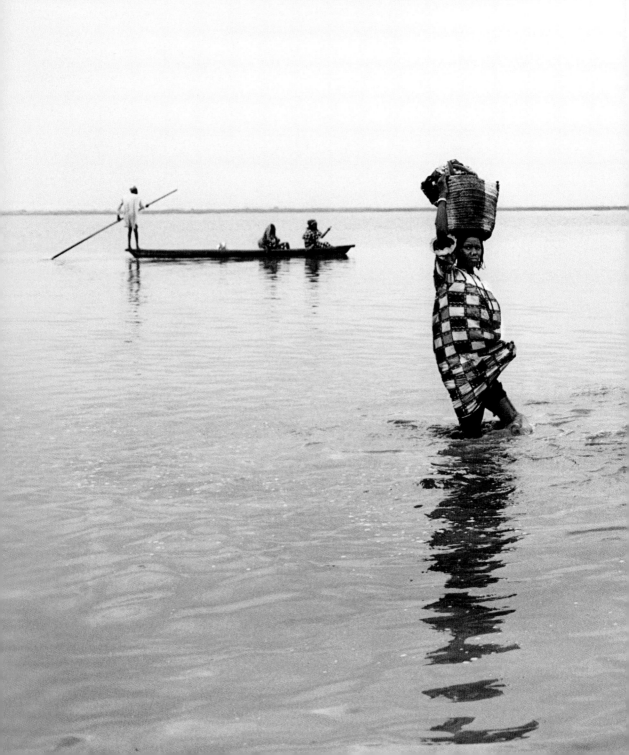

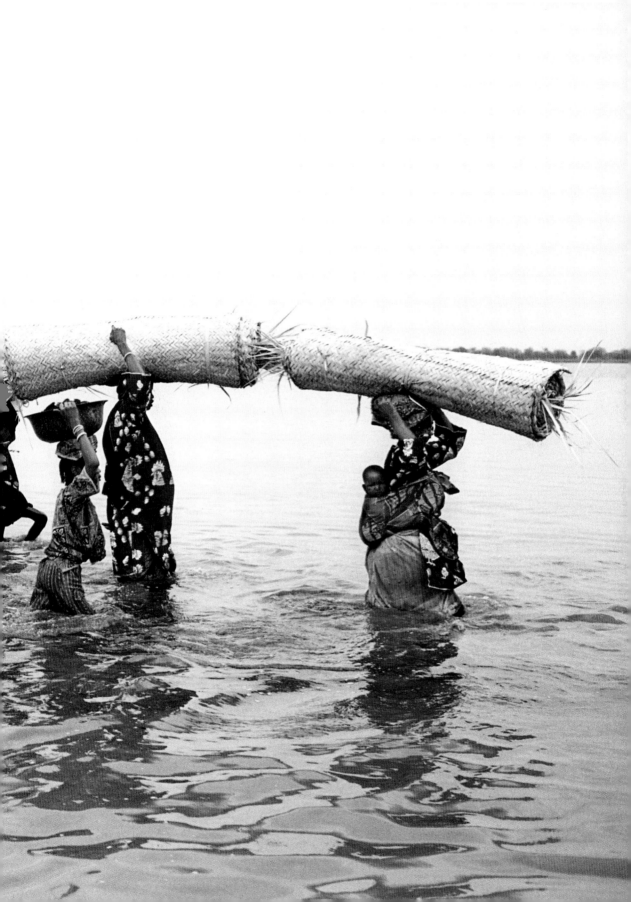

→ *Because the water is not deep
enough, the men have to get
off and push their pirogues
to get to the Blarigui island
situated in the Chadian part
of the lake.*

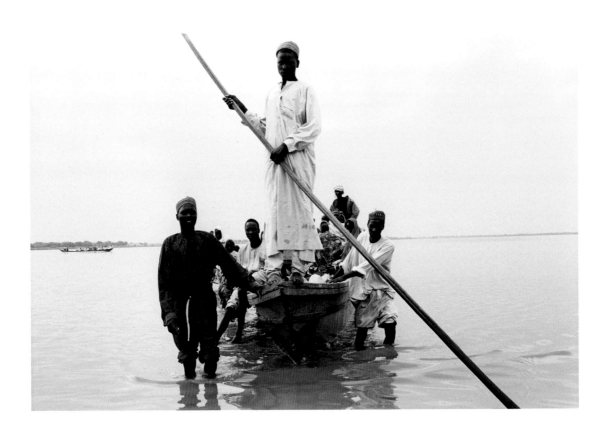

→ *In the past, when one could*
sail on it, the lake used to be
a key artery for commerce
between the four states
bordering it. Now boat
carcasses are rusting away
on its shores.

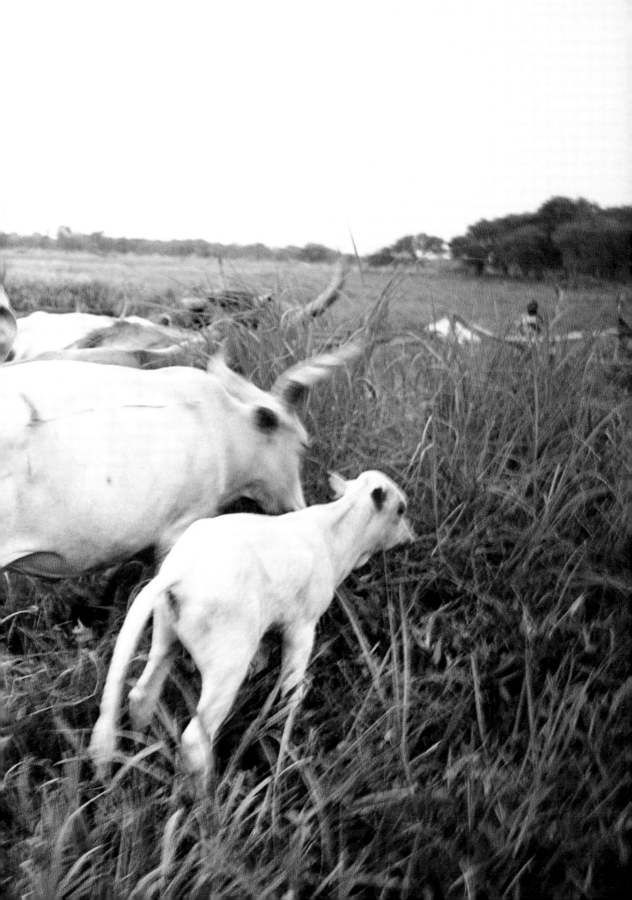

→ *(Preceding pages) According to Jacques Lemoalle, a researcher at France's Development Research Institute, not only fishermen but also livestock breeders and people who come to farm the dry lakebed because there isn't enough rain where they hail from are all climate refugees.*

→ *Sunday, market day on Blarigui Island. A wedding taking place today is cause for celebration.*

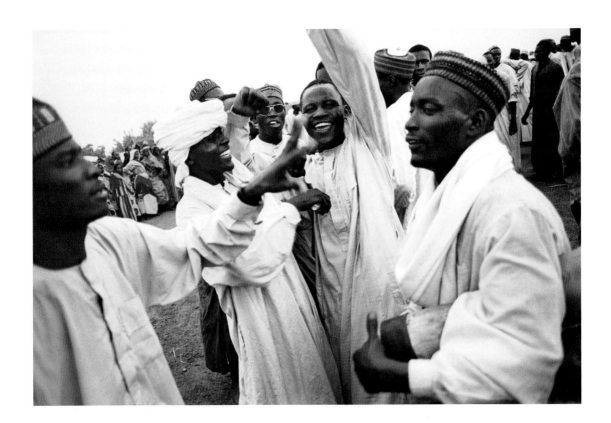

→ Farmers cultivate the
 floodplain in a polder near
 the village of Bol.

→ (Following pages) Alhadje
 Mamat Salé, 55, a former
 fisherman who has turned to
 farming.

→ (Following pages) During
 the 1960s, the lake was an
 average of six metres deep.
 Its depth is now just
 1.5 metres.

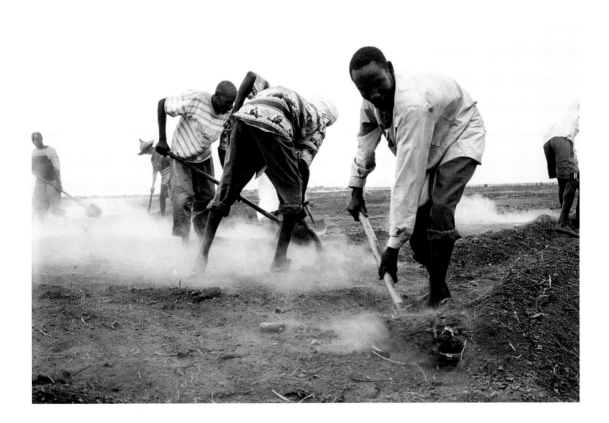

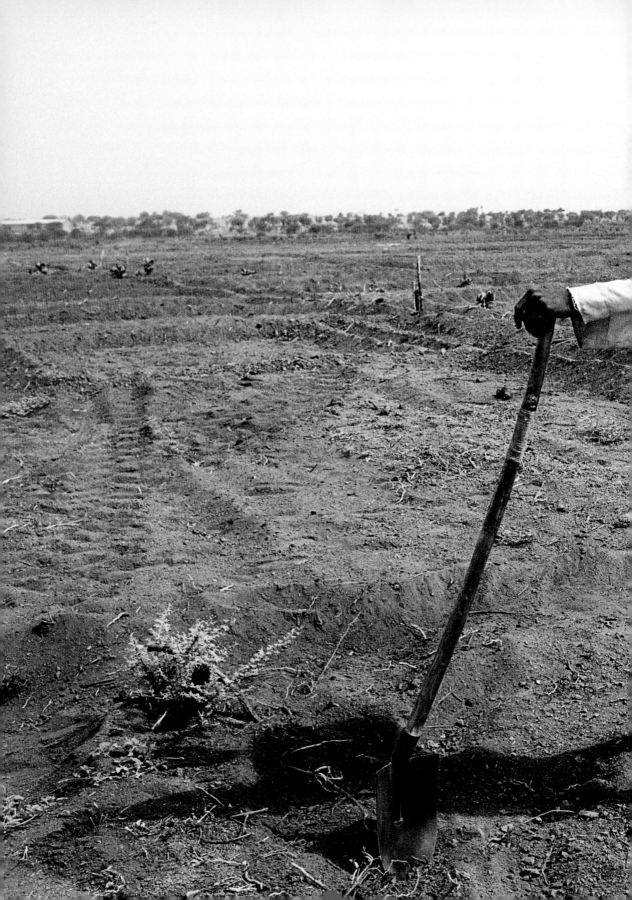

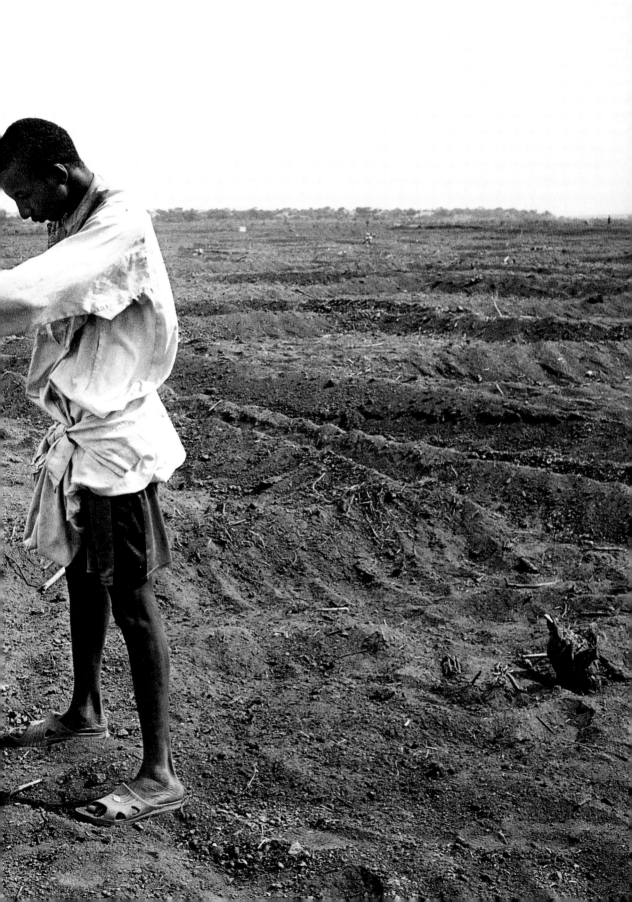

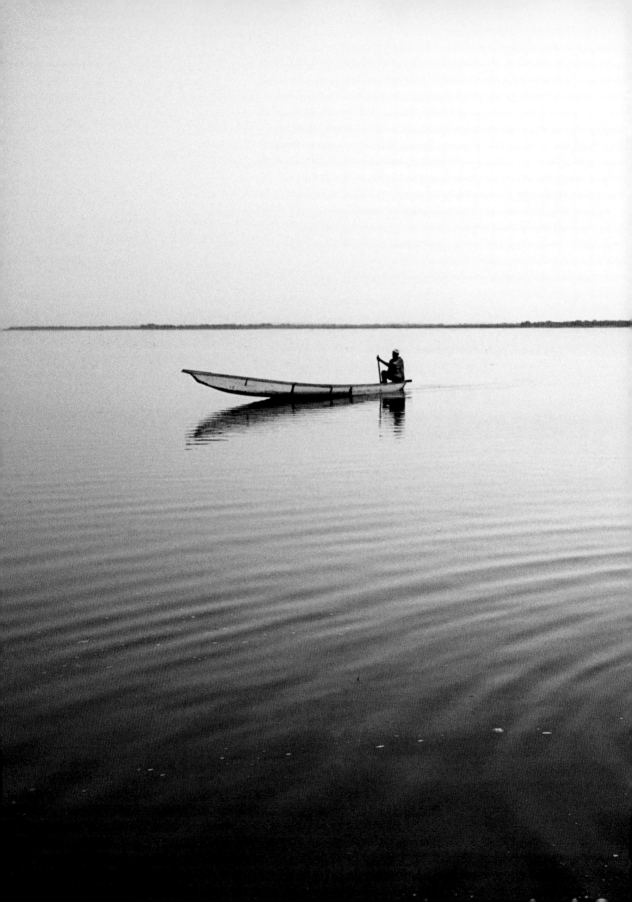

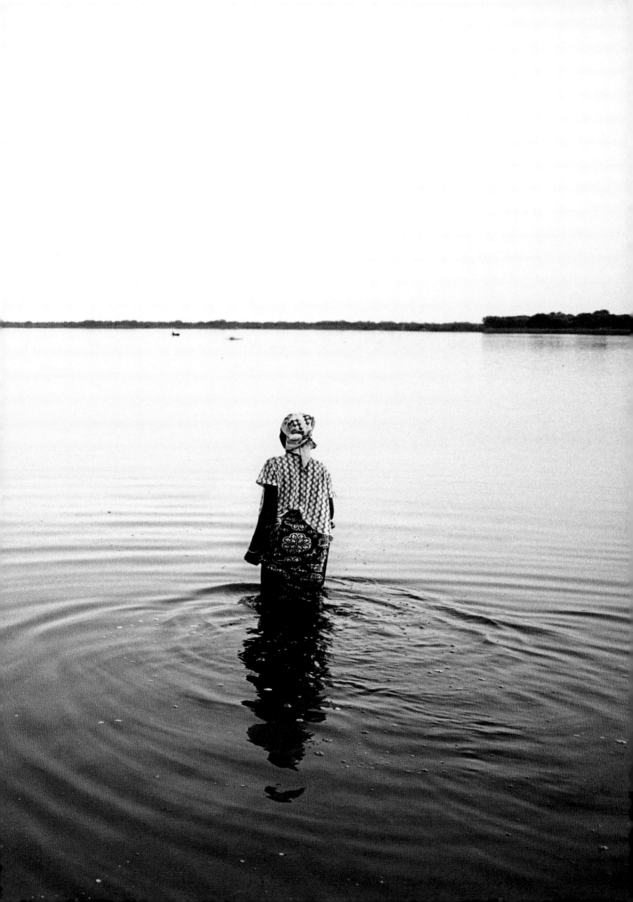

INDIAN OCEAN

Malé Atoll

Thulhagirii

MALDIVES (1 cm → 70 km)

Malé, Hulhumalé

INDIAN OCEAN

Mundoo

Laamu Atoll

Kalhaidhoo

Gan, Thudi

TEXT: GUY-PIERRE CHOMETTE
PHOTOGRAPHY: GUILLAUME COLLANGES

INDIAN OCEAN
Maldives, an archipelago in peril

Looking down at it from the plane, the first thing we feel is amazement. It's a sun-drenched world of blues and greens, a handful of emeralds strewn from the heavens into a halo shape on an ocean the colour of the night sky. Lagoons jut up out of the waves like so many pearls scattered in vast atolls, the giant petals of a rare, fragile, vulnerable aquatic flower. Vulnerable – that's the word that best expresses the indefinable feeling of uneasiness that follows our amazement. Looking down on the Maldives, we realize how fragile these islands really are. A puff of wind, a wave, and this emerald necklace that appears to be floating precariously on the water might just sink irretrievably into the depths of the Indian Ocean.

The submarine topography around the Maldives is extraordinary. Nothing on dry land comes close, except perhaps the comparatively Lilliputian Monument Valley in the United States. A dozen underwater mountains rise up steeply from the flat seafloor 4,000 metres below. Their climb towards the air is abruptly interrupted 100 metres below the surface, where they form immense plateaus that are sometimes dozens of kilometres wide. These are the Maldivian Atolls. For millions of years these plateaus, in particular their dizzying edges, have been home to colonies of coral. Like cones of sugar, they cover the mountain with spiny vertical peaks up to the water's surface, where the sea creates the turquoise colour characteristic of coral reefs. These are the lagoons. The majority of these plateaus are

submerged, but some rise up 1-2 metres out of the water and are covered with white sand and coconut trees. These are the Maldive Islands. There are some 1,200 of them – totalling just 300 square kilometres – but only 200 of the islands are inhabited.

*

On one of them, the sand has been replaced by a blanket of concrete, and a forest of high-rises has ousted the coconut trees. This is Malé, the capital, where one-third of the total Maldivian population of 360,000 squeezes together onto 2 square kilometres, making it one of the most densely populated capitals on earth. It's a far cry from the idyllic images of postcards. Over the past 30 years, Malé has come to resemble a mini-Manhattan perched on a fragile coral peak. We ask some inhabitants a few cautious questions about the effects global warming might have on the future of the Maldives. It's a bit of a taboo subject in Malé, but they soon admit to feeling some trepidation. They wonder, for example, whether the coral mountain peak could collapse under the weight of the city some day. When we visit the Marine Research Centre, members of its staff explain that, during the last ice age, the sea level was several dozen metres lower than it is today. Over the centuries, the waves carved a deep hollow into the coral at that level. It's as if Malé were built atop a needle propped up on a base of clay – the coral is just as fragile. It's hard to know whether these are mere imaginings or something closer to the truth. They say that when the seafloor was sounded prior to construction of the wall around Malé, the Japanese divers discovered a very strange crevasse at the foot of the steep slope beneath the city. Long before it's ever swallowed up by rising waters, Maldivians fear, Malé may very well collapse into them – a kind of Apocalypse before the Flood.

*

Like everyone in Malé, Mohammed Ali, director of the Maldives Environmental Research Centre, has already heard talk of this danger. Malé is a sinking ship, people say, overloaded, undone by its own weight. These are the beliefs of the common folk, perhaps, but not totally unfounded, Ali tells us, adding that, until more is learned, it might be a good idea to prohibit construction of new buildings on the few free spaces remaining in the city. As a scientist, however, he knows that there are more urgent matters to attend to. He shows

us into a huge conference room, where a giant photo of the Maldives covers an entire wall. That sense of extreme fragility returns.

Ali spends two hours with us, explaining the message he's been spreading since 1991, when he participated in the drafting of the first IPCC report. The waters are rising, and fast, he says. This is caused in part by glacial melt, but the warming water's expansion plays an even larger role. Ali has observed that the sea level rises by an average of 5 millimetres per year, *"which would mean 50 centimetres by the end of the century if the warming were to continue at the same pace,"* he points out. *"As we know, however, the warming is accelerating, so we must expect a greater rise in sea level."*

And it gets worse. Before the Maldives are even flooded, Ali tells us, they may be eaten away by erosion, which is growing in intensity. *"Erosion is completely natural in the Maldives. It's caused by marine currents scraping the islands, but it has always been compensated for by an accretion of similar scale. When a beach disappears from one side of an island, it reappears on the other side, and vice-versa when the current changes direction with the season. We've seen that this natural balance is now broken, and that erosion wins out over accretion. The ill health of the coral is at fault."* He makes some quick sketches to show us how each island is encircled by a coral lagoon that functions as a breakwater to protect the beaches. *"It all depends on the coral,"* he says again. *"It's a living organism that's very sensitive to fluctuations in water temperature. It more or less succeeded in adapting to the planet's previous climate changes, but that's because they took place over several millennia. The current global warming is happening much more rapidly. There's no guarantee that the coral will survive. And without coral, the Maldives will quickly crumble into the sea."*

And so coral is on the front line in the fight against the slow but infinite assault of the waves, and it recently had the opportunity to alert people to its fragile health. In 1998, the climatic phenomenon El Niño – believed to be intensified by global warming – had disastrous consequences for the Maldives. The water temperature is usually very stable at about 28° C, but that year it climbed to 31° C and stayed there for six weeks. This extra heat was enough to cause an unprecedented amount of coral bleaching, which means that the coral has died. Pilots of seaplanes linking the islands were the first to notice this disaster, in which two-thirds of the coral reef was damaged. And although the coral is quickly returning in some areas, it will take two or three more decades before the damage done by El Niño is repai-

red – and that's only if no more damage is done to the coral in the meantime. In other words, the water temperature must remain stable.

In Ali's opinion, El Niño showed Maldivians just how dependent they are on the coral reef. They better understood the reasons why, in the 1980s, the government had banned the longstanding practice of coral mining. Bricks cut right out of the coral reef were once used to construct buildings, but this could not continue. If the coral reef were to disappear, the whole country would have to be crossed off the map, and even if that didn't happen, it's certain that the country's entire economy – dependent as it is on coral – would founder.

Every morning at 7 am, a speedboat leaves the Port of Malé for the Thulhagirii tourist resort, 30 minutes north of the capital. It's one of the 85 island-hotels that have sprouted since the early 1970s. Constructed only on uninhabited islands, these resorts are kept isolated from the islands where Maldivians live, though the physical distance separating them may not be very great. The locals do not have free access to these islands, just as the tourists may not visit the Maldivians' islands without special authorization and an official escort. Over 70% of the Maldivian economy depends on high-end tourism, a sector that has generated rapid growth and a per-capita GDP higher than that of neighbouring India and Sri Lanka. The government has recently granted some 100 additional licences to large international hotel groups for the construction of new tourist enclaves like the one we visit this morning.

Tourists are having breakfast in the panoramic restaurant hanging over a huge lagoon with dependably emerald waters. The place has a palpable ambiance of luxury and relaxation. About three-quarters of these tourists have come to the Maldives to dive on the coral reef, equipped with scuba tanks of compressed air or just a mask and snorkel. Any Maldivian will tell you that, despite the damage wrought by El Niño in 1998, this seafloor is still one of the most beautiful in the world. We quickly realize that this is a delicate topic. The authorities hate reading in the foreign press that scuba diving in the Maldives is not what it once was, and only a foolhardy Maldivian would imply as much to visiting journalists. For the moment, the tourists on Thulhagirii digest their food in silence before they leave for their dive. The quiet is broken only by the lapping of little waves against the stilts of the water bungalows.

Meanwhile, Abdulla Mifthah, the resort's head engineer, has begun his slow inspection of the shore. The island is so small that he's able to complete his round

of the entire shoreline in a quarter-hour. *"Look,"* he says, pointing to a coconut tree with bared roots at the shore's edge. *"See how the sand has disappeared?"* Five minutes later, we're on the other side of the island looking down at an extensive, magnificent beach. *"The water currents have moved it here over the past few weeks. Soon it too will disappear. Every six months the currents change direction, sweeping large quantities of sand along with them."* Not far from us, three hotel staff members are repairing small sandbag seawalls that are supposed to keep a little sand in front of each bungalow in spite of the currents. *"But I've been working at these resorts for several years now,"* Abdulla continues, *"and I can tell you that the beaches are getting smaller. This amount of erosion is unusual. Some resorts even have sand brought in from the high seas to renew their beaches once they get too depleted."*

One wonders whether these resorts will still be able to fill up with tourists in 30 or 40 years if the beaches disappear and the coral reef is slowly killed off by warmer water, bringing about the decline of the incredibly diverse population of sea creatures that are part of the reef's unparalleled ecosystem. The group of scuba divers from the Thulhagirii resort has just emerged from the depths. The reef's beauty did not fail to delight the Italians, Germans, French, Australians and Americans who have ended up together at this resort, like a sampling of the industrialized world washed up onto this confetti of sand through the quirk of hotel reservations. In spending their vacations here in the Maldives, these tourists provide the country with an important financial base that's indispensable for any major projects needed to combat rising sea levels. And so the citizens of the industrialized countries responsible for global warming are encouraged to come to the Maldives while they still have the chance. The situation is not without irony.

*

Back on Malé, the day is quickly vanishing, taking with it the light and heat that have flooded the city since morning. A relative coolness begins to invade the streets. This is the Maldivians' favourite time of day. A large number of people – alone, in couples and in family groups – head out to stroll along the shore. A call to prayer by the muezzin of a nearby mosque resounds above the clamour of the city. If we concentrate, we can hear the reply of another muezzin at the other end of the city.

Boduthakurufaanu Magu is a long street that encircles the island, hugging the coastline. It seems as though the thousands of motorbikes in Malé have arranged

to meet here tonight, increasing the already dense traffic. It's like this every evening – to cool off after the long, hot day, Maldivians like to hop on their bikes and take a spin around the island. Even at the speed limit of 30 kilometres per hour, the wind whips their faces into smiles even bigger than usual. At the edge of the sea, where a single, small, artificial beach serves as a reminder that Malé was also once surrounded by sand and coconut trees, some people amble along, cell phones to their ears, while others jog, and children dive into the refreshingly cool water. A few of the swimmers surface 30 metres out and clamber up onto the enormous concrete tetrapods piled one on top of the other, rising some 2 metres above the waves. Beyond this lies the ocean, contained behind this imposing seawall that surrounds the majority of the 7-kilometre coast.

The Great Malé Seawall was constructed in the early 1990s to prevent the repeat of a disaster like the terrible storm of April 1987, when an unprecedented combination of violent winds and a particularly strong tide flooded half of the capital, causing extensive damage. The 33-million-euro seawall, financed by Japan, serves as a shield from ocean-borne threats. These tetrapods have changed the landscape quite a bit, blocking the horizon, but Maldivians don't mind. They've even erected a tetrapod on a pedestal – like a monument to a general who has thwarted an advancing enemy army – in commemoration of Japan's assistance.

Sheltered behind this seawall, Malé is clearly keeping danger at arm's length, but for how long? Although the tetrapods are effective at warding off erosion and extreme weather conditions, they won't be of much use against rising waters. The island would have to be raised, a task that's more or less impossible in the case of Malé – but not for Hulhumalé, the Maldive Islands' newborn child, whose lights we can see shining 2 kilometres away.

"Welcome to Hulhumalé!" proclaims a large billboard Mohammed Shahid likes to point out to visitors. There's something incongruous about this phrase hovering over a distant corner of this immense, almost empty plateau made of blindingly white, shredded dead coral. Shahid is part of the team managing this vast project, which is intended as a solution to Malé's overpopulation. The island will be home to some 153,000 Maldivians by the time construction is completed in a few decades. Young, dynamic, detail-oriented and with a flawless command of English, Shahid is no different from any manager educated at a prestigious English-speaking university. He gives us a tour of the island in the comfort of his air-conditioned 4x4, driving up and down the perfectly straight streets of the em-

bryonic modern city that's forming on the plateau. He points out blocks of flats, a school, a hospital, a mosque, a shopping centre and office buildings. Some 15 structures have shot up here so far, and as many more are under construction. The city is growing with a vengeance.

"Only 10 years ago, Hulhumalé was still just a lagoon covered by a metre of water," Shahid tells us. *"We had to bore 4 metres into one part of the reef and transfer the crushed coral to another area to raise its level. This first phase of the project created 188 hectares, about the size of Malé. The city we're building here is already home to 2,000 people."* By 2020, the population will have risen to 53,000. Then begins the second phase of the project: the creation of 204 more hectares to accommodate 100,000 more people. Hulhumalé will be completed when a final 305 hectares of land is added for an international airport.

Some men are waiting on the banks of the landing stage for the arrival of the next dhoni in the service linking Hulhumalé to Malé every half-hour. The water here is an abnormally dark blue – this is the spot where the excavation machines dug into the coral, penetrating deeper than planned. *"Before work began in 1997, we did extensive research on the impact the project would have on the environment,"* Shahid tells us during our next meeting, in a conference room with large photos of the excavation work on display. *"Teams of international scientists came to help us with the planning. They strongly recommended elevating Hulhumalé to protect it from rising waters."* As a result, while most of the Maldive Islands rise just a metre above the water, Hulhumalé is a full 2 metres above sea level.

Is building artificial islands like Hulhumalé a solution that will make the future of the Maldives secure? *"Islands raised to 2 metres above sea level will perhaps help us, but it's not a real solution,"* Abdullahi Majeed, the Maldivian Minister of Environment and Construction, tells us later. *"If the water rises by 50 centimetres, storms and erosion will become 10 times stronger."* And Hulhumalé will be threatened as well: at least, that's the opinion of Mariyam Mastar, a 37-year-old mother of seven that we visit at her home in Hulhumalé. To economize, she and her children share their 80-square-metre flat with another family, splitting the 4,500-rufiyaa rent (about 300 euros). *"It's cheaper and more comfortable than in Malé, where we were even more cramped,"* Mariyam says. *"I no longer have to worry about my children's safety, or about robbery or drugs. Their school is just across the street. They come home to have lunch every day at*

noon and play downstairs in front of the building without having to worry about getting hit by a car. It's more peaceful here, and more modern, but I would prefer it if we had a protective seawall around Hulhumalé like Malé has. They tell us we're safe here, 2 metres above the water, but the Malé seawall broke the impact of the tsunami when it hit, while this entire island was submerged!"

*

On 26 December 2004, the tsunami that devastated the coasts of countries bordering the Indian Ocean passed through the Maldives as well. With 'only' 82 deaths and 27 people reported missing, the country was spared the incalculable human losses experienced in Indonesia, India and Sri Lanka. One explanation for the relatively low number of victims in the Maldives is that the submarine topography of the area provided a multitude of channels that diverted the force of the wave, but all Maldivians are well aware that the coral reef also played a role in breaking the impact of the crashing waters.

Macabre death-toll comparisons aside, the tsunami did greatly traumatize the population of the Maldives. Never before had such a danger arisen from the sea, with which the Maldivians had been living in trust and harmony for ages. On other shores of the Indian Ocean, some old-timers recognized the telltale retreat of the waters a few minutes before the disaster and were able to react in time, but no such collective memory exists in the Maldives. *"Neither my parents nor my grandparents had ever spoken of a disaster caused by the sea,"* says Mariyam. *"We've never been afraid of it – but it's no longer a friend we can trust."*

Since that day, the tranquillity that had characterized the Maldivians' relationship with their ocean began to grow murky. Little by little, their awareness of their country's vulnerability to the untameable forces of the water is growing. On Malé, Hulhumalé, Thulusdhoo, Gan, Mundoo and all the islands that we visit, the subject of the tsunami pops up countless times as we discuss the effects of global warming with the locals. The Maldivians know that the two phenomena aren't related, but the wave made a lasting impression, and many now contemplate the future with a degree of fear. In the last two years, the number of women wearing the Muslim headscarf has grown, reflecting a clear rise in religious devotion in a country where Islam is the official religion but has always been practiced in moderate form. Many people, especially on

the more remote islands, believe that God alone will decide whether the Maldives are to be engulfed by the rising sea.

Storms in 1987, El Niño in 1998, the tsunami in 2004 – each in its own way, these events have raised Maldivians' awareness. In 1989, the government of President Maumoon Abdul Gayoom – re-elected in 2003 for a sixth five-year term in this single-party state – began attempting to alert the international community of the dangers. He undoubtedly took up the cause of environmental protection mainly as a bid to enhance his image before the rest of the world, but the results were nonetheless positive. From 14 to 18 November 1989, 14 small insular countries, including Barbados, Fiji, Grenada, the Seychelles and Vanuatu, met in Malé for a conference on rising sea levels. Using the IPCC's initial conclusions as a basis, they drafted the Malé Declaration, in which they called on the UN and industrialized nations in particular to take immediate action in terms of using alternative energy sources that cause less pollution. Their message implicitly reflects their shared sentiment of being victims of a terrible injustice. The Maldives, as just one example, produces less than 0.01% of total planetary greenhouse gas emissions, but will be among the first countries to disappear if the process now warming the planet is not halted soon. Fate was to deal the Malé Conference a cruel blow, however: it was held just a few days after the toppling of a large concrete wall in Berlin, very far from Barbados, Fiji, Grenada, the Seychelles, Vanuatu and the Maldives. Capsized by a wave of international news, the Malé Declaration sank virtually unnoticed into the ocean of current events.

Eight more years would pass before the very first tool for fighting global warming – the Kyoto Protocol – saw the light of day. *"Kyoto isn't the solution,"* Mohammed Ali said when we brought up the subject of responsibility. *"Industrialized countries must be obliged to develop effective technology to reduce pollution. We hear about the level of greenhouse gases emitted by China and India, but who is all their production for? The developed countries! And so they're exempt from the Kyoto Protocol. It's a huge hypocrisy. And by setting up their factories in these two countries, certain companies from developed countries are able to squeak out of the Kyoto obligations agreed to by their governments."* Mohammed Zahir, a Haveeru *Daily journalist specializing in environmental issues, added, "I can't think of any technology that would allow us to continue living on our islands if the sea level continues to rise. We can only hope that the developed countries will step up and do their part by considerably reducing their greenhouse gas emissions."*

Technological solutions do seem limited. If the wellspring of tourism does in fact slowly dry up over the coming century, where will the Maldives get the billions of euros necessary to construct more artificial islands? Where will they find the funds to build tetrapod seawalls around the 200 inhabited islands? Only the international community can provide the financial assistance that Maldivians will need. However, rather than sit and wait for help that might not come for a long time, if ever, Maldivians are already working to find other solutions, and they may just have hit on one answer that can at the very least delay permanent exile: the Population Resettlement and Development Plan.

Scattered over 12 atolls covering close to 1,000 kilometres from north to south, the 1,200 islands of the Maldives form an archipelago so vast and fragmented that it takes a dhoni several days to travel from Malé to the other end of the country. Over 75 of the 200 inhabited islands have populations of less than 500. This dispersal leads to high costs and slows infrastructure development with regard to hospitals, schools, water desalination plants and seawalls to protect the shores. It was decided that this situation could be ameliorated if all Maldivians were resettled on about 80 islands, which would become the focus of greater development efforts. *"This relocation will take place on a strictly voluntary basis, and not by force like on some atolls in the 1970s,"* Minister Majeed takes care to point out. *"As a result, this plan will take some time to complete – probably several decades. The population is beginning to understand the need for such an initiative, however. After the tsunami, we received many requests from isolated families who wanted to move to islands where they would be better protected from the dangers of the sea."*

The Population Resettlement and Development Plan had been in the works for a long time, but it experienced a surge in popularity right after the tsunami struck. The environmental aspect of relocation was clearly reinforced and stood out from purely economic motivations. The 80-odd islands targeted as relocation sites had been referred to as the Focus Islands but now began to be called the Safe Islands. The Plan is coming to be seen as a way to progressively evacuate islands that are too fragile and particularly exposed to erosion, but because it bears the potential for social and cultural upheaval never before seen in Maldivian society, it has not garnered unanimous approval.

Laamu Atoll, a 45-minute flight south of Malé, was one of the islands most deeply affected by the 2004 tsunami; more than one-third of the victims resided there. The inhabitants of Mundoo and Kalhaidhoo, two islands along the eastern

edge of the atoll, which was struck by the full force of the wave, are still trauma-tized today. A 20-minute dhoni ride away, on the island of Gan (one of the Safe Islands under the Resettlement and Development Plan), lies the town of Thudi, the site of a new district the Maldivian government is constructing for the 1,000 inhabitants of Mundoo and Kalhaidhoo with the assistance of major internatio-nal humanitarian organizations. It's a sort of dress rehearsal for what will happen when other fragile islands have to be evacuated one by one after erosion and ri-sing waters have made them too dangerous.

There are very few regular dhoni lines between the Maldivian atolls, or even bet-ween the islands of a single atoll, and Laamu is no exception. To travel from one island to another, you have to keep an eye out for random fishermen and mer-chandise transporters who might be making a trip. You have to stay close by, keep your ears open and jump at any chance to get to your destination, even when you don't know the time or date of the return trip. There are limited relations, and thus little communication, between the communities, each of which cultivates its own sense of insularity.

A tropical rain begins beating down on the roof of the dhoni that's taking us from Gan to Kalhaidhoo, but we're more or less sheltered from it and pass our time in conversation with a Kalhaidhoo notary, one of the few passengers making the trip with us. We don't learn much – he prefers not to discuss *"that relocation bu-siness"* – but like all the Maldivians we meet, he's friendly and eager to help. He advises us to go and talk to the village head, but when we find him, this man turns out to be no more willing to discuss the topic than the notary was. He's not from the area originally, he tells us; he was transferred there a few months ago by the atoll prefect, and now waits morosely for the relocation to take place. The com-munity he's in charge of is torn between a feeling of bitterness over the imminent evacuation, which will mean the permanent loss of its identity and ancestral land, and enthusiasm for the safe, modern new town. He doesn't know how many peo-ple are still in Kalhaidhoo or how many have already moved to Gan. For the time being, new arrivals are being accommodated in the refugee camps that were set up on Gan right after the tsunami disaster. They'll receive their permanent trans-fer to Thudi once its slow-moving construction is complete.

On the eastern side of the island near the shore, the ruins of a few devastated houses have been taken over by weeds. Their coral walls were not able to with-stand the wave. No more than one-quarter of the village seems to have sustained

damage, but Kalhaidhoo has slowly been deteriorating over the past two years. Farm fields made unusable by the saltwater that covered the entire island have been abandoned, even though tropical rains gradually desalinate the soil. The fenced walls would be easy enough to put right, yet they remain where they fell. *"Ever since we found out we were going to be moved to Gan, we've given up. We're waiting. We're on borrowed time here on our island,"* says one inhabitant, who informs us that the community is now entirely dependent on the government and receives subsidized food supplies. *"Out of the 40 families that make up the community of Kalhaidhoo,"* he continued, *"only six want to stay. Officially, nobody can force them to leave, but can they really stay here if the two food stores close, the dhonis forget to stop here and the power station is abandoned? Anyone opposed to the evacuation programmes will be forced to give in. Come with me."*

He takes us to meet 50-year-old Ali, a neighbour who won't hear of relocating, and his entire family. Ali shows us large cracks in the walls caused by the tsunami. The water rose as high as 2 metres, he tells us, but the house held up and no one was hurt. He takes us on a tour of some courtyard-side buildings he built himself to accommodate his children and grandchildren. Like most of the inhabitants of Kalhaidhoo, Ali lives humbly. He has just enough of everything he needs: fish caught in the lagoon in the early morning, vegetables from his garden and coconuts just about everywhere – and a little rice too, which they have to buy since it doesn't grow in the Maldives. *"This is my land,"* he says softly. *"I was born here and I want to die here. Of course, my daughters don't share my opinion. They're young and dream of moving to Thudi, to a brand new house with a nice school for their children and a hospital just a stone's throw away, plus an airport for easy access to Malé and the jobs that will be created as the city grows."* Ali's daughters smile shyly and nod in agreement. As soon as the houses in Thudi are ready, they'll move. *"But what they don't realize is that it won't all be the way they imagine it,"* Ali continues. *"The communities of Kalhaidhoo and Mundoo have never gotten along. Both groups are going to be cut brutally from their roots, from their way of life, from everything that makes them different in spite of appearances. They'll suddenly have to coexist in a city where they have no bearings. I don't know if they'll be able to live together. And we're not very welcome on Gan – the inhabitants of Thudi have reservations about our arrival. They fear intergroup tensions, crime and drugs, like in Malé."*

Heavy rain pours down once again while we're on the dhoni back to Gan. In fact, these downpours have been drenching Kalhaidhoo all day long. *"For the month of*

January it's really very strange," remarks the notary, who is also returning to Thudi, where he's staying temporarily with friends until construction is finished. *"It almost never rains during this season."*

*

At Thudi's hospital, head physician Ali Nassir speaks to us in emphatic terms about new threats to public health. *"The epidemic of dengue fever hitting the Maldives right now is caused by the abnormal rainfall, and the Chikungunya virus has even shown up for the first time! Dengue fever always strikes during the rainy season in June and July, but since it's been raining non-stop for weeks, the water no longer has the chance to filter down into the soil. This leads to stagnant-water conditions that are perfect for breeding mosquitoes. We've never seen this before in the month of January."*

Could this be caused by global warming? Maldivians don't go so far as to make the connection; they just notice the progressive change in the very precise alternation of their seasons. Mohammed Manik, head of operations at a fish-packing plant in Gan, knows what he's talking about. He's spent a good part of his life on the ocean, picking up catches from fishing boats and taking them back to the plant. He explains that the Maldives, like many tropical countries, benefit – or used to benefit, he corrects himself – from a weather system so regular you could set your watch by it. There are only two seasons. First there's iruvai, the dry season, which runs from mid-December to mid-May and is characterized by calm, dry weather and, in particular, a wind coming exclusively from the east. Then comes hulhangu, the wet season, which sets in over a period of a few days at the end of iruvai and brings with it the rains of the southwest-Asian monsoon, mainly in June and July. During this season, the wind blows only from the west. *"But you see,"* he went on, *"this seasonal routine is now nothing but a memory. Each year we notice strange things. And I can even tell you the exact date of the first one! It happened on 23, 24 and 25 July 1995. At the time, I was the captain of a boat that picked up tuna catches. I'd been living on the sea for 20 years. The morning of 23 July, I suddenly noticed that something strange had happened during the night: the wind had turned, and was now coming from the east. This went on for three days. Everyone will tell you that this had never happened before, and ever since then, the phenomenon recurs every year on random dates."*

Over the centuries, this very precise regularity allowed the Maldivians to create an extremely accurate calendar of weather patterns dividing the year into 26 mini-seasons, lasting 15 days each, called nakai. These mini-seasons document

the sometimes very subtle modifications that take place from one fortnight to the next. Maldivian fishermen have always used the nakai to plan their forays into the ocean, but Abdul Aziz, for one, no longs puts stock in them.

This evening Abdul has decided to leave Thudi Port at 9:00 pm to go out and fish for skipjack tuna. A crew of 12 accompanies him. They will first spend the entire night hovering near the coral reef, looking for schools of hatchlings that they can use as bait. Four men will spend hours in the water trapping the little fish in a huge net, a powerful searchlight from their vessel piercing into the dark waters. *"These are fish that live amidst the coral,"* mentions Abdul, who's manning the tiller of the boat. *"In 1988, during El Niño, the coral was in such bad shape that these hatchlings had almost disappeared. Without them, there's no way to fish. We really had a tough time back then."*

To avoid overexploitation of reserves, tuna fishing has been very strictly regulated in the Maldives. Nets are now prohibited; only traditional fishing poles may be used. It's a spectacular method of fishing, but the men exhaust themselves filling up the hold of the dhoni before going to the Malé market to sell their catch, or, like Abdul, to the plant where Mohammed Manik works. When the sun begins to rise, Abdul sets course for the high seas, pushing the boat's motor to full speed. Several hours pass before they find the first school of skipjack, then suddenly fish are flying through the air at the ends of the fishermen's lines. Rain begins pouring down yet again. "This isn't a very good day for fishing," Abdul observes after a while. *"Everything depends on the weather, which is more difficult to predict now. This rain in January...who can trust the nakai anymore? Their predictions used to be accurate every year. Now they're changing. It's as if the Earth were getting old and forgetful."*

Abdul doesn't know whether or not all of this is due to global warming. He turns the boat back towards Gan, where they'll collect more bait. He lingers at the tiller. *"Do you think the Maldives will disappear?"* we ask him. Mariyam back in Hulhumalé had answered this question without hesitation. *"Of course! The water will rise higher and swallow everything up, destroying everything. It's no longer possible to live here."* For his part, Abdul has no idea. It's too far off, too abstract, he says, impossible to predict such a future. So we put the question in other terms. Where will he go if Maldivians are one day forced to abandon islands invaded by floods? Australia? After all, there's been talk in the Maldives that the Australian government has secretly agreed to accommodate them. *"But that's just a rumour,"* Abdul says, smiling. *"What will I do if our islands are engulfed? There'll be nowhere to go. I'll take refuge right here on my dhoni!"*

∫

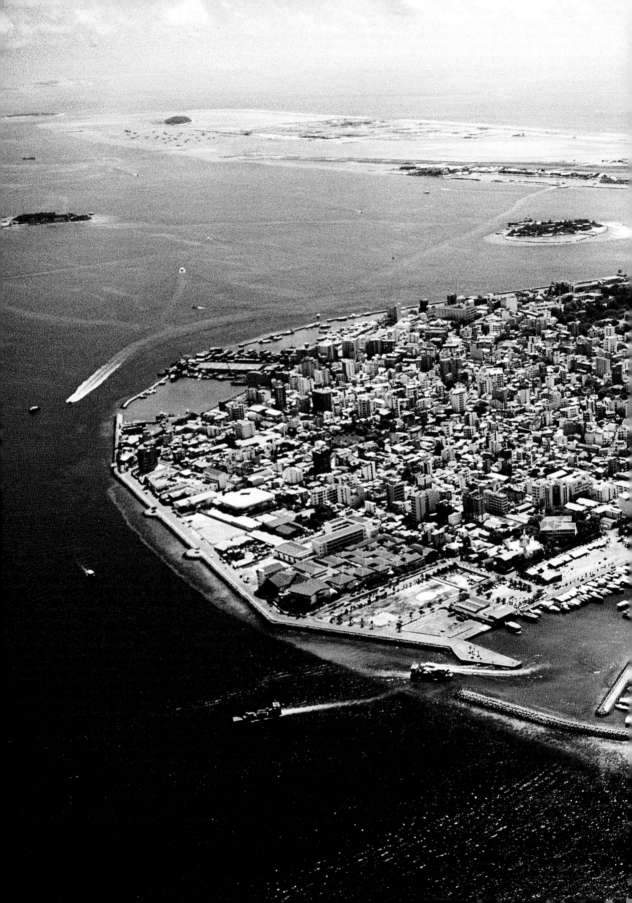

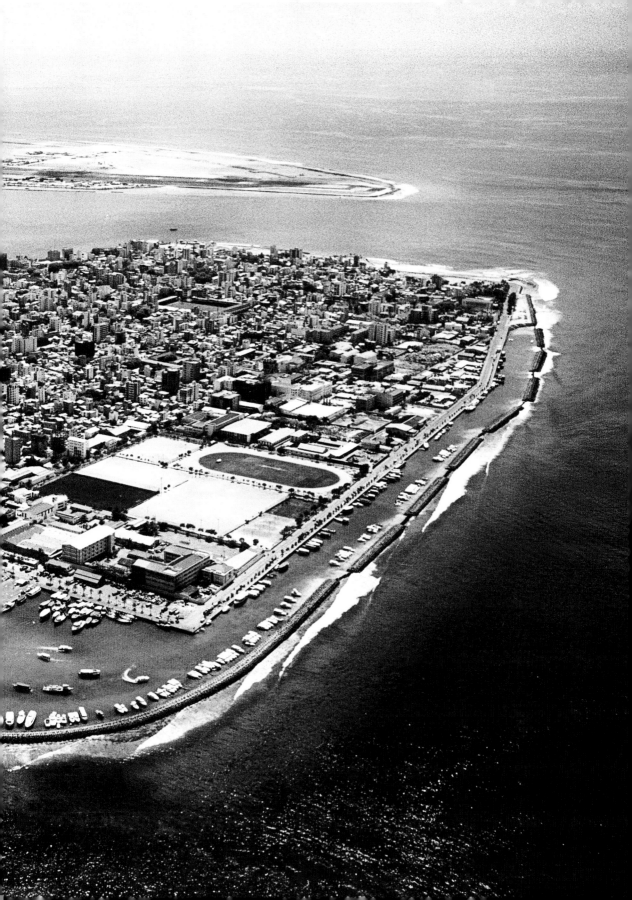

→ (Preceding pages) Malé,
 capital of the Maldives, has a
 population of 100,000 packed
 into 2 square kilometres. It's
 the only island in the
 archipelago protected from
 erosion by a concrete seawall.

→ Rocks imported from India
 and Sri Lanka are now used
 to build the traditional
 seawalls.

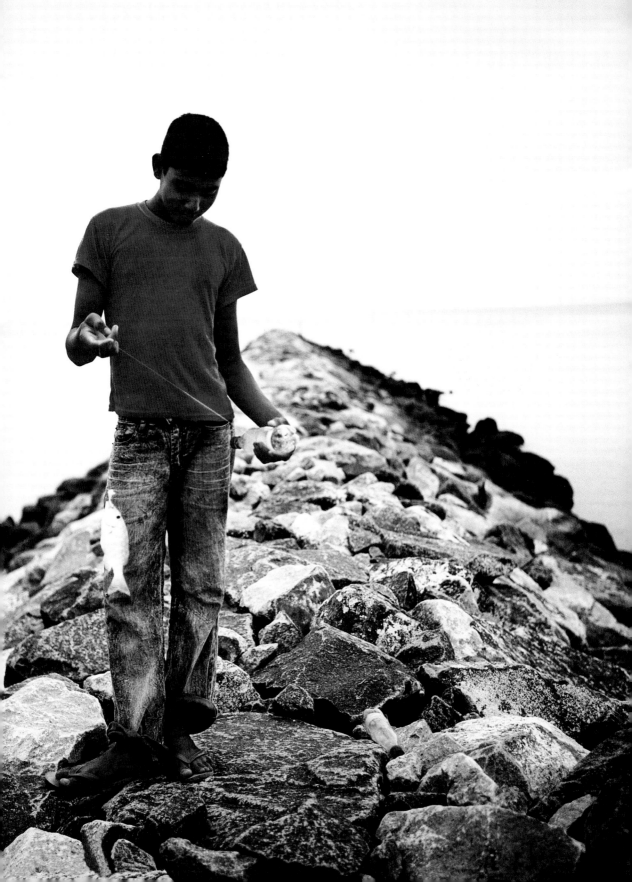

→ *The Great Seawall surrounding Malé was constructed from thousands of concrete tetrapods with financial assistance from Japan. This barrier is effective at warding off erosion, but it cannot protect the island from rising sea levels.*

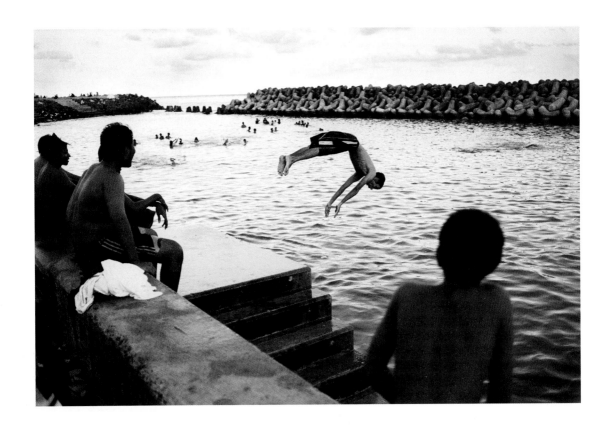

→ *Around Thulhagirii, like the
other 85 island-hotels of the
Maldives, makeshift seawalls
of coral were long used to
slow the natural erosion of
the beaches. To protect the
reef, the use of coral is now
prohibited.*

→ *(Following pages) The Great
Malé Seawall surrounds
almost the entire 7-kilometre
coast*

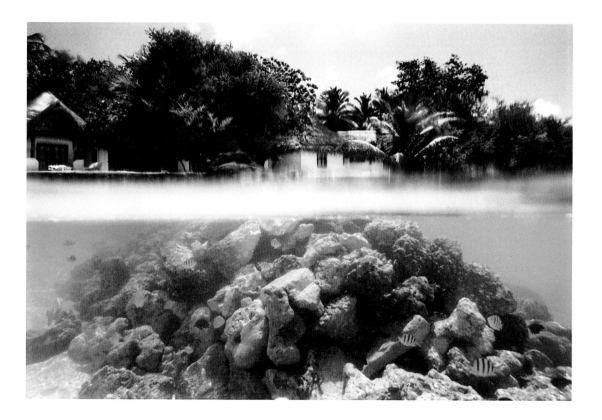

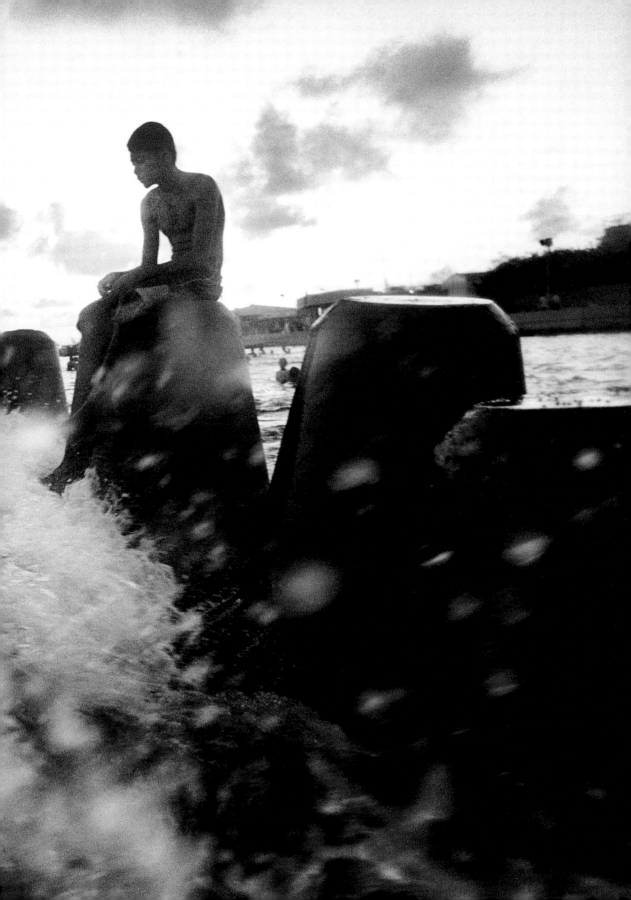

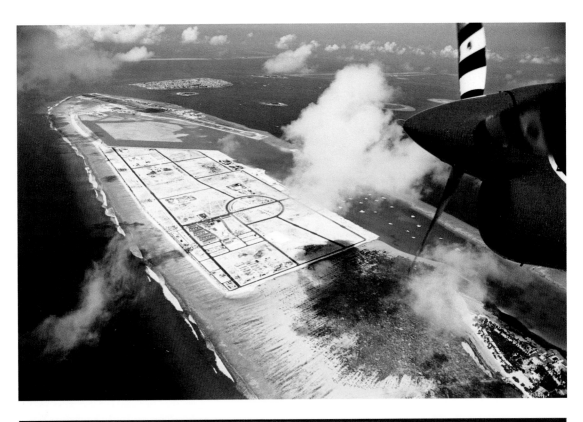

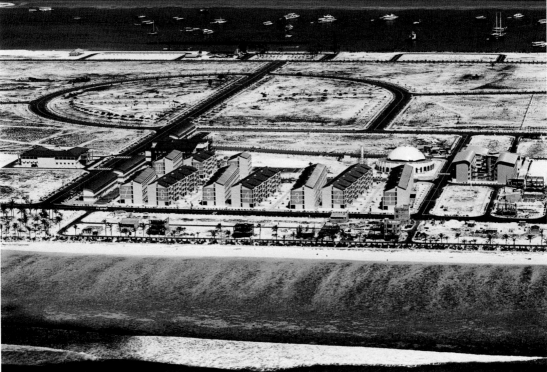

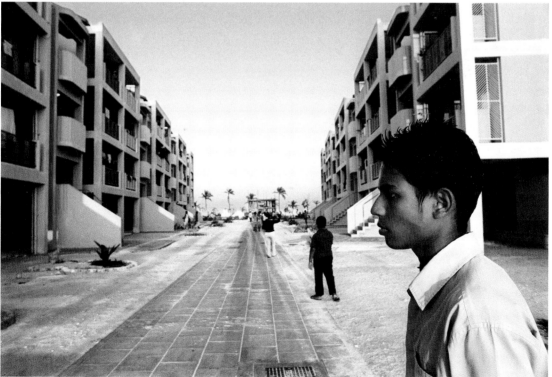

→ (Preceding pages) In 1997,
work began on the 188-
hectare artificial island of
Hulhumalé, which will help
solve Malé's overpopulation
problem.
To raise it out of the water, it
was necessary to bore into the
seafloor and extract millions
of tonnes of coral.
Since the arrival of the first
inhabitants in 2003, over
2,000 people have relocated
from Malé to Hulhumalé.
A 20-minute ferry ride
separates them from the
cramped, overpopulated city
they left behind.

→ Fishermen were the first to
notice the gradual changes in
the very precise alternation
of the two Maldivian seasons,
iruvai and hulhangu.

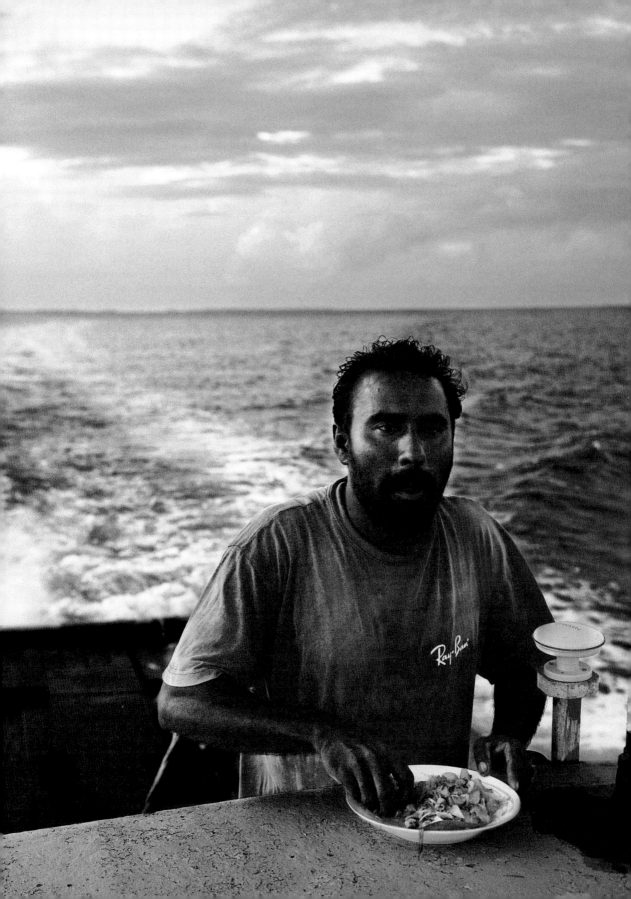

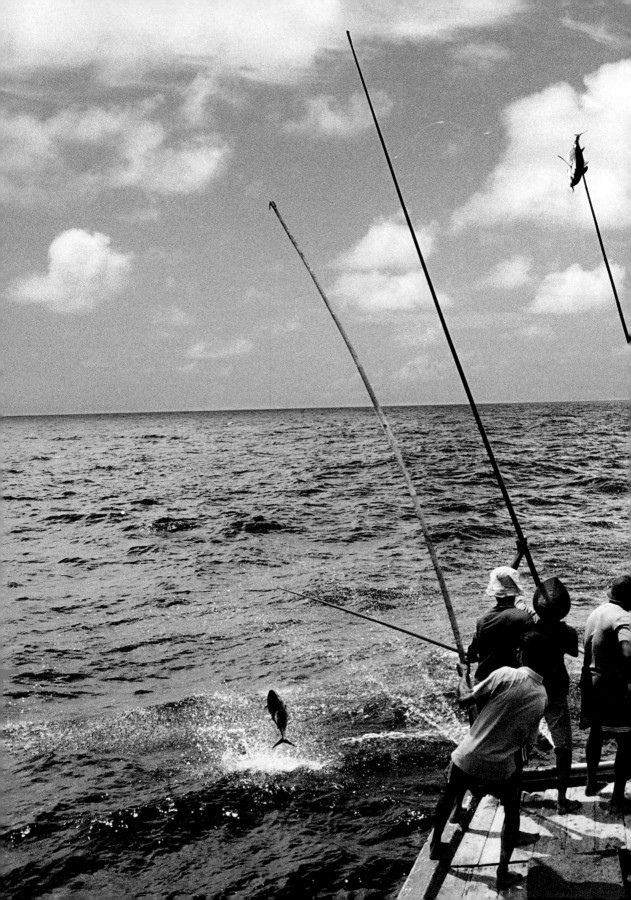

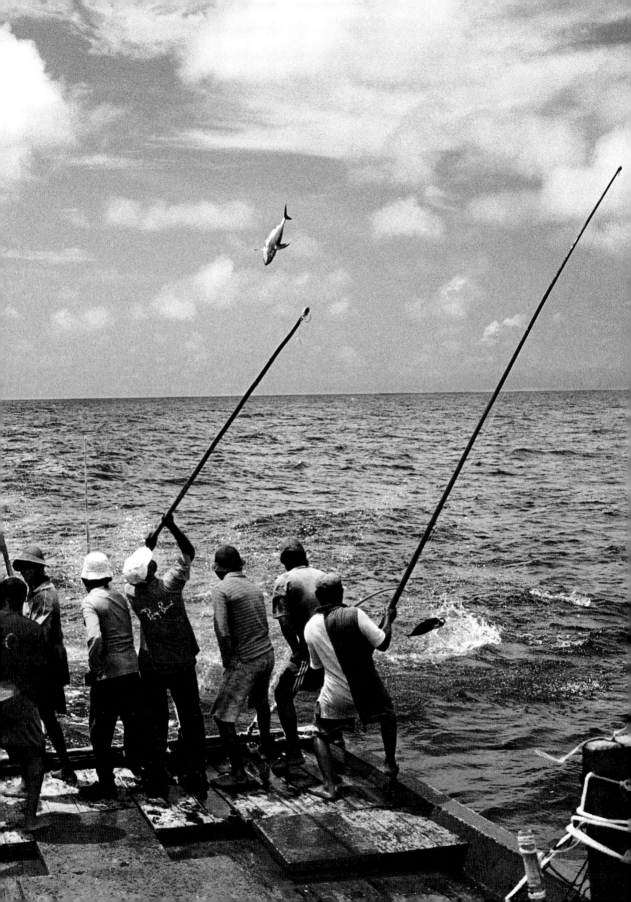

→ *Kalhaidhoo Island (Laamu Atoll) was hit hard by the December 2004 tsunami and had to be evacuated. Its inhabitants were temporarily accommodated in refugee camps and then resettled permanently in a brand-new district in Thudi, on Gan Island.*

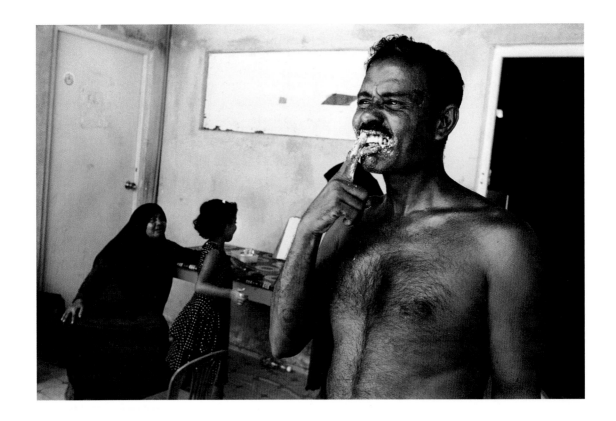

→ *Close to half of all Maldivians are under age 14. By 2050, the need to evacuate certain islands will be more urgent, and the population will have doubled to 700,000.*

→ *In the Maldives, erosion is due to the marine currents which scrape the islands. It is compensated by a phenomenon of accretion of similar scale. When a beach disappears on one side, it reappears on the other.*

But this natural balance is now broken: erosion has taken over accretion. The ill health of the coral is at fault.

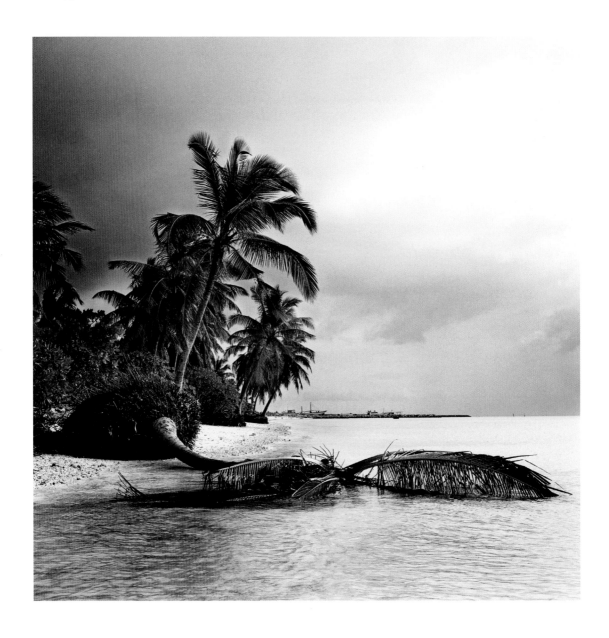

→ *Thudi (Laamu Atoll), January 2007. Never in Maldivian memory has so much rain fallen in the middle of the dry season.*

→ *(Following pages) Erosion has always been a natural phenomenon in the Maldives, but with its recent acceleration, some beaches are no longer renewed.*

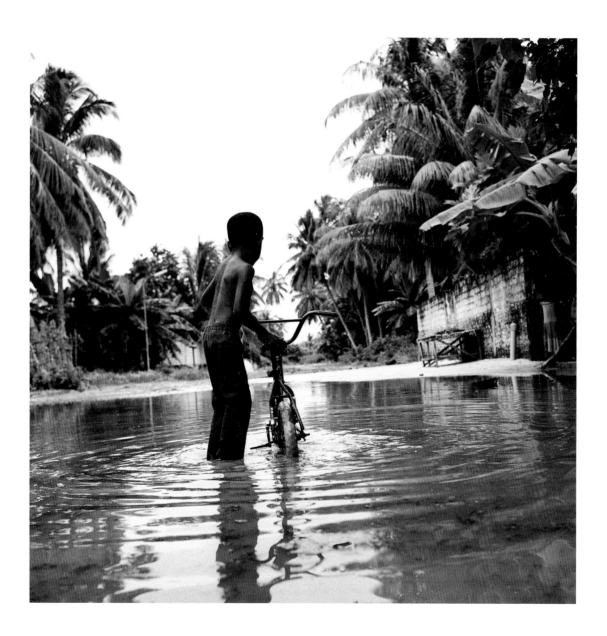

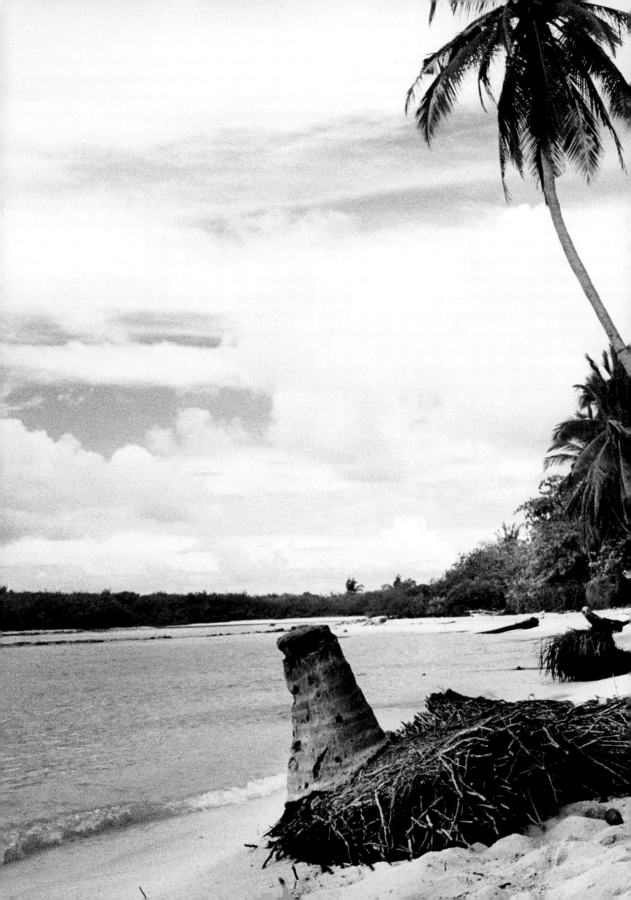

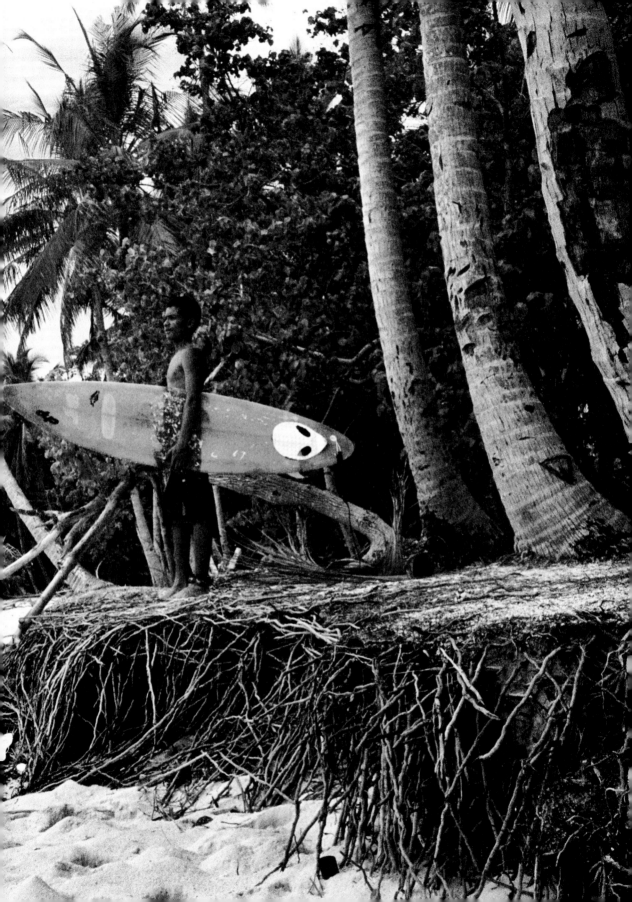

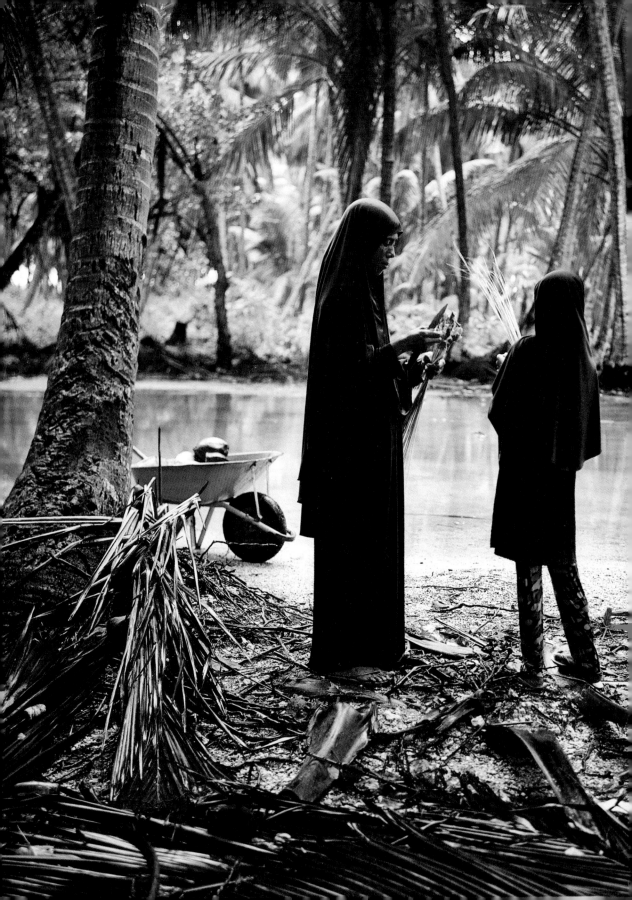

→ *Ever since the December 2004 tsunami, when Maldivians were made aware of their islands' vulnerability to the ocean, religion has experienced an impressive resurgence.*

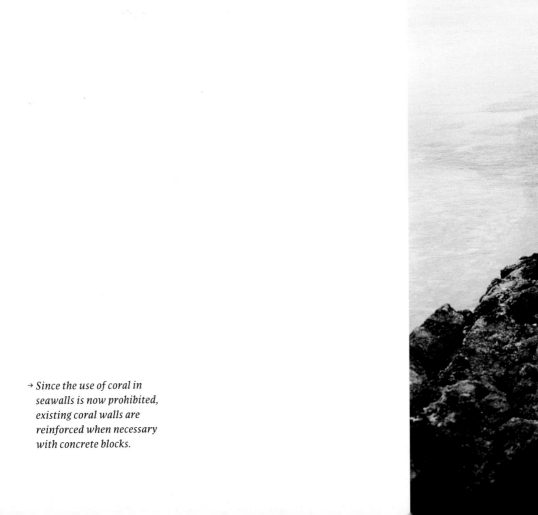

→ *Since the use of coral in*
seawalls is now prohibited,
existing coral walls are
reinforced when necessary
with concrete blocks.

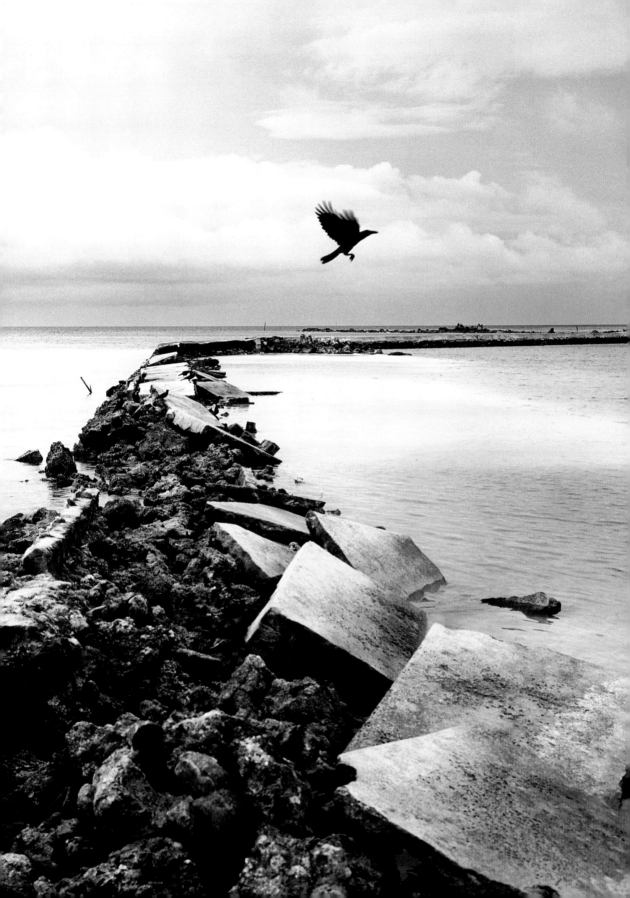

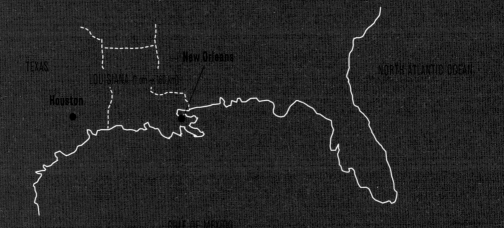

UNITED STATES

TEXAS

LOUISIANA (1 cm = 160 km)

New Orleans

NORTH ATLANTIC OCEAN

Houston

GULF OF MEXICO

TEXT: DONATIEN GARNIER
PHOTOGRAPHY: CÉDRIC FAIMALI

UNITED STATES
Gulf Coast, farewell to the Big Easy

1. George Bush International Airport

10 May 2006: Nine months after the disaster created by Hurricane Katrina, the states bordering the Gulf of Mexico are anxiously awaiting the beginning of hurricane season, while preparations are underway for the second round of municipal elections in New Orleans. Eight months after our first visit, photographer Cedric Faimali and I have touched down again in Houston. Today, like every day, the sky is blue and the heat stifling.

The airport in the economic capital of Texas is one of the least hospitable we have ever encountered. Its soulless terminals are so far away from each other that, despite their huge size and passenger flow, we feel as if we have landed in a cul-de-sac. The airport mirrors the city it connects to the world – a megalopolis of 5 million people that always seems strangely deserted.

Cedric takes the wheel of our Korean rental car. We pass through the dense woods bordering the airport and enter the network of loops and highways set against the skyline of the fourth-largest city in the United States: a collection of glass and concrete towers piled high and filled with government offices, capital, artwork and medical researchers – a powerful core, but relatively small compared to the enormous ring of residential suburbs surrounding it.

We leave the Interstate 610 loop and enter a vast residential area. The streets we

pass on the way to our lodgings file by in a monotony of sameness: perfectly manicured, insect-free front lawns; leafy oak, pine and magnolia trees; air-conditioned homes with one or two floors (never more); backyards – and not a pedestrian in sight. You would never guess that 150,000 refugees from Louisiana are still being sheltered in Houston. We should add, however, that they were nearly invisible when we first met them in October 2005, less than a month after they arrived en masse.

It seems sadly ironic that the United States, which refused to sign the Kyoto protocol and is the world's major emitter of greenhouse gases, should be the victim of the largest population displacement in its history at a time when scientists are beginning to agree that global warming might be increasing hurricanes' strength and size. So we came to find out what these uprooted people were thinking and planning after being so suddenly plunged into an uncertain future.

2. The importance of keys
At the time of our first visit, New Orleans had lost nearly four-fifths of its population, particularly residents of the many communities located along the hurricane's path. People from New Orleans were now scattered throughout the United States, mainly in the neighbouring states of Mississippi, Arkansas and Texas. Over 150,000 people had found refuge in stadiums and convention centres in Houston before being put up in hotels, empty apartments and church facilities.

In one such facility, a gymnasium loaned by a prosperous Baptist parish in the southern part of the city, we had met Evangela Bailey, 31, her husband Robert, 36, and their three children, Leron, Lyschine and Jajuan (13, 11 and 8, respectively). Despite their exhaustion, they had allowed Cedric to photograph their move to a neighbouring house, which the Baptist church had just finished renovating for them. We then followed them for eight days, developing what we thought was a solid relationship, so we were very eager to see them again. Things got off to a bad start, however: they were not at the same address, and no one knew what had become of them.

The questions troubling us since we left Paris started spinning around in our heads again. Are they still in Houston as they had planned? Have they finally become accustomed to this city, which is so radically different from their own?

Have the parents found jobs? Have they sunk into despair? While waiting to learn the answers, we went back to our notes, searching for clues while recalling the pleasant moments we had shared with this endearing family.

When we had finished our first interview, Evangela had whispered, *"I can't wait until we have the keys to our new home. Keys! You have no idea how important they are to me!"*

Evangela had a tragic expression on her round, youthful face – an attractive face with an amber-black complexion and features sharpened by anger both deep and tenacious. But her expression sometimes softened with the onrush of unexpected emotions, the determination in her voice, the proud look in her eyes, and her clear desire to measure up in the face of her current fate and perhaps that of past centuries as well. All these factors, added to the poignant story she had just told, helped us understand the value of a set of keys, with its promise of privacy, rest and reconstruction.

3. Katrina

At 9:30 a.m. on Sunday, 28 August 2005, while Hurricane Katrina gained strength with winds of over 160 miles (260 km) an hour as it neared the Louisiana coast, New Orleans mayor Ray Nagin finally decided to order the evacuation of the city after much hesitation. Most residents with cars left the city, while some 100,000 people remained – mainly the poorest residents, who, lacking cars, were unable to leave, as well as the misinformed, who refused to heed the mayor's order. The Bailey family fell into two of those categories: they no longer had a car, and Robert didn't think there was any cause for concern because the public housing in which they lived was located in a large complex built of brick instead of the plywood used in most of the area's homes. Their building would hold up, thought this slightly-built man, who had once, long ago, been involved in trafficking and had paid the price. He was mainly worried about the direct effect of the wind, never imagining that its power could provoke a tidal wave that would breach several sections of the 320 miles (520 km) of levees designed to protect the city. He had long ago stopped believing in this much-feared disaster scenario.

Robert suddenly changed his mind the followed morning when, dumbfounded, he saw the flooding in his neighbourhood. Lyschine, a young, sad-looking girl forced to grow up too fast, will forever remember her family's departure: *"The*

electricity went out, the trees fell over and the water was rising fast. We put my lit-tle cousins in a plastic tub and my little brother Jajuan climbed onto my father's back. It was disgusting; garbage was floating in the water and we didn't know where to walk. I was afraid of hurting myself and getting sick. In some places, the water came up to my chin."

The family ended up reaching the bridge that leads to the Superdome, the Ame-rican-football stadium that is home to the New Orleans Saints, a team that Robert ardently supports. However, they had to wait a long time before they found shel-ter – in hell, as it turned out. It came as a shock to Leron, the oldest child, who up till then had experienced the situation as an adventure. *"I was really scared. It stank, and we heard screaming and gunshots. We were drenched and starving. They gave us military rations, but we were still hungry."*

Four days and three nights of horror then ensued in an overcrowded, unheal-thy, poorly-lit shelter overrun with the most sordid rumours, with no air condi-tioning and inadequate security. Four days and three nights of waiting on cramped, uncomfortable stadium seating, with virtually no sleep for the ever-vigilant adults. After this miserable period, Evangela began to question her own humanity: *"I tried to hold out, to pray to God with my children, but it was hard not to fall apart with all these people around us who thought the end had come. At one point, I gave the little bit of drinking water I had left to an old woman who was even thirstier than me, and I felt relieved that I was still able to help someone."*

On Thursday, when the family, at the end of its rope, was about to board one of the buses that had finally been chartered to take the refugees to Houston, they found out that they would have to separate: the first buses were only taking women and children, so Robert would have to wait until the following day. Along the way, he would also discover that he was headed for Dallas and not Houston.

Meanwhile, Evangela and her children were given shelter in the Astrodome, yet another football stadium. This time, the response was worthy of the humanita-rian challenge, and the Baileys were able to get some sleep, wash up a bit and have something to eat. Without any news of Robert, however, they were sick with worry. It took them five days to learn his whereabouts and to finally set up living quarters with him and a dozen other families in the gym, which is where we met them.

They barely had time to recover and search for missing friends and relatives when Hurricane Rita started heading towards Houston, sending the Baileys off again on a brief exile to Dallas. This incident convinced them that Katrina would most likely not be an isolated occurrence, that the disaster could happen again and that it would now be impossible to return to a city as fragile as New Orleans. *"Our confidence is gone,"* Evangela concluded. *"New Orleans has lost the confidence of its citizens."*

4. Mourning a city

During our conversations with them, Robert and Evangela often mentioned that they were born and raised in New Orleans, that the same held true for at least one of their grandparents, and that their family could even be traced back many generations. This is a trait they shared with most of the refugees we met in Houston. In this country of high geographic mobility, New Orleans was one of the few cities where most people stayed put.

Living in New Orleans, however, was not easy. Crime and unemployment were constantly on the rise, the public school system was a disaster and corruption was pervasive. These factors had led Evangela to seriously consider leaving despite her husband's deep reluctance and her own attachment to the city. *"I was thinking of Houston. Everyone knew you could find work here and that the pay was better than at home. I really wanted to come here – but, God, not under these conditions! Not by being forced to and without anyone to turn to in case something happened. I have nothing and no one left in New Orleans. It's really hard to know that everything you had is gone. And I'm not talking about material things but a place, the feeling of belonging to a certain place on earth. A place you can think about when you're far away. New Orleans has disappeared and it will never be rebuilt as it was before. That hurts, it really hurts."*

The possibility of returning to one's native land, even as a purely abstract idea: isn't that what gives refugees the strength to keep going, to adapt to environments radically different from those they have always known? When they left the gym, Evangela and Robert, despite everything, seemed persuaded that only a return to family life in the privacy of their own home would give them the energy they needed to meet this challenge, so on the day they moved, Robert was all smiles as he carried the few belongings they had received from charitable organizations. The future now seemed promising: *"If you're not in your own home,*

you can't relax. And if you can't relax, you can't find work. Now I can really get going. I'm straight now, man."

It wasn't that simple, however. Despite their joy at being alive, their fatigue remained and life refused to resume its normal course. Family members struggled to regain their old habits, only to realize how intertwined they were with the layout, culture and ambiance of their old city. New Orleans had been a chaotic, concentrated, interlinked city where you could visit your relatives or friends after a short walk or bus ride. It was a street-oriented city, with many gathering places and community spaces where partying and 'chilling' (hanging out) were the pillars of social life. We understood how difficult it was for the family to find their bearings when their loved ones were scattered to the four corners of a megalopolis where walking raised eyebrows, taking the bus was a complicated affair and even visiting people by car was a real journey. This was a big city, where, other than churches and shopping malls, there were few community gathering-places. It was also difficult to develop new relationships when the neighbours headed straight from their cars to their air-conditioned homes.

Now that the issue of shelter had been settled for the time being, the identity question surfaced. Evangela, however, clung to the idea that God had wanted her to make a fresh start. She even publicly asked the pastor to rebaptize each member of her family *"to wash off the stain of the angry waters."* But I couldn't help thinking that it was simply the thorny problem of mourning that was behind this dramatic gesture –mourning a city, a former life, a part of yourself – and that the family's future would depend on its ability to face this problem.

It was in this climate of uncertainty that we had left Evangela and her family when we returned to France.

5. Misunderstanding
Persistence paid off. By reviewing our notes and examining a map of Houston, we ended up finding the Baileys. They were living in a public housing complex located at the other end of the city. With its two-storey buildings and lawns packed hard by basketball games and barbecues, the place seemed better suited to the family's lifestyle – it was friendlier and less sterile.

We were warmly greeted by the family. Robert, still jobless, came to get us at the

reception desk dressed in immaculate white tennis shoes. He seemed happy to see us and told us with a smile – a smile recently adorned with gold – that his wife had started working that day as a Hyatt hotel chambermaid. The children gave us a warm welcome when they came home from school and we later greeted a cheerful Evangela, heavier by at least 10 lbs. (about 5 kg). We learned that Evangela's Baptist ardour had cooled, that the family had travelled back to New Orleans and witnessed the death of their city and neighbourhood, and that the elections taking place in New Orleans no longer concerned them. Amen. We talked for a long time, like old friends meeting up again, and we said goodbye with the understanding that we would photograph Evangela at her hotel as soon as possible.

We're far from that goal at this time. The Baileys just stood us up a second time and we have the feeling when we call them that they don't want to see us again. Did we do something wrong? Are they hiding something from us? Without finding any convincing answers to our questions, we told ourselves that, carried away by our satisfaction with the way things were going, we may have imposed ourselves and our plans too abruptly on a family that was, after all, under enormous stress. So we decided to let a little time pass before calling them back and to take advantage of this interlude to return to New Orleans.

6. Music Street

We have now spent two days in the city that, before Katrina, Americans called the *"Big Easy"* – the city where everything comes easy. Tourists and affluent residents are content: the city's major attraction, the French Quarter, and the business district are humming again. The contrast with the poorest areas, located nearby, is striking. According to Cedric, who visited the city shortly after the hurricane, nothing has changed except for the fact that the water has been pumped out. All you see are lines of empty houses with crumbling walls and missing roofs. You do occasionally hear the crack of hammers, but the pathetic sound they make in the vast silence of the streets only serves to underscore the enormous financial, technical and human resources that will be necessary to bring the city back.

And how should it be rebuilt? Many people in the black community suspect that the city council wants to reconstruct the city with luxury projects to prevent the most disadvantaged populations from returning to the neighbourhoods bordering the French Quarter.

When I ran this idea past historian Douglas Brinkley, author of The Great Deluge, a lengthy book on Katrina in which he criticizes the negligence of Ray Nagin, the mayor currently running for re-election, he immediately warmed to the subject. In his opinion, it was less a matter of what to build than a problem of time. *"It will take at least a decade to rebuild the neighbourhoods lying below sea level,"* he said. *"By then, people will have settled in the major cities that took them in, including Houston, Texas, and Baton Rouge and Lafayette, Louisiana, where the largest trailer camps for refugees are located. New Orleans will still exist, but it'll be a different city."*

It will be very different indeed, because with the final departure and scattering of a whole segment of the city's population and the destruction of an urban way of life unique in the United States, a singular culture is disappearing, a culture whose major traits were celebration and music: music for celebrating and celebrating through music. The wax-museum image of blues presented by travel agencies was only one part of the story. The city also served as an incubator for creative ideas where many artists came to draw their inspiration.

I was thinking about all of this as we parked on Music Street, the little road where Errol Donahue, 32, lived with his wife, Lisa, and their newborn son, Ethan. (Errol had given us his address with such delight!) This former DJ and composer, who recently became a truck driver in Houston, had explained just how important music was to the identity of the city where he grew up. I still get pleasure thinking of the intensity of his answer when I asked him how he would characterize the city's musical identity. *"The vibe, man, the vibe!"* he exclaimed. *"And also how easy it was to meet other musicians. You heard something you liked, you went to see the guy and you were all set!"*

I also remember the tone of helplessness that had crept into his slow, gentle voice when he told us how sad he felt for his son, who would not grow up, as he did, in this sometimes-violent but ever-vibrant cauldron. He would never experience 'second-line bands,' those brass ensembles that marched down neighbourhood streets performing on Sundays and during Mardi Gras celebrations, nor would he know *"streets that talk to you, this unique feeling."* His only consolation was his collection of CDs, cassettes and vinyl records – rare jazz and blue recordings inherited from his uncle and grandfather – that he had managed to save from the hurricane. *"At least I can hand that down to him,"* he said.

It's nice outside, and we're standing in front of Errol's old house. It seems to be in good shape, but a neighbour tells us the roof is damaged, and no one has shown interest in renting it. We've seen enough, so we leave. Cedric plays a Johnny Cash CD, but it doesn't seem appropriate. We'll put it back on in Texas. Until then, Mystical, Robert's favourite rap artist, and little bit of bounce – New Orleans' irrepressible dance music – will be just the thing.

7. Did you say global warming?

"WELCOME TO TEXAS: Proud Home Of President George W. Bush." It's impossible to miss the imposing green road sign on Interstate 10. We slow down and stop close to the sign because Cedric wants to take a picture of it. We wonder what the victims of Hurricane Katrina must have thought when they saw it last September. Were they reassured? Did they make the connection with global warming? Or with the Kyoto protocol?

Not very likely. Among all the refugees we interviewed, Errol was the only one who brought it up on his own. He took the TV documentaries he had seen very seriously and believed that the predicted increase in hurricane strength was a good reason to leave a city as vulnerable as New Orleans.

That's not surprising: in Texas, a Republican stronghold and oil-producing state, the issue of global warming is largely ignored by the political class. I still remember the burst of laughter from Houston-area judge Robert Eckles, who gained fame when he opened the Astrodome to accommodate victims of Katrina, when I asked him if he thought the hurricane would influence his thinking on the greenhouse effect. *"I haven't seen anything yet that would make me change my mind,"* he said. *"Hurricane trends have nothing to do with global warming. It's a natural cycle that's not related to carbon dioxide emissions."*

Interviewed before we left for New Orleans, Bill White, the Democratic mayor of Houston, expressed a similar opinion, though with perhaps a bit more flexibility, but he grew more expansive when describing the hurricane's impact on his city: *"Our population grew by 3% in just a few weeks. To handle the situation, we provided 34,000 housing units and accepted 22,000 students into our school system. Our social services and police force have really been put to the test and now we have to tackle job training, because, sad to say, the quality of the Louisiana school system was very poor, and under-qualified people are not finding*

jobs here. All of this has cost us hundreds of millions of dollars. It's an enormous effort, and we would like the federal government to do its part. We're fighting for that."

While listening to him speak, I was wondering what would have happened if Houston hadn't been located close to New Orleans, or if Houston hadn't reacted in such an efficient manner, striving to take in the wave of refugees as quickly as possible and to transform them into regular, decently housed, socially integrated 'migrants' (in the words of Eckles). I was also thinking that Houston, like all low-lying coastal cities bordering the Gulf of Mexico, would be increasingly exposed to a dangerous combination of rising sea levels and the growing intensity of hurricanes.

8. An enlightening failure

Back in Houston, we make our first telephone call to the Bailey family and are given the brush-off – still no explanations, but we're not surprised. While driving on long, straight, monotonous Interstate 10, we had time to examine all our theories about the cause of this unfortunate development, and one of them finally stood out.

On the day of our reunion, Evangela had showed us her computer, telling us that the Internet had enabled her to get back in touch with family and friends scattered all over the United States. Carried away by our own enthusiasm, we had given them the Argos collective's website address, which described our work on climate refugees, accompanied by pictures of our first reporting trip to Houston. At the end of that trip, I had however taken the precaution of writing in my notebook: *"If we return, be careful about explaining our articles to the Baileys."*

We discovered that the concept of 'refugee' posed a problem. While the media had spontaneously used the term to describe a critical humanitarian situation, voices had quickly been raised in the black community rejecting this word. The major reason was that refugees are people forced to leave their country, which was not the case with Louisiana citizens who went to another state, as different as it might be. The reaction was so strong that journalists, politicians and even the major parties involved began to use less offensive terms like *"Katrina survivors," "New Orleans evacuees"* and *"displaced persons."*

But Evangela rejected even these terms. She told us how hurt she was when the pastor at her church used the term *"displaced family"* when introducing them to the congregation. *"I wasn't displaced,"* she said. *"I was PLACED here by Christ. And I don't consider myself an evacuee, either. An evacuation by definition only lasts a short time, and I'll be here for a long time."*

In fact, it seemed clear to us that the black community's rejection of the term 'refugee' stemmed more from the still-open wound of segregation and the community's categorical refusal to be considered second-rate citizens than from concerns about the relevance of the word itself. In Evangela's mind, therefore, it would be inconceivable for us to use it, and the climate-change nuance we attached to the term in no way mitigated the sense of betrayal she must have felt when she visited our site. It's too late now for precautions and explanations, but I regret not having had the opportunity to tell the Baileys why we had continued to use a term that they found so offensive. I also regret not having been able to explain that this was our way of challenging the restrictive definition adopted by the Geneva Convention of 1951. Too many political leaders hide behind this convention to deny the impact of global warming on human beings and to avoid developing the international systems that will be essential for managing the large displaced populations of the future – including in the United States, where 23 million people live in hurricane-vulnerable areas.

9. Epilogue

I'm writing these lines a year after our second trip. The news coming out of New Orleans is not encouraging. Mayor Nagin was re-elected in an atmosphere of general apathy, but reconstruction of the low-lying neighbourhoods is at a standstill despite a mild hurricane season in 2006. Crime is resurgent, and New Orleans is now the deadliest city in the United States. In Houston, where, as predicted, over 100,000 people seem to have found a permanent home, the mayor welcomed the federal government's decision to extend its financing of rental units until 2009 with great relief. If these subsidies had ended, thousands of jobless residents might have ended up on the street.

There's no need to wait for scientific support. In its February 2007 summary, the second working group of the Intergovernmental Panel on Climate Change

(IPCC) states: *"It is likely that future tropical cyclones...will become more intense, with larger peak wind speeds and heavier precipitation associated with ongoing increases in tropical sea surface temperatures."* The summary also notes that, *"There is less confidence in projections of a global decrease in the number of tropical cyclones."*

Nor do we need backup from economists. As stated by Nicolas Stern in a report published in late 2006, *"A 5-10% increase in cyclone strength, together with a rise in ocean temperatures, could double the cost of annual damage in the United States."* Once again, therefore, communities along the Gulf of Mexico await the coming of the hurricane season with great trepidation.

∫

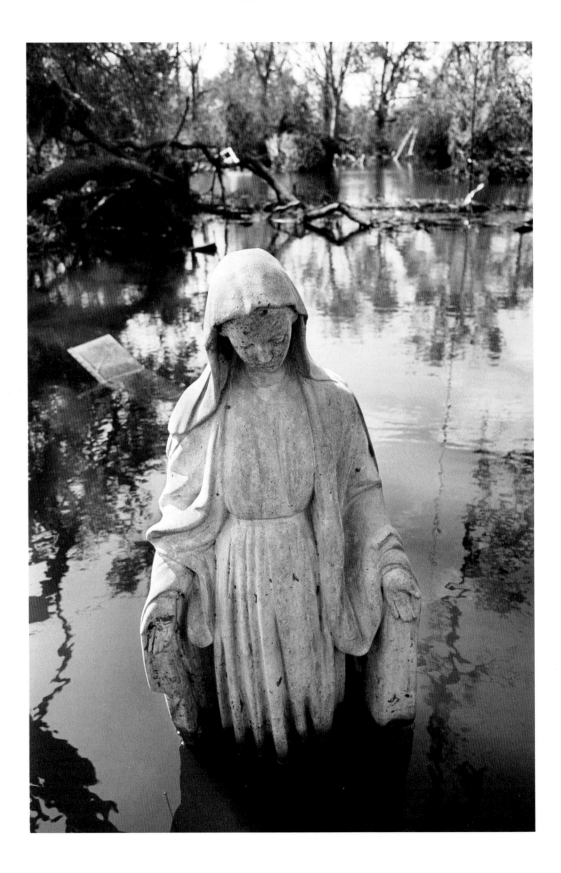

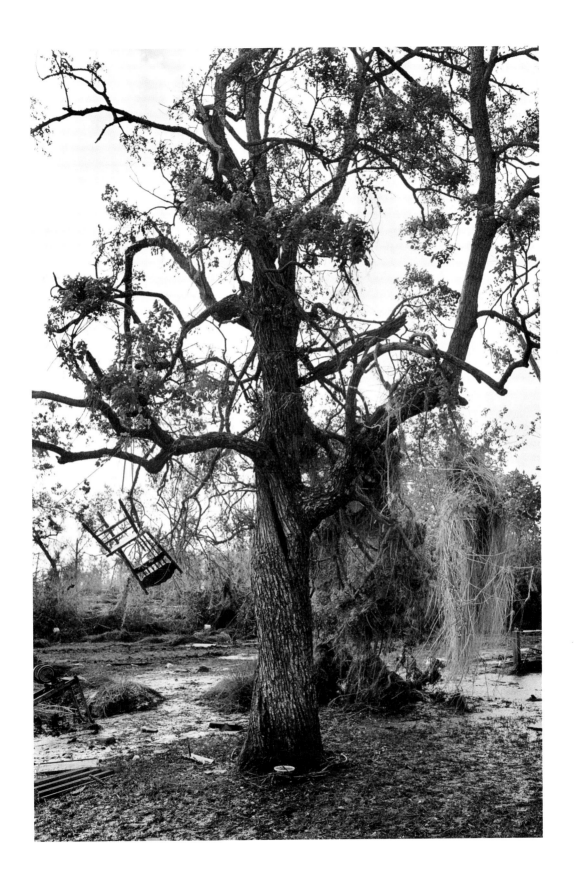

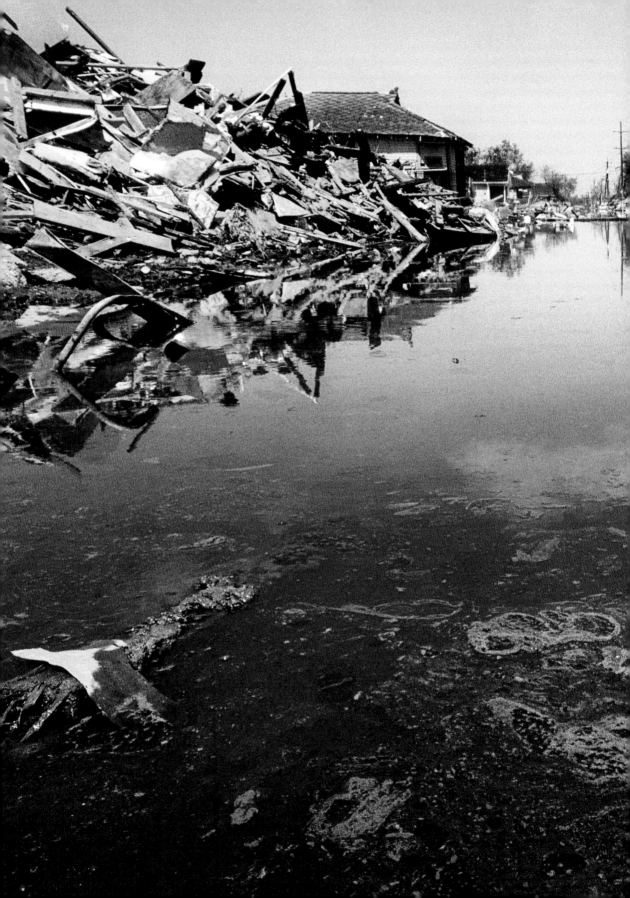

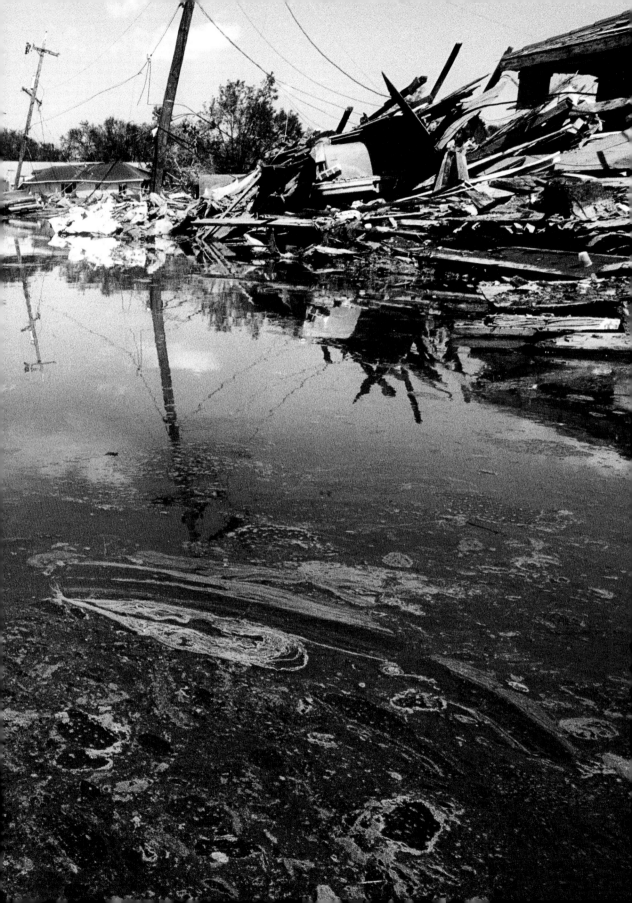

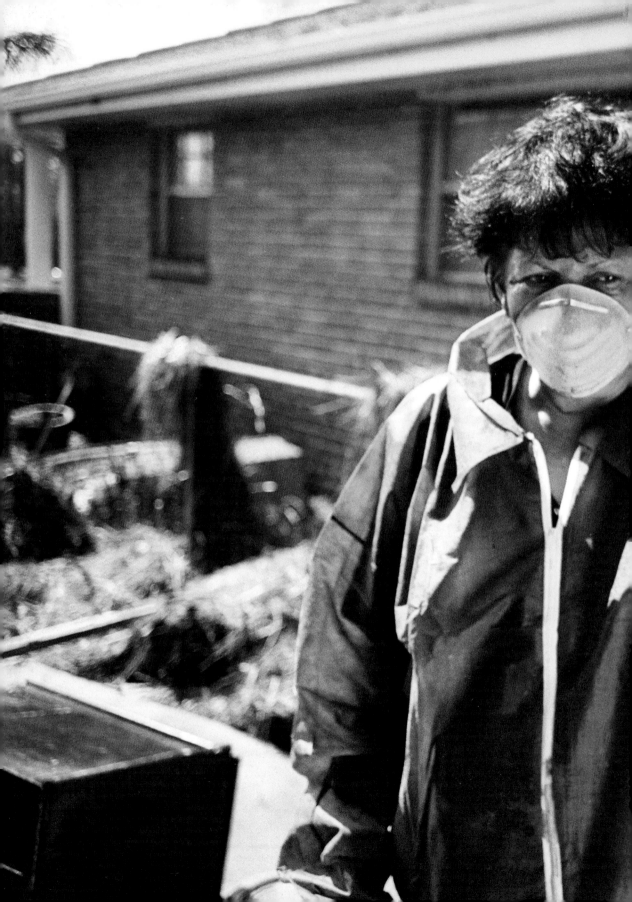

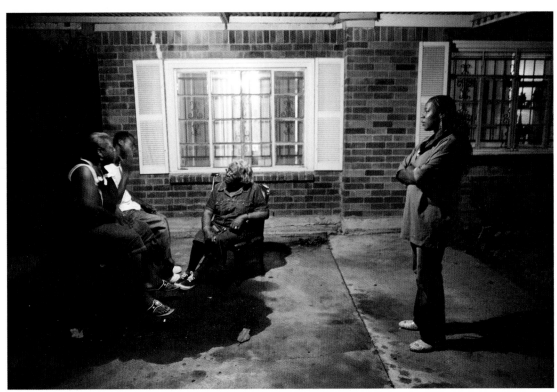

→ (Previous pages) May 2006.
New Orleans. Photos from
a family album found in the
rubble of a house.

→ October 2005. New Orleans.
Post-Katrina chaos.
An inhabitant exiled in
West Virginia returns
to her house fifteen days after
the hurricane to salvage
whatever she can.

→ October 2005. Houston.
Evangela Bailey settles down
in a house lent to her by
the Wheeler Avenue Baptist
Church.

→ May 2006. Houston.
Eric Willis has found a job as
head baggage porter in a
hotel. «I'm trying to see this
as an opportunity but I would
rather have remained in New
Orleans», he says.

→ October 2005. Houston.
With her neighbors, Evangela
Bailey tries to recreate the
atmosphere of her hometown.
Evangela Bailey has requested
a second baptism, for herself
and for each member of her
family. Evangela Bailey's
daughter, Lyschine (center),
has made new friends in the
neighborhood.

→ February 2008. New Orleans.
A volunteer sent by the
Oklahoma Church. Volunteer
workers from all over the
United States are still coming
to help rebuild the city.

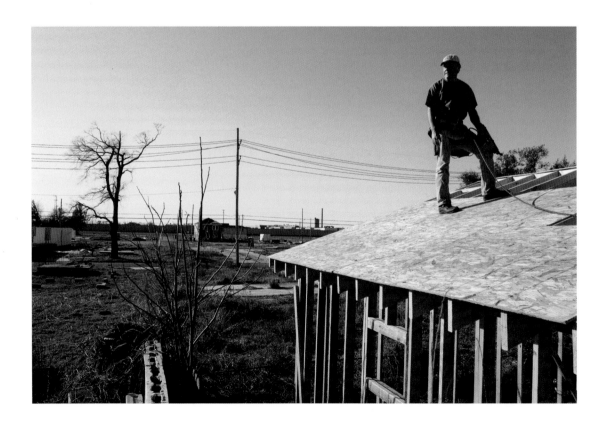

→ *February 2008. New Orleans.*
The few houses built with
the help of volunteers or
with the money of private
foundations only draw
attention to politicians'
failure to take responsibility.

→ *(Following pages)*
Robert Green's mother and
one of his grand-daughters
drowned during the flood
which followed Katrina. He,
however, decided to remain
there, living in a trailer lent
by the Federal State.

→ *Cora Charles, 69 years old,*
rebuilt her house with her
savings.

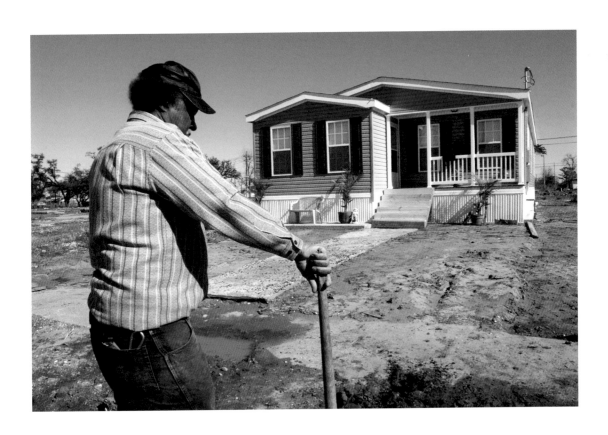

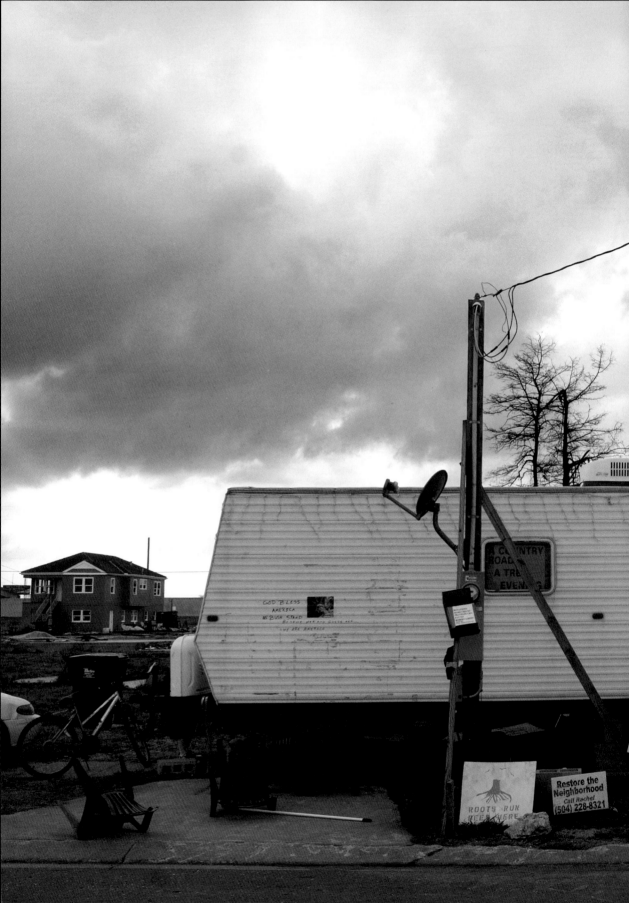

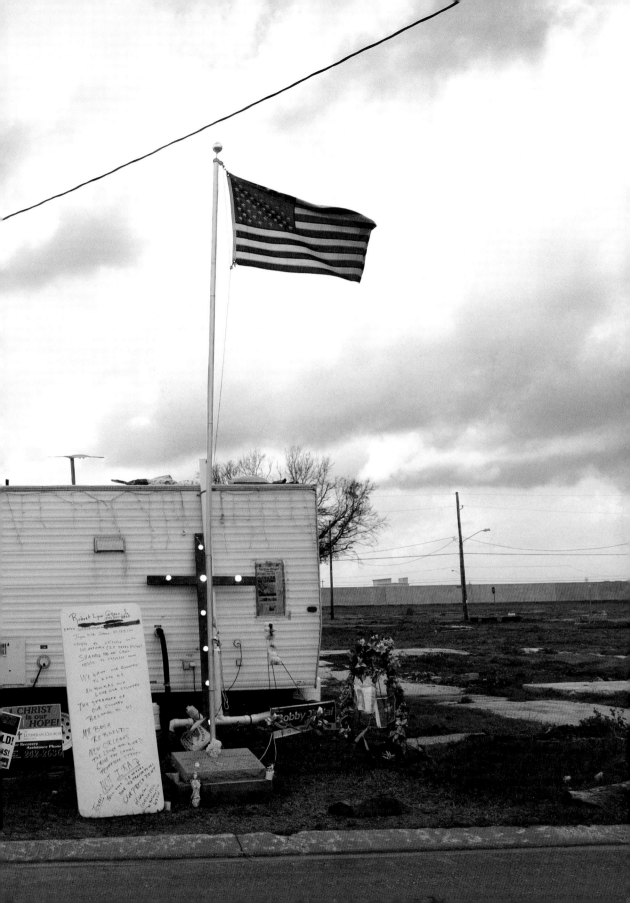

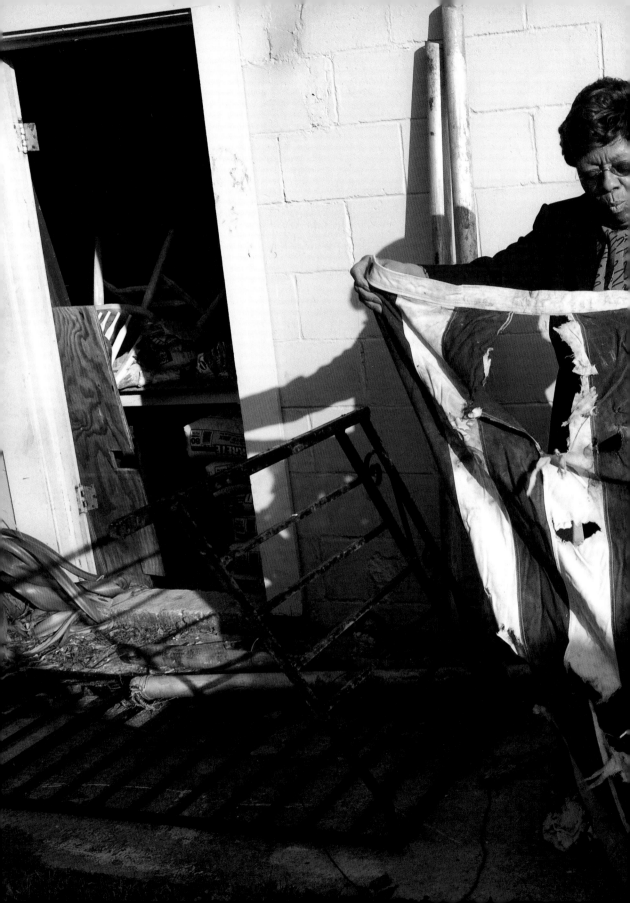

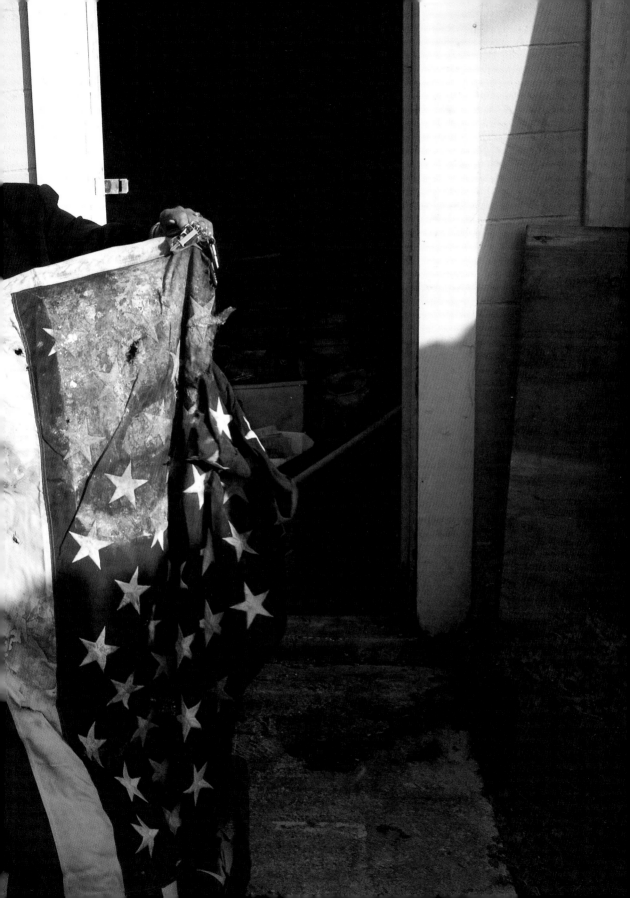

→ *(Preceding pages)*
February 2008. New Orleans.
Previous inhabitants
of Lower NinthWards, the
neighborhood most affected
by Katrina, take the
opportunity of the Mardi
Gras celebrations to return
to the premises.

→ *February 2008. New Orleans.*
How to bring back the
musicians whose
omnipresence was the soul
of the city? Musician Village,
funded by an NGO, is an
attempt to do so.

→ *February 2008. New Orleans.*
 Many former residents
 scattered all over the United
 States since Katrina return
 to celebrate Mardi Gras.
 During the short span of a
 carnival, they can pretend
 nothing ever happened.

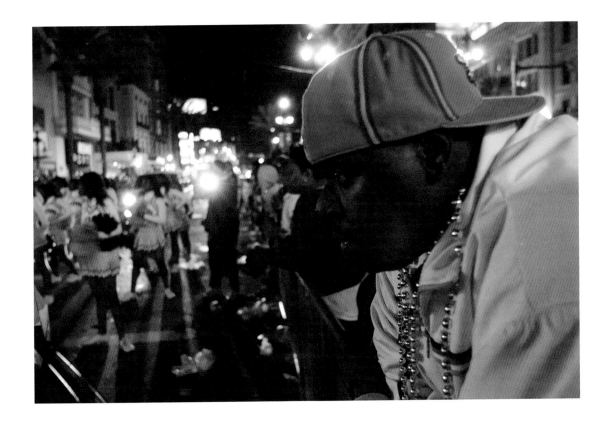

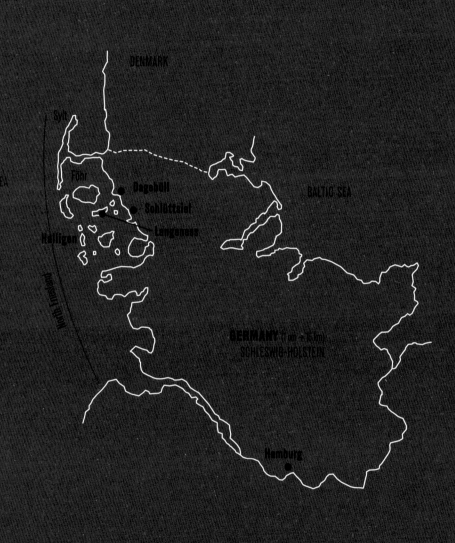

DENMARK

Sylt

NORTH SEA

Föhr

Dagebüll

Schlüttsiel

Langeness

Halligen

North Friesland

BALTIC SEA

GERMANY (1 cm = 15 km)
SCHLESWIG-HOLSTEIN

Hamburg

TEXT: GUY-PIERRE CHOMETTE
PHOTOGRAPHY: HÉLÈNE DAVID

GERMANY

Halligen, sentries on the North Sea

From Hamburg, the train rolls towards the north on the flat, white expanse of Schleswig-Holstein. Covered with snow, Germany's northernmost region is almost like a peninsula – embraced by the waters of the Baltic Sea to the east and the North Sea to the west. If we forgot to get off the train, it would take us all the way to Denmark, just 50 kilometres to the north, but we have to make a connection at Husum, a small North Sea port, to take a coach that crawls along the coast to the Schlüttsiel pier. The fields bristle with wind farms, and you would have to climb a windmill to see the sea as it is hidden behind the 8-metre-high dike that protects the land from the North Sea, which rushes inland during its infamous surges. Sheltered behind that imposing mound, the coastal residents have no view of the horizon. Only at the last minute does the coach cross the barrier and stop in front of a small ferry. The sea is ice-free and calm. The boat fearlessly sets off and heads towards Langeness; to avoid vast sand flats, it will have to make a complete detour around Langeness before docking. On the lower deck, the portholes in the passenger lounge hug the water line, depriving us of any height from which to view our surroundings. The horizon becomes more opaque at times, as if coloured over, and the North Frisian Islands seem to hover between sky and water.

It's hard to believe that in the Middle Ages this landscape did not even exist, and that the distance covered by the ferry – perhaps 20 kilometres – was travelled on

foot over dry land. That was before 17 January 1362, when the coast was torn to shreds and reduced to rubble by one of the greatest storms that Northern Europe has ever seen. The resulting tidal wave ravaged Friesland all the way from the Netherlands to Denmark. Around here, the disaster is known as 'the Great Drowning.' The few accounts from the period left no record of how many people died – 100,000? 200,000? – but when the sea receded, it carried off a wide swathe of land populated by farmers and paludiers (Atlantic coast salt-marsh workers). The dike was breached in too many places that day. Thus weakened, the area could no longer withstand the fury of other exceptionally powerful storm tides, such as those in 1412, 1471, 1532, 1570 and 1717. Each time, the raging sea swallowed more people and land.

You need only consult a map to understand the magnitude of these successive disasters. From the mouth of the Elbe River to northern Denmark, North Friesland looks as delicate as lace. Only islands like Sylt and Föhr still bear witness to the Great Drowning and the gradual erosion of the shoreline – as well as a few halligen (tidal flats without protective dikes), 10 to be exact, lying level with the flood tides a few cable-lengths away from the Schleswig-Holstein coast and populated by some 300 hard-core holdouts.

*

"Don't call the halligen 'islands' – it means you haven't understood a thing!" In the van he uses to pick us up at the landing stage, Fiede Nissen, the Langeness postman, starts off by spelling it all out for us. With a big smile, he warns us against using a term that halligen residents don't approve of. No, the halligen are not islands. The German word hallig (plural: halligen), which has no French or English equivalent, refers to the peat, sand and clay flats that were formed over the centuries thanks to the changeable currents that meander through North Friesland. Surrounded by water, these flats only rise a metre above the flood tide and are completely covered by the sea a dozen or so times each year. This phenomenon, unique to this area, is the pride of the halligen's inhabitants, who have learned to tame it so well that they are able to survive on their chimera-like – half-land, half-sea – alluvial plain. For centuries, they have adapted to the eternal whims of the elements, which, in minutes, can raise the sea high enough to carry it to the thresholds of their homes. These landuntern

(literally, 'submersions of the land') are largely unpredictable, says Fiede: *"A strong west wind, an especially high tide, a full moon – we're well aware of the precipitating factors, but all three can appear at the same time without anything happening. And a landuntern can occur in the middle of summer when we're least expecting it! Maybe that's the charm of the halligen."*

Perhaps, but not their only charm. The halligen's appeal also resides in the 8-metre-high mounds called warften, on which homes are perched to stay safely out of the landuntern's reach, giving the landscape its unique appearance. It is said that during a journey in these barbarian lands during the first century AD, well before storm tides scattered the Frisians, Rome's Pliny the Younger described this type of coastal home built on artificial mounds. The warften technique opened up the halligen to human habitation, wresting back lands stolen by violent seas. A question remains, one that Fiede, who climbs each of Langeness's 20 warften to reach his own at the far end of the hallig, cannot answer: How have residents been able to put so much distance between themselves in such a small place? Langeness is like a fragmented village whose 20 houses have been scattered throughout the hallig's 500 hectares (1,200 acres). One warft is home to the school, another the grocery store, and another the post office – little fortresses that are still attacked by the sea from time to time, as in 1962.

After showing us to the rooms he and his wife, Annelore, rent to tourists in the summer, Fiede takes a seat in his kitchen, where, in 1962, at the age of 13, he watched his father fight like the devil against the waves. *"It was a storm like we hadn't seen in decades,"* he recalls. *"The radio had issued a warning, so we spent the day reinforcing our doors and windows. The water swiftly submerged our warft and burst through the door. We tried to save some of our furniture, but we quickly lost our grip and had to go upstairs for safety. All night, we heard loud noises banging on the house and counted the cracks in the walls."* While no lives were lost, the 1962 storm seriously damaged most of the homes in the halligen. Why then, despite the danger, do people cling to these peat reefs with so many strikes against them? *"We're not really afraid,"* says Fiede, whose family roots on Langeness extend back into the mists of time. *"The danger is real but it's rare, and we've learned to live with it. I believe it's just part of our way of life. After the 1962 storm, some people did think about leaving to live on the mainland, but the government helped us raise the warften and rebuild our homes. We also added a safe room reinforced with four*

large cement pylons. During the last big storm, in 1976, which was even stronger than the one in 1962, we hardly had any damage."

Life on the halligen is nevertheless a constant challenge. The mounds, eaten away by the landuntern, must be regularly maintained. In 1996, large European Union (EU) and regional subsidies paid to raise the warften an additional metre and thus prepare them for rising sea levels, though this move will not help save the fragile coasts along the North Sea. In fact, like endlessly reinforced fortifications, the halligen are constantly under construction. *"We'd never be able to do it alone,"* notes Fiede. *"The federal government, the state [Schleswig-Holstein] and the EU are all helping us stay here because we're part of their plan for defending the mainland. During storms, the halligen act as natural dikes that break the waves and protect the coast. Without us, the large dike you saw in Schlüttsiel would give way in a few years' time. Protecting the halligen means protecting the mainland. I'll show you what I mean tomorrow."*

<div align="center">*</div>

　　It's 8:00 in the morning and, as usual, Fiede goes to pick up the post in Dagebüll on the mainland. He takes the Löre, a small railcar that runs along the top of an embankment, connecting Langeness to the mainland. In summer the Löre delights tourists, but in winter it's battered by polar winds, requiring Fiede to wear several layers of wool under his thick yellow oilskin. On Langeness, every family has its own rail truck, which is more or less comfortable. Fiede's truck is completely open to the elements, and the postman's beard is soon covered with frost. Chugging along at 8-10 kilometres an hour, he still has 40 minutes to go before reaching Dagebüll.

The Löre is only passable at low tide. Last night, the sea left chunks of ice on the tracks that the rail truck is now crushing as it passes. As we approach, white ducks fly off with a wide sweep of their wings. From Langeness to the mainland, we drive on an enormous foreshore of black sand speckled with miniature icebergs. Halligen residents call this foreshore a watt. Together with the landuntern, warften and Löre, the watt is one of the distinctive features of this world apart. Some people enjoy strolling along the watt for hours on end and walking to the mainland for the simple pleasure of feeling the open air lash this endless, ephemeral,

flat expanse, but on occasion Fiede uses the Löre when the tracks just barely peek above the tide. You will then see him riding on the sea in a train, floating on the water with his little truck loaded with yellow waterproof boxes from the German post office.

For the time being, Fiede slows down halfway between Langeness and the mainland. He wants to show us the work underway on the new embankment. Built next to the first one, it tops it by at least a metre. *"The current Löre dates from 1926,"* explains Fiede, driving at walking speed. *"It has serious weak spots, so rather than restoring it, we're building another, higher one. It's a question of planning ahead for rising sea levels."*

Rising sea levels: a phenomenon whose very mention can sap Fiede's confidence when he talks about the halligen's future, but he doesn't believe in it. In fact, his thinking runs along the following lines: if the experts believe that sea levels are rising, fine, but driving the halligen people off their alluvial plain is another matter altogether, because many of them, like Fiede, believe that as each landunter ebbs it leaves behind a thin layer of sediment on the surface of the tidal flats and, millimetre by millimetre, the sediment will imperceptibly grow in height. *"We'll have to raise the warften every 50 years,"* concedes Fiede, *"but the sea will not drive us away. That said, go talk to Ark Boysen, who has a different opinion."*

On the way back from Dagebüll, the Löre provides a breathtaking view of Langeness. You can see the hallig's shores, protected by a dike of dark rocks imported from the mainland. This dike completely hems in the shoreline, enclosing Langeness with a metre-high wall. With sledgehammers and crowbars in hand, Ark and his crew of six construction workers are somewhere along this dike, struggling with both rocks and the glacial wind that constantly blows in from the north. Like all his co-workers, Ark, 50, was born in Langeness and currently lives here. After studying on the mainland, he returned to live in his hometown, armed with a diploma as a hydraulic technician specializing in the maintenance of coastal structures. It was therefore natural that he be given responsibility for maintaining the Langeness shoreline and overseeing work to raise the dike.

In the small, well-heated caravan where the men take their break together, Ark explains what these fortifications have gradually come to mean for halligen inha-

bitants: *"For centuries, every large storm damaged the halligen a little bit more, dragging under and carrying away people and animals. It was only in the 19th century that our ancestors began to protect their lands with dikes – to avoid disasters, of course, but also to limit the slow erosion caused by the landuntern. The storms of 1962 and 1976 showed the limitations of these old defences, and it was at this point that the federal and state governments started paying guys like us to maintain the dikes and build new ones."*

Most of the halligen men now work half-time as local civil servants, and everyone benefits: the federal government, because it's providing the funds to protect the Schleswig-Holstein coastline, and halligen residents, because it enables them to stay and live comfortably in their little corner of the world. In summer, they work with wood, installing fences on the watt to hold back sediment, just like polders (reclaimed low-lying land protected by dikes), and in winter, they position millions of rocks one-by-one on the halligen's shores.

"We initially raised the Langeness dike to a metre in height," says Ark, warming his hands on his boiling-hot cup of tea. *"By 2015, it will be raised to 1.5 metres. After that, I'm not sure – maybe 2 metres. It all depends on the sea level; during the 20th century, it rose 15 centimetres, and the most pessimistic forecasts predict another 80 centimetres by 2100. If that happens, all our efforts to raise the dikes will have fallen short. During storms, the waves will be much more forceful and will carry away the halligen bit by bit."* Like Fiede, Ark thinks the halligen rise slightly during each landunter, but not enough to make up for the increase in sea level. In his opinion, the halligen's future is rather bleak. *"If the sea level really rises, people will no longer be able to survive here. A few stalwart souls clinging to their land might stay, but I doubt it. Deep down, I believe that no one will be left in 100 years."*

<center>*</center>

Hanke Johannsen has heard this argument many times before. He works with Ark's crew every morning and wonders how anyone can be as pessimistic as his boss. How is it possible to spend hours handling rocks in such cold weather while believing it may be pointless in the end?

Hanke doesn't deny that the halligen are vulnerable, at the mercy of a sea swol-

len by global warming. In his mind, however, this only represents one more epi-
sode in his people's long struggle against the sea's fury. Meanwhile, if we don't
mind the smell of cows and sheep, he invites us to sleep on his warft, where his
wife, Britta, also runs a bed and breakfast.

Together, Hanke and Britta work at the three major occupations of halligen resi-
dents: as civil servants, when Hanke fortifies the long stone parapet encircling
Langeness; as farmers, when he takes care of his 50 dairy cows and his sheep,
whose salt mutton is particularly prized throughout Germany; and as hoteliers,
when Britta manages their bed and breakfast and the small flats for let in their
old converted barn. By the time spring restores colour to halligen fields turned
yellow by the winter landuntern, most families, like the Johanssens, have the re-
sources they need to welcome the tourists who come to enjoy the natural beauty
and walk on the wide expanse of the watt at low tide.

Hanke, 34, took over the farm from his parents when they retired and built a
small house in a previously unoccupied area of their warft. With a perfectly ma-
nicured lawn, red brick walls and thatched roof, their home was built in traditio-
nal halligen style. The actual farm where Hanke and Britta live with their three
children, Niels, Lasse and Ose, has room for more contemporary features: in sec-
tions where the roof isn't of corrugated metal, it's completely covered with solar
panels.

It's been decided that tomorrow we'll accompany Niels to his school, which rests
on a warft some 500 metres away, to meet Jan Niemann, the Langeness teacher.

*

"Landunter! Landunter!" shouts Niels as he opens his shutters to a superb
post-flood landscape. The residents had felt it coming for several days. This
time, the sea swept through the halligen in the middle of the night, and Lange-
ness is now covered in 2 metres of water. Perched on their warften, the houses
are isolated from each other for several hours. From his window, Niels can see
his school, which will be inaccessible today. It's too dangerous to take a boat
from one warft to another due to the powerful currents. Needless to say, Niels

loves the landuntern, even though Jan will be faxing homework to him and the other five Langeness students.

"It's paradoxical, but we like the landuntern," says Britta, who originally hails from Dagebüll. *"The way they seem to suspend time without warning, the feeling of sweet solitude, the landscape suddenly changing dramatically right at your doorstep, with all of our houses isolated like little islands. That said, sometimes when the landuntern arrive unexpectedly, they carry away with them hay that was freshly cut earlier on a beautiful summer's day, or worse, they drown a few cows or sheep that we didn't have time to get to safety."*

Some 24 hours later, the water has receded. Hanke clears away the pile of seaweed and twigs, swept in by the waves, that blocks the road halfway up the warft. A few puddles remain, but the road is passable, so we go to visit Jan. On the way, I notice drenched clumps of grass and seaweed clinging to the barbed wire on the fences, clumps that will stay dangling there like bad omens, battered by the winds, until the next landunter. They serve to remind anyone who would sooner forget that the halligen are like frail skiffs on the surface of a tempestuous sea.

When Jan was offered the three-year teaching job on Langeness, he immediately accepted. He didn't want to pass up the adventure of leaving Hamburg for an isolated warft on a hallig. *"I'm 30, and this is one of my first jobs,"* he says. *"A class of six students in an environment so close to nature – how could I refuse? It's true, though, that there are some disadvantages that a city person like me has trouble getting used to. Everyone around here immediately knows everything you do and say, but the people who live here are not insular. About half of them, like me, come from the mainland, proof that the mysterious charm of this strange world exerts a strong pull. In addition, the people native to the halligen depend on that attraction to maintain a population that is gradually starting to decline."*

From his classroom window, Jan points in the distance to the last few fields shimmering with seawater that has yet to recede. The landunter is like an early metaphor for what could happen to the halligen if the water were to climb too quickly over the course of the century – not to mention that the sea, once it overran the hallig, would no longer retreat, and would begin to methodically chip away at the warften one by one. Will 21st-century global warming finish what the 14th-

century Great Drowning started? *"I don't know,"* answers Jan after some hesitation. *"The people here have told me, though, that while the warften have been maintained over the centuries, they've never really been raised. Yet they've felt the need in recent years – in 1965 and 1996 – to make them twice as high."* Might this reflect a vague fear?

Whatever the case, halligen residents have decided to lovingly defend the moorings that tie them to their little storm-tossed corner of the world. They know that the government is spending a great deal of money on their small community, and that the German countryside has few schools with only six students, but they underscore their role as sentries at the front line of Europe, and no one disputes their claim. *"Protecting the halligen means protecting the continent"* from the storms' ferocity, Fiede had said. *"Maybe,"* Ark had responded in his crew's caravan. *"But if the water continues rising, how long will the government be able to support us?"*

∫

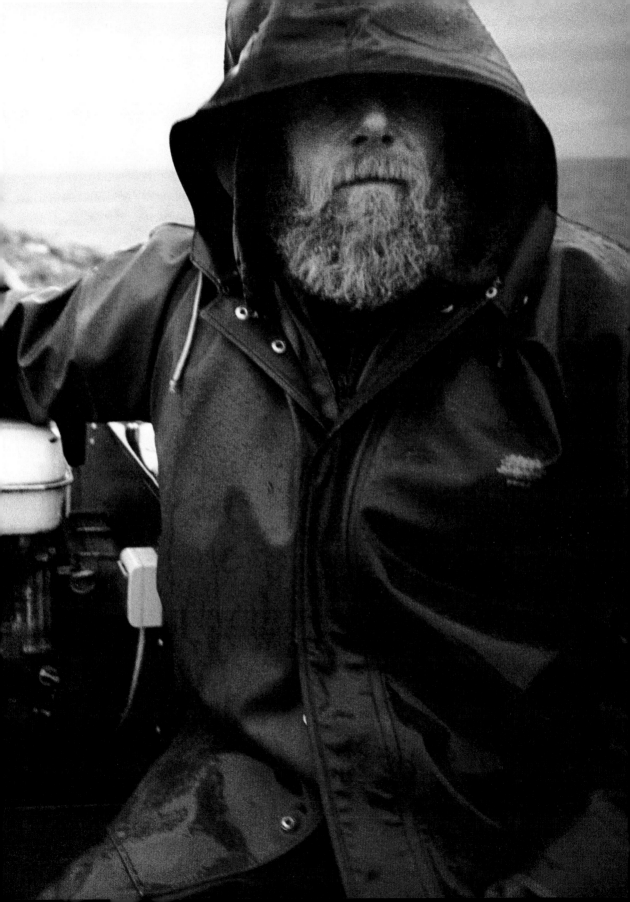

→ *(Previous pages) Since 1926, Langeness has been connected to the mainland by a small railcar called the Löre, which runs along the top of an embankment. Fiede Nissan takes the railcar every morning to pick up and deliver mail. Under reconstruction, the embankment will be raised to prepare for rising sea levels.*

→ *In summer, the Löre delights tourists; in winter, it's battered by polar winds. On Langeness, every family has its own rail truck, which is more or less comfortable. Fiede's truck is completely open to the elements. At 10 kilometres an hour, the trip takes 40 minutes.*

→ *In the middle of winter, the halligen are covered with ice and snow – much less, however, than 20 or 30 years ago, when you could still skate from one hallig to another.*

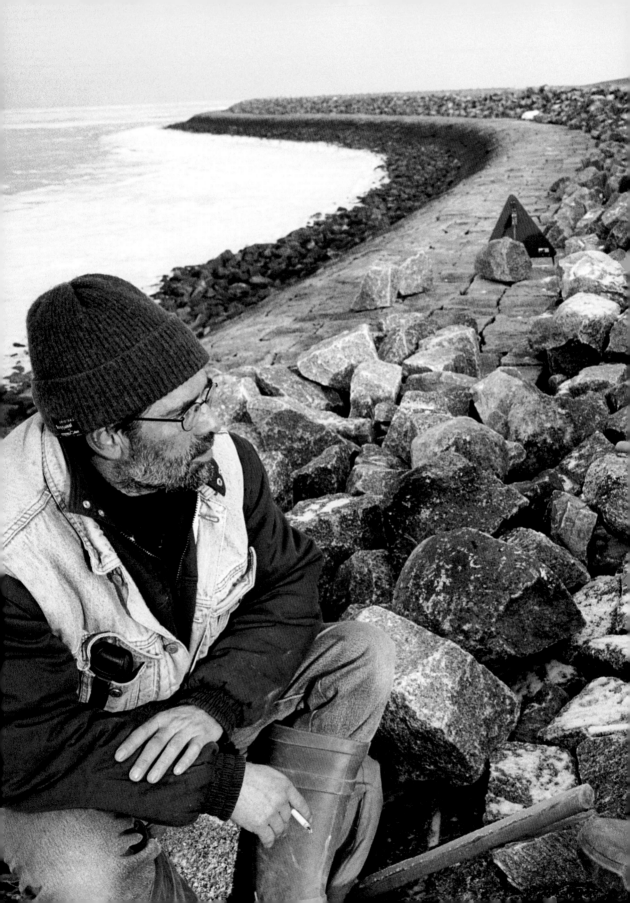

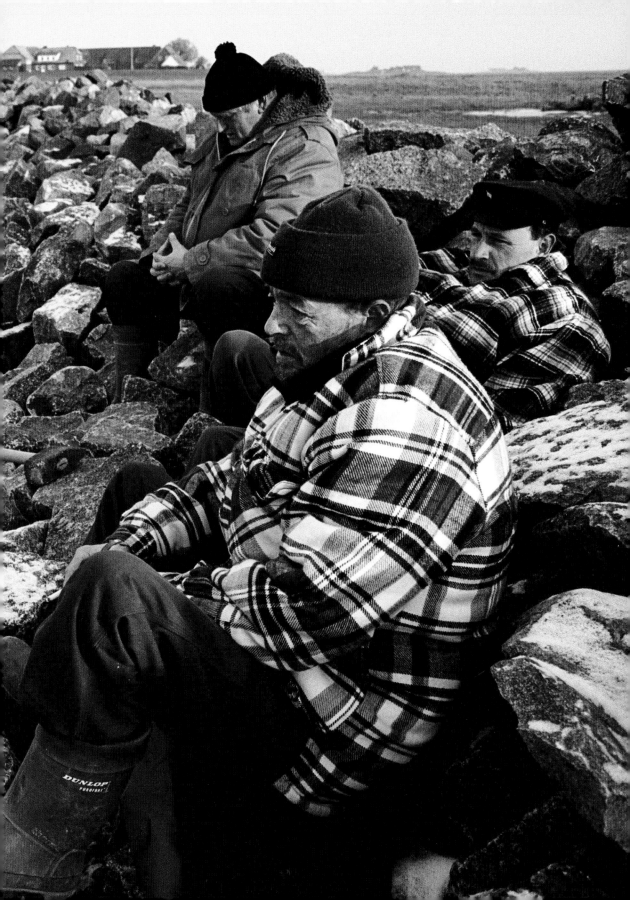

→ *(Previous pages) Ark Boysen and his crew of construction workers position millions of rocks, one by one, on the Langeness shoreline. The rocks completely hem Langeness in, enclosing it with a metre-high wall.*

→ *Neuwarf, on Langeness, is the mound where Fiede and Annelore Nissen live. Like all the warften in the halligen, the 8-metre-high mound protects the houses from the landuntern, sudden floods that cover the land for several hours.*

→ *A former teacher on the*
mainland, Theo Steinmann
has long had a passion for the
halligen, where he's spending
his retirement. Jan Niemann,
from Hamburg,
enthusiastically accepted the
teaching position at
Langeness school.
This one of his first jobs.

→ *"Don't call the halligen 'islands' – it means you haven't understood a thing!" The halligen are not islands, say their inhabitants. These flats of peat, sand and clay were formed over the centuries due to changeable currents that meander through North Friesland.*

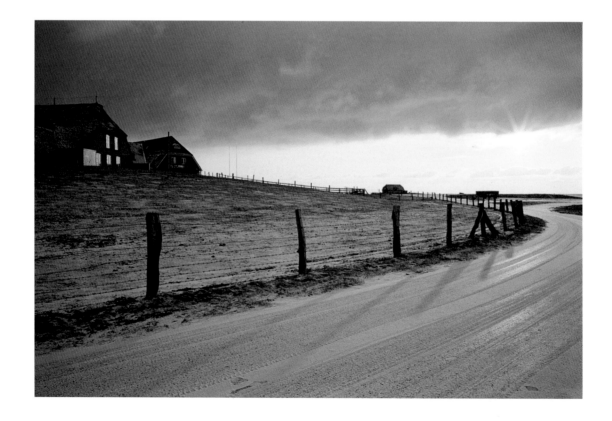

→ *After the Great Drowning of 17 January 1362, the warften technique developed as the mounds were created opened up the halligen to human habitation, wresting back land stolen by violent seas.*

→ *Hanke and Britta live with their three children, Niels, Lasse and Ose, on Honkenswarf. They are civil servants when Hanke fortifies the Langeness shoreline, farmers when he takes care of their farm and hoteliers when Britta manages their bed and breakfast.*

→ *After the 1962 storm, which caused major damage to the halligen, the houses were restored and reinforced. Safe rooms fortified with four cement pylons now serve as rescue shelters in case of disaster.*

→ *(Following pages) For centuries, halligen residents have adapted to the landuntern, which, in a few minutes' time, can cause the sea to swell and carry it to the thresholds of their homes.*

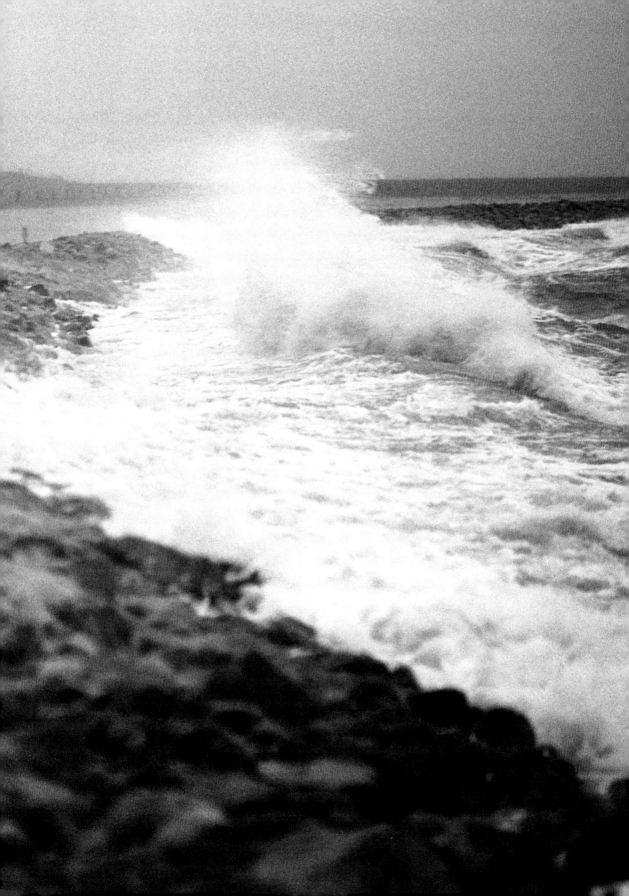

→ *(Previous pages) "Landunter! Landunter!" Children love these sudden, unpredictable floods that isolate the warften from each other for several hours. From his window, Niels can see his school, which is inaccessible today.*

→ *"A strong west wind, an especially high tide, a full moon – we're well aware of the precipitating factors for a landunter," says Fiede Nissen. "But all three can come about at the same time without anything happening, and a landunter can occur in the middle of summer when we're least expecting it!"*

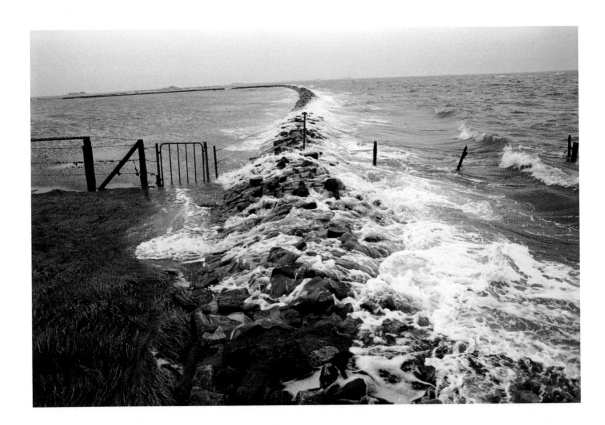

→ "It's paradoxical, but we like the landuntern," says Britta. "The way they seem to suspend time, the feeling of sweet solitude, the landscape suddenly changing dramatically right at your doorstep, with all of our houses isolated like little islands."

→ (Following pages) "Sometimes when the landuntern arrive unexpectedly, they carry away with them hay that was freshly cut earlier on a beautiful summer's day, or worse, they drown a few cows or sheep that we didn't have time to get to safety."

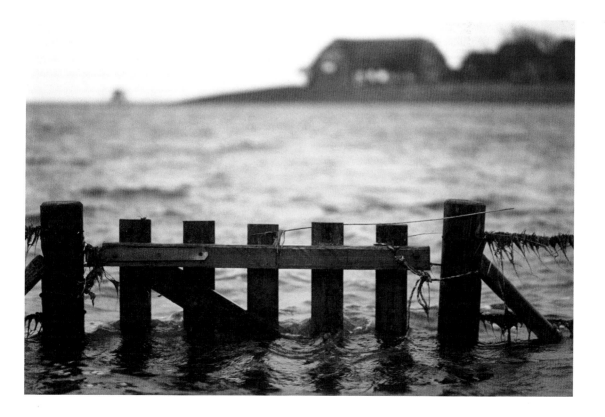

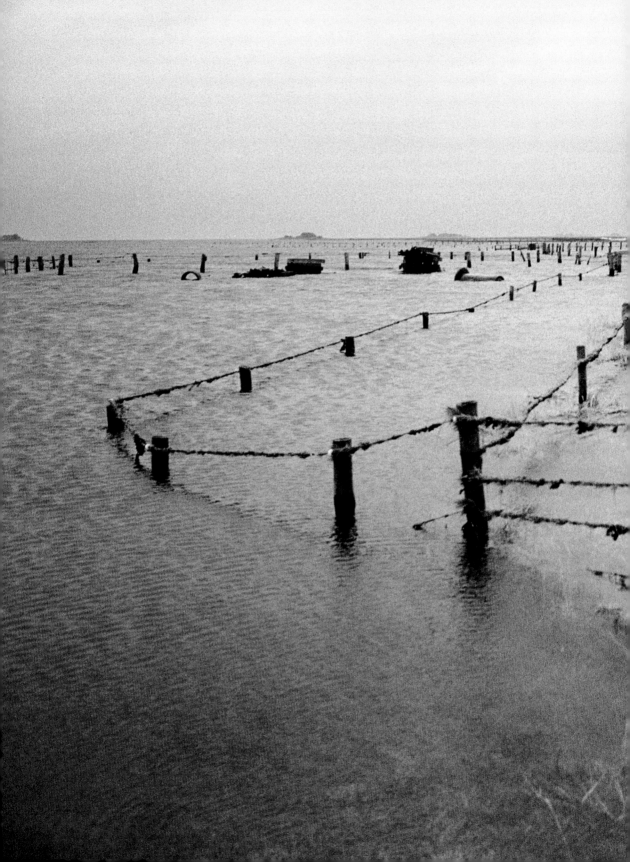

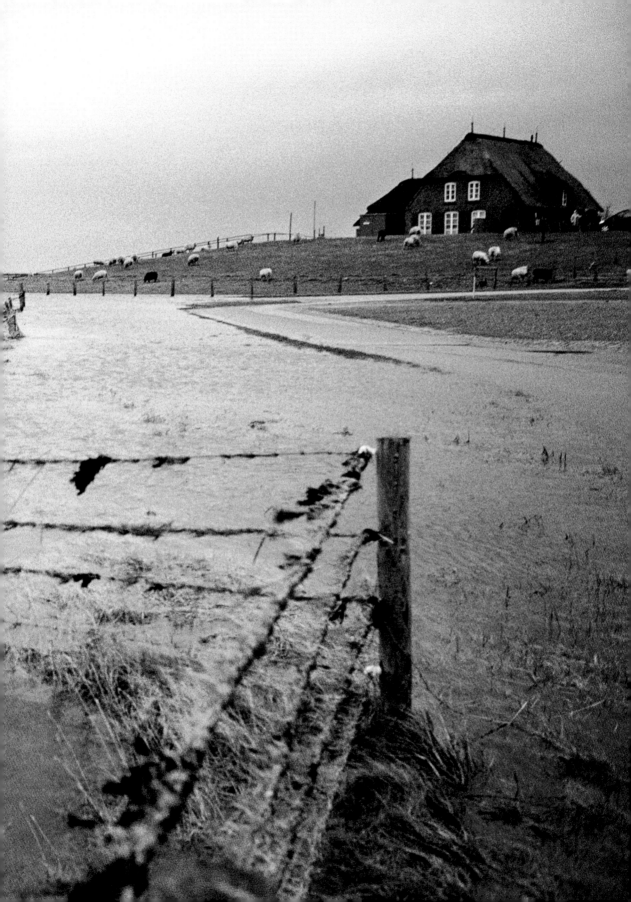

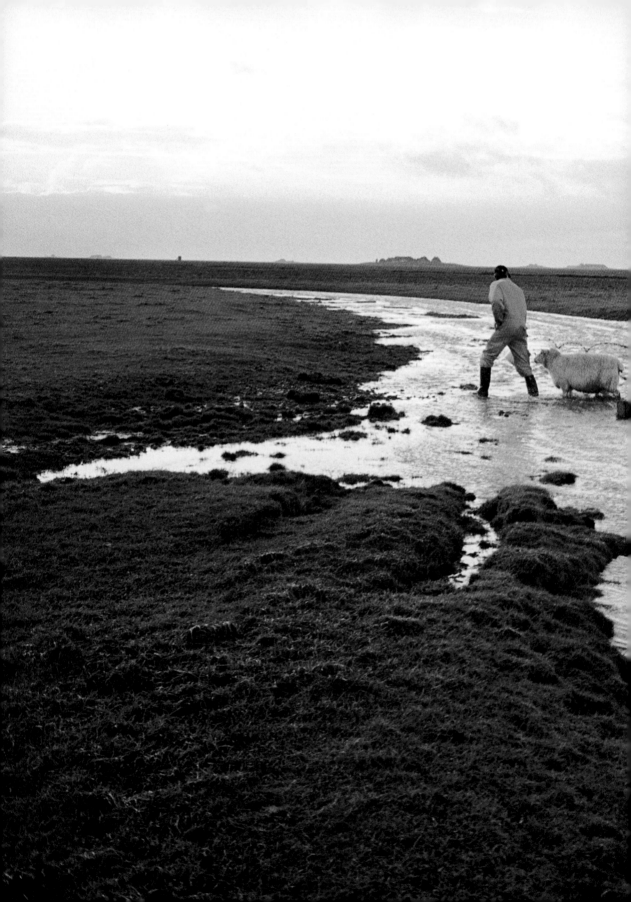

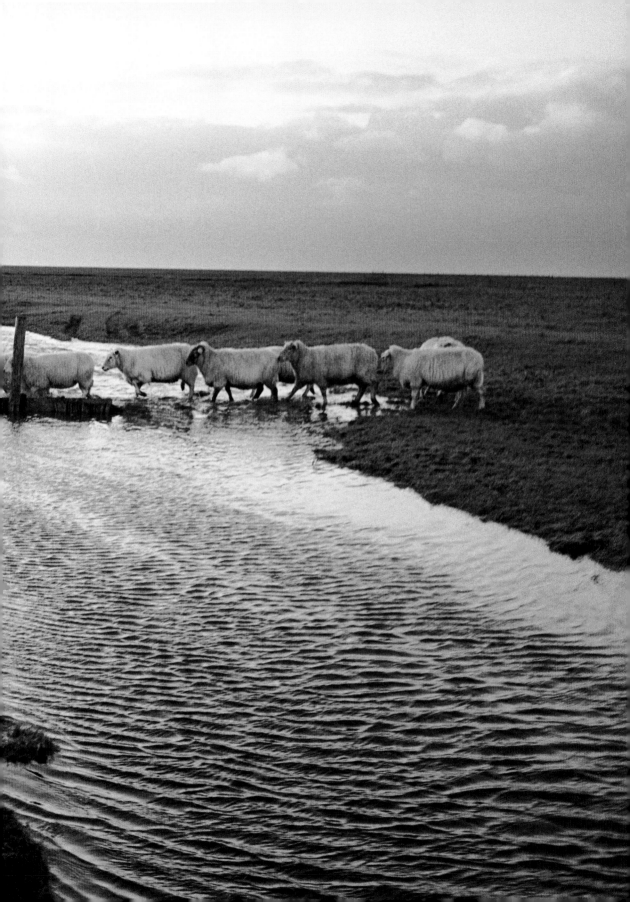

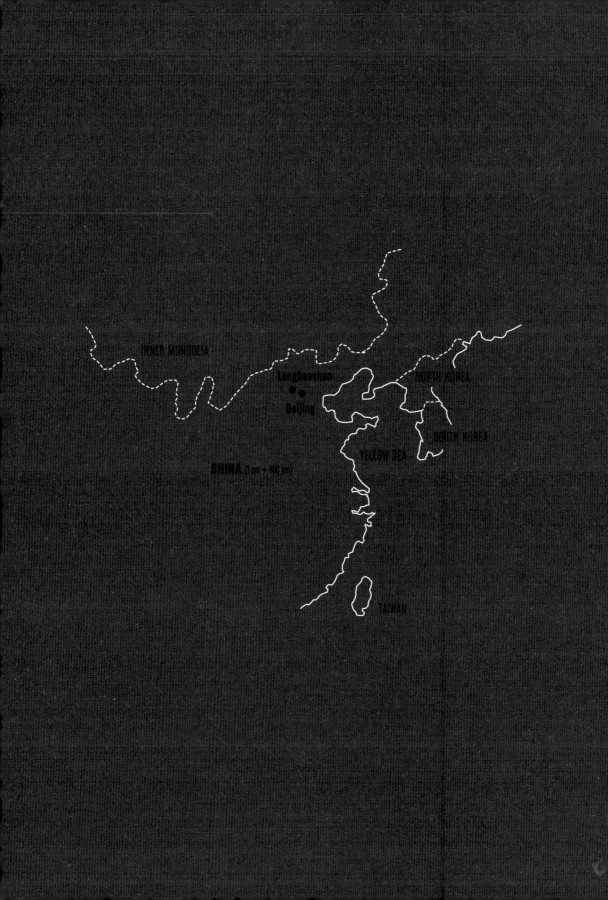

INNER MONGOLIA

Longbaoshan

Beijing

NORTH KOREA

SOUTH KOREA

YELLOW SEA

CHINA (1 cm → 400 km)

TAIWAN

TEXT: AUDE RAUX
PHOTOGRAPHY: ÉLÉONORE HENRY DE FRAHAN

CHINA
Longbaoshan, the wrath of the yellow dragon

Waves

She's here. Her spade and rake lie at her feet. She's here. She stands outside among her fields and orchards, despite the heavy clouds of dust. The springtime sky is ochre-coloured. The wind swerves, sweeps and twirls, snagging plastic bags on tree branches. After a moment, her eyes close. Her face, framed by close-cropped hair, becomes dull. She's no longer here. *"I was working in my field when the wind suddenly rose up. I heard a sound: rrruh, rrroo-uh. It came in waves – one, then another. I didn't have time to get to my house. I covered my face with my hands to protect myself, but grains of sand whipped my cheeks and stung my eyes. It got everywhere – in my mouth, between my teeth, in my ears and nose, inside me. I was coughing. I couldn't breathe. I was buried alive in the sand."*

Exile

Longbaoshan is located in Hebei Province, just 38 kilometres northwest of the Beijing suburbs. It's a village of sand, where high walls enclose the roads to keep them clear. Only 700 people now remain in the redbrick houses built around square, walled courtyards and arranged in perfectly aligned rows. Over the past few years, 200 people have already left Longbaoshan for the capital.

The sky

When Ze Zhen Wang, 57, returned to her fields the day after the big sandstorm, she found her corn, sunflower and pumpkin crops ruined. This small-scale vegetable farming is her only source of income. *"I spend my days hunched over, digging in soil that's every bit as poor as I am. I have pains all over. I was born poor and will die poor. That's just how it is… My fields are nothing but stones and sand, sand and stones. Where's the soil? Where's the rain? The sky is my only hope, the only way we're able to eat. After the big storm in the spring of 2000, my son had to leave. He became a cook at a restaurant in a Beijing suburb. We don't see him anymore. He's far away from us now, thanks to this sand."*

The dune

Across from the redbrick houses stands a large sand dune – a menacing mountain looming over a village with no umbrella.

Shelter

Grains of sand are whipped off the dune by the slightest spring breeze and make their way into Dehai Li's home. Sheer, plasticized cloth has been tacked up over the windows in lieu of glass panes to protect her family from the cold, wind and sand, albeit with limited success. *"There was sand in our bed when I woke up this morning. Our house faces the dune and receives the full force of the wind. I have to sweep the floors several times a day to remove it. As soon as a storm rises up, sand begins pouring down upon us. Sand is the reason we're so poor."*

Stay

Dehai Li crouches down in front of her stove and touches a match to a mass of dried corn stalks. The fire crackles. Flames rise higher, licking the bottom of a large wok in which she places millet paste rolled into balls. She has one child, Jian, a charming three-year-old with cheeks chapped by the icy March sandstorms. He steals a bit of the uncooked paste from his mother and chews it slowly. The door opens and his father comes in, taking off his long coat, his hat and scarf and the topmost of the two pairs of pants he was wearing, one over the other, keeping on the bottom pair, two sweaters and his holey canvas shoes. He rubs his face and hands with a dingy sponge, rinses them with cloudy water, and then sits down at a low table and noisily slurps down a bowl of boiled vegetables and a steaming mug of jasmine-scented tea. His dinner finished, Weifengying Li turns to his son, lifts him on his knee and tells us of his hopes for the boy. *"I want him to have a better life than mine. I want him to have money and to meet a beautiful*

young girl. I want him to be honest. And most of all, even if the soil is worthless for farming, I want him to stay close to us in Longbaoshan."

Rain

"Nothing grows here because of the drought. We depend on the sky, but it rains nothing but sand." – Dehai Li

Desert

China is one of the countries where desertification has had the greatest impact. One-quarter of its area is already affected, and the desert is expanding by over 2,500 square kilometres per year.

Glazed ducks

"It's hard, very hard, to stay and live here. Myself, I had to go to the city to do some odd jobs. I worked as a dishwasher at restaurants, then as a labourer at construction sites. I couldn't make ends meet just by cultivating these sandy fields." To be able to stay in Longbaoshan, Weifengying Li and his wife have recently begun raising ducks. An enclosure covered with coloured plastic tarp at the back of his courtyard provides shelter from the wind for 800 birds that will finish their days glazed in Beijing kitchens. When we mention the risk of bird flu, he gives us a big smile. *"There's no danger here – they said so on the news. But I've heard that Europe was hit hard by the epidemic."*

Slogans

Columns carved with slogans can be found in the stands of frail birch and pine trees surrounding the village of Longbaoshan. Bearing such phrases as *"Plant trees to fight the sand,"* they've been installed by the government in a bid to enlist the help of local populations in the effort to stem desert encroachment. At 7:00 every morning in the springtime, Weifengying Li sets off in his panel van to dig holes for young trees at reforestation sites in Badaling, at the foot of the Great Wall. For his efforts, the government pays him a daily rate of 30 yuan (3 euros).

Arid

We meet with Sun Baoping, a professor at the Beijing Forestry University and expert adviser to the Ministry of Water Resources. The large bay window in his office affords a view of a forest of construction cranes in motion. *"For the past 50 years, we've been witnessing an increase in temperatures and a decrease in precipi-*

tation," he tells us, making no attempt to disguise the truth. *"This is particularly noticeable in Hebei Province, which has been reclassified from semi-arid to arid. Western countries are most at fault for atmospheric pollution, the cause of climate warming, but China's now developing at an impressive pace and playing a larger role in environmental damage. It's therefore partly to blame for the drought. We've been encouraging people to convert prairies to farmland, since this is more profitable for the peasants – but only for the short term, since farm fields retain soil much less effectively than grassy areas. The same goes for deforestation: between the 1950s and 1980s, large treed areas were cleared to provide wood for fuel and construction. This is unfortunate, since trees are also very helpful in anchoring the soil."*

Yellow dragon

The wrath of the 'yellow dragon' – as sandstorms are known in China – is a very old phenomenon, but desertification increases the storms' frequency and severity. According to the Chinese Academy of Meteorological Sciences, in the 1950s there was a yearly average of five 'black winds' (a condition during a sandstorm when visibility is less than 200 metres and wind speeds exceed 20 metres per second), and this number has doubled since the early 2000s. In 1993, a black wind caused the deaths of 85 people and injured 284. In a black wind, we are told, visibility is sometimes so low that you can't even see your hand in front of you.

Pollution

Each year, some 90,000 tonnes of sand swept by the wind from the Gobi Desert arrives in clouds at Longbaoshan before moving through Beijing and on to Japan and Korea. For entire days during the months of March and April, the capital is buried under a thick, dusty fog and experiences dangerous peaks in pollution.

Erosion

"These sandstorms provide a rather extreme demonstration of the ravages of erosion in China. This is not only the fault of humans, but can also be attributed to global warming. Unfortunately, this phenomenon may worsen if atmospheric pollution causes diminished rainfall. And when sand dust is picked up by the wind, the falling particles destroy roots and grass, thus contributing to erosion."
Michel Ayrault, researcher at the CNRS

Old skin

A man wearing a jacket and an army-green cap is perched on a tree branch. With

one stroke of his pruning knife, he slices off a piece of bark, caresses the smooth exposed surface of the trunk and grins. *"I'm cleaning the tree's face. Its skin is too old."* It's the end of March: sap is flowing, buds are blooming, but there hasn't been enough rain and the tree's roots aren't able to grab onto the soil.

For good

"It used to rain more. My apple trees were more robust and yielded more fruit," Chsengzhen Chang tells us from the top of one of his trees. *"Now, to earn money, I spend the time between the cutting period and the fruit harvest in Beijing. Last year, I fixed lamps there. My 15-year-old son, still in middle school, had to leave – for good. We can no longer farm this land. It's become too dry."* He explains his view of things: *"The rich live in the city and the poor live in the country, where they're doomed to stay."*

Ruins

Surrounding the fields and orchards is a chain of arid mountains covered with large rocks. Bushes with spindly, peeling branches and a few withered leaves cling to some sandy areas. Along the ridge we can see earthen ruins of the Great Wall dating back to the Qin Dynasty (two hundred years before our time).

The old village

A few families have remained in old Longbaoshan, an isolated village of caves at the foot of a mountain. In 1988, the government moved the inhabitants of this village to a new location five kilometres away. The official reason for the move was to bring them closer to the road. Yet one wonders whether forcing the villagers to leave their home wasn't instead a way for the State to fight desertification.

The Great Wall

In China there are very few government initiatives that fail to make reference to the Great Wall, a symbol of strength. Even the 2008 Olympic Games are being presented as *"the most important thing since the Great Wall."* In the late 1970s, in an effort to stop the spread of the desert, the government launched a programme called 'The Great Green Wall.' The aim was to plant a barrier of trees and bushes between the outskirts of Beijing and Inner Mongolia. Professor Sun Baoping tells us that this programme hasn't proven very effective, however: *"The few hydraulic resources available in the area have been exhausted. Moreover, the initiative has caused a decline in living conditions for the peasants. Their fields have been requi-*

sitioned and they've been forced to plant species like birch and pines, which they cannot use." To complement this initiative, the government implemented a policy of building what Sun Baoping nicknames 'village cities' and urged entire populations to relocate alongside the roads. No consideration was given to the unsanitary hygienic conditions that would result or the total absence of a downtown area for organizing social activities. Nor did the government concern itself about the sand that rains down from the dune in Longbaoshan. *"But China is enormous,"* concluded the professor, *"and this village is tiny. The inhabitants have to sort things out for themselves. The central government can't oversee everything."*

Asphalt

After their move to the new location, the inhabitants of the new Longbaoshan found themselves living near a dusty path leading to an asphalt road, which in turn merges into a motorway serving Beijing. During the Cultural Revolution, city dwellers were forced to work in the fields, but now we're seeing a new revolution in the opposite direction, with peasants being urged to leave their farmland to go and earn money in the cities. Ever fond of slogans, the Party has even come up with a catchy phrase – *"Let's build roads to get rich"* – to encourage this policy. Paradoxically, the phrase seems to advocate the emergence of a consumerist society in the very heart of the communist dictatorship.

The call of Beijing

The literal meaning of 'Beijing' is 'Capital of the North,' but to all Chinese, Beijing is the centre of China. Every Chinese citizen views it as the reference point in all matters. All roads lead to this capital, which was once protected by the Great Wall but has now been made very accessible with the construction of no less than six ring roads.

Waltz

Panel vans congregate at the foot of the dune. Their drivers jump out wielding spades, load sand into the bellies of the vehicles and then take off again in the direction of Beijing. *"It's for constructing buildings for the 2008 Olympic Games,"* one of the villagers informs us.

Lao-Tzu

"Help that which comes by itself." For Chinese philosopher Lao-Tzu, to whom the Tao Te Ching is attributed (tao = way, te = virtue and ching = sacred book), life is a continuous transformation. This philosophy holds that victory isn't obtained

through violence, as Westerners believe, but rather over time, by letting things unfold at their own pace and following through on them. In building these roads, bridges, criss-crossing motorways and ring roads, the Chinese authorities are slowly but surely attracting peasants whose fields have become too sandy.

Absurd

At the time of the relocation of Longbaoshan, the 30-metre-high sand dune was 150 metres from the outermost houses of the new village. It has been creeping closer ever since, and is now less than 70 metres away. It will continue advancing at an average rate of eight to nine metres per year. In his cave, which, like all the other dwellings in the old village, has neither running water nor electricity, Facai Shi (whose name ironically means 'he who earns money') laughs at the absurdity of the situation. Along with his father and brother, he belongs to one of the 10 families that chose to stay. *"To work in their fields and orchards near the old village, the people who relocated are now forced to travel five kilometres each way. The ones with horses are fine, but the others? I don't see what advantage there was in leaving. As for me, I was born here and I'll stay here. And I'm less exposed here in the old village: when storms rise up, they're the ones who get showered with sand from the dune."*

Opera

Weifengying Li's 68-year-old mother munches on sunflower seeds while she mends an old pair of pants. She has a warm, comfortable seat on a kang, the traditional bed used in northern China. Made of bricks, as large as one-half the living room, the kang is heated from below by the oven in the adjoining room. A pair of laughing eyes sparkles in her wrinkled face. *"I think living here in the new village is better. We have water in the courtyard, and at night we can turn on the lights to play mah-jong. Still, I miss the New Year's festivities. The whole village used to attend. Now everyone stays home and watches opera on TV."* The door to her house is decorated with small 'New Year 2007' posters featuring the words 'Luck,' 'Prosperity' and 'Fortune' inscribed in gold letters on a red background. In her courtyard, two horses are eating feed purchased in the neighbouring village to supplement the inadequate corn harvest.

Blood

"One day, my brother went off to sell his blood. He was so poor; he could no longer count on his field and orchards for survival. But they took too much from him, and he never came back." Mrs Li

New life

"To help stop the spread of the desert, we're currently implementing a policy of returning some agricultural land to a prairie state. We're also developing a programme for optimum water resource management, and we've begun using a recent invention, the 'biological carpet,' which doesn't require irrigation. It involves spreading over the ground a covering that combines grass seeds and protective sheets. Finally, the government is implementing a policy of relocation to urban areas, which offers peasants a new life." – Wang Tao, director of the Arid Zone Research Institute at the Chinese Academy of Sciences

Tears

The 'new life' of these peasants is sometimes marked by tears. *"I called my little boy yesterday. He was sick and had a fever. He was crying, and I cried right along with him."* We're in the kitchen of a restaurant in Beijing, where Jian Bing Li is preparing vegetable-and-fresh-herb wonton for the noontime customers as she tells us about her son, who stayed behind in the village with his grandfather. *"I hate this city. There's too much pollution, too many cars, too much noise. But I hate Longbaoshan just as much. There's too much sand there now. Rain no longer falls from the sky. It's become impossible to make anything grow."* So, three years ago, the young mother came to Beijing to join her husband, a peasant from Longbaoshan like her who arrived in the capital in 2002 to renovate apartments. *"When our son came to see us during our vacation, we did all the touristy things. We visited Tiananmen Square and Mao's mausoleum. His dream is to take me for a boat ride on Ho Hai Lake!"* Jian Bing Li's 'new life' can be summed up in one word: work. She's in the restaurant kitchen every day from 9 am to 9:30 pm with a break from 2 to 4 pm, a vacation of two days per month and a 10-day vacation every year in the fall. At night, she and her husband retire to their nine-square-metre single room equipped with a bed, sink and storage units full of their suitcases. A photo of their son, yellowed with age, is taped to the door of their closet.

The sand game

Eight-year-old Dang Guo Qing Li has stayed behind in the village with his grandfather. He watches television in a cloud of smoke from the cigarettes the old man rolls, one after the other. The boy is terrified. The grandfather explains that his grandson has never seen 'all-white' people so close up, much less spoken to anyone 'like that.' The boy stares intently at the television as if he wishes it would swallow him up so he could escape the two intruders. A miniature Buddha – a souvenir from his vacation in Beijing – hangs around his neck from a red string.

An avalanche of ads filmed in the style of home shopping programmes unfurls during a break in a soap opera featuring actors dressed in period clothing. The grandfather rants about an assortment of evils ranging from the Japanese who invaded China and the high price of tobacco to the new face of Beijing. *"The last time I was there, I kept getting lost. From one week to the next, I no longer recognized anything on a street or even in an entire neighbourhood."* The shouting and laughter of children drifts in from outside the house, and the boy takes advantage of this opportunity to make his getaway. He grabs a cap with a People's Liberation Army pin on it and runs to join his friends in playing 'the sand game,' which involves staging noisy battles on the dune.

Schoolchildren

It's recess time at the village's single school. Some 70 children in blue uniforms from three classes meet in a courtyard surrounded by high walls. Girls play Chinese jump rope, raising sand dust in the process. Two boys trace designs on the sandy ground using a stick of wood. Another child begins crying, interrupting a game of blind man's bluff. *"I've got sand in my eyes! It hurts. I don't like this. I can't see!"* The bell rings and the children return to their classes. A set of 'schoolchildren's rules' is posted on the walls. The rules include such guidance as, *"You must love your native country," "You must love its people," "You must love the Communist Party"* and *"You must get to school on time."*

Illusions

A few hours' drive from Longbaoshan is the model village of Xiaoba. A decade ago, its inhabitants tell us, it was surrounded by tall grasses and a river full of fish. *"We depend on the sky to help us, but it rains less and less often,"* one of them says. A herd of bony cattle makes its way slowly to the centre of a large expanse of sand in search of green shoots. A pole on the village's concrete plaza testifies to a visit from the Prime Minister in 2000. *"Prior to his arrival, we received money to remove the sand that had been invading the village, even burying the roofs of some houses. We covered the dirt paths with concrete. In his speech, he asked us to plant trees and bushes in exchange for compensation, so we obeyed. The problem is that these species bear no fruit; they serve only to anchor the sand. It's good for the government, but for us? As for the compensation, we still haven't received anything. Ever since the Prime Minister's visit, delegations of foreign officials have been coming to our village, which is presented as an example of what the government is doing to stop the spread of the desert. These people are always accompanied by Chinese officials for fear that we'll speak up about our true living conditions. To create*

the illusion that all is well, the government has gone so far as to install telephone lines all along the length of the village – but none of us has a telephone! If nothing changes, we're going to have to leave." Endlessly, indefatigably, the sand-laden winds are sweeping these peasants far from their fields and roots.

∫

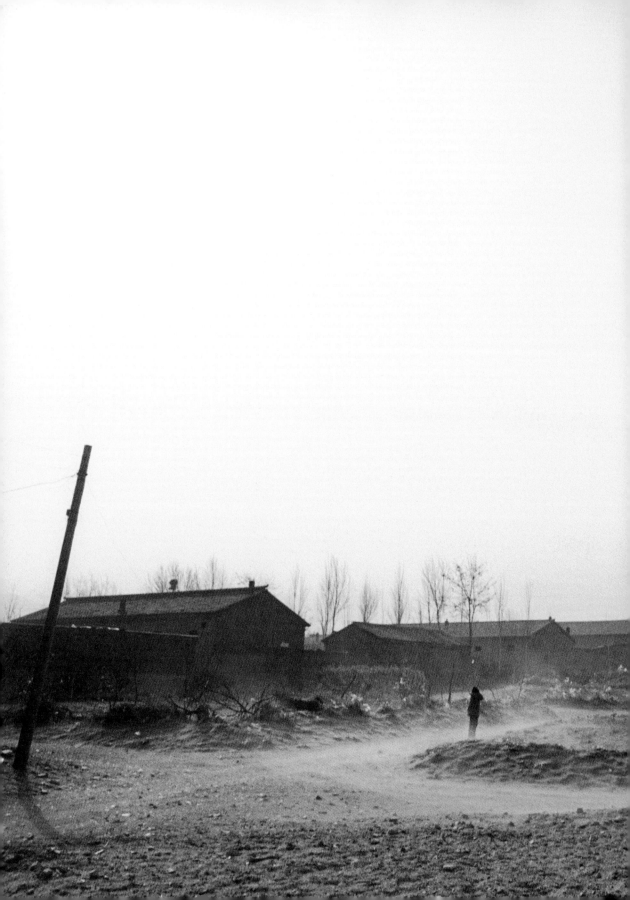

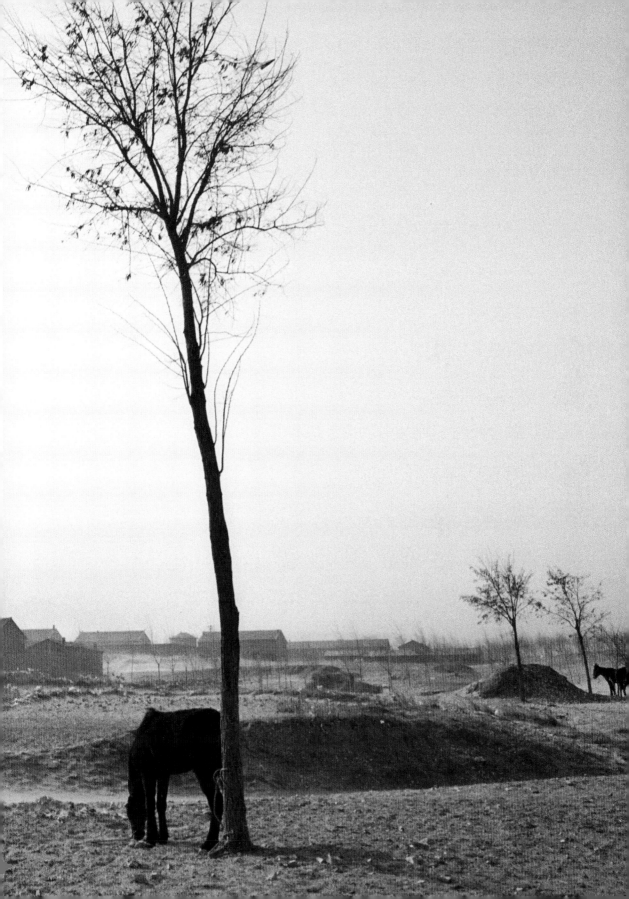

→ (Preceding pages) Located 75 kilometres northwest of Beijing in Hebei Province, the village of Longbaoshan is afflicted by winds that sweep its men and women towards the capital.

→ To fight the spread of the desert, the government has launched a programme called "The Great Green Wall." The aim is to plant vast expanses of trees and bushes between the outskirts of Beijing and the border of Inner Mongolia.

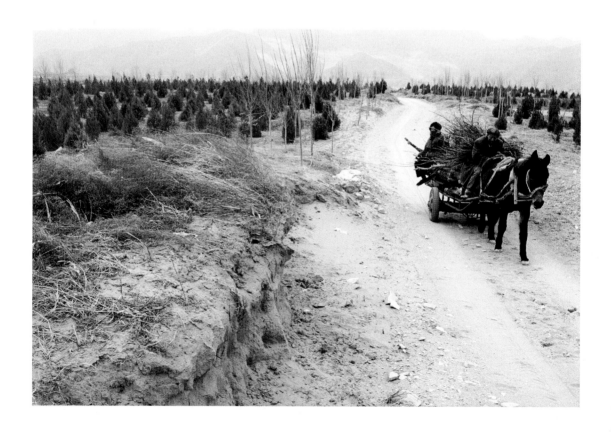

→ *(Following pages) In order to stay in the village, Weifengying Li and his wife have begun raising ducks.*

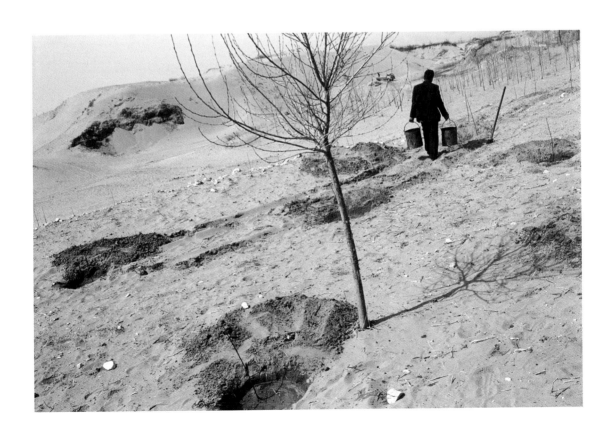

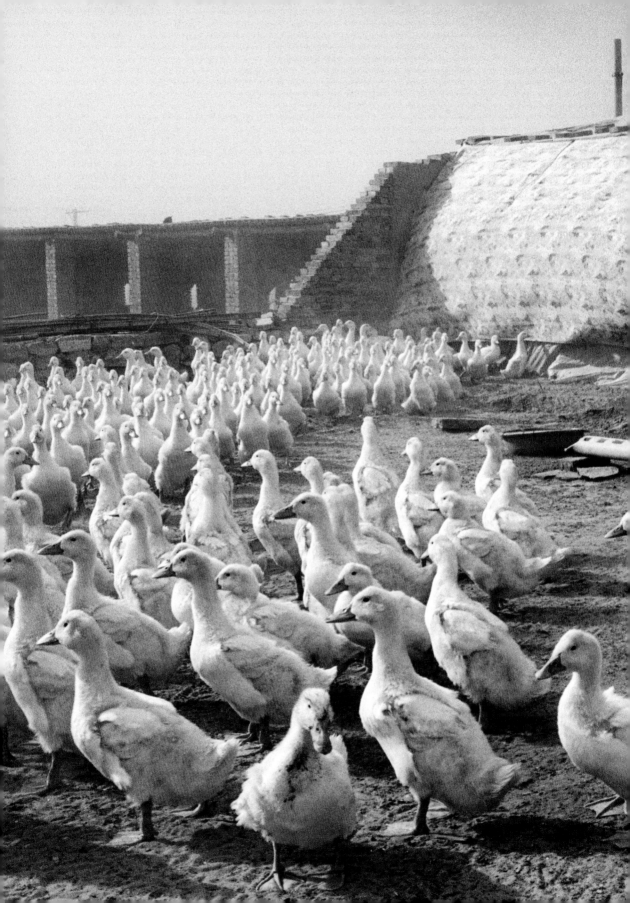

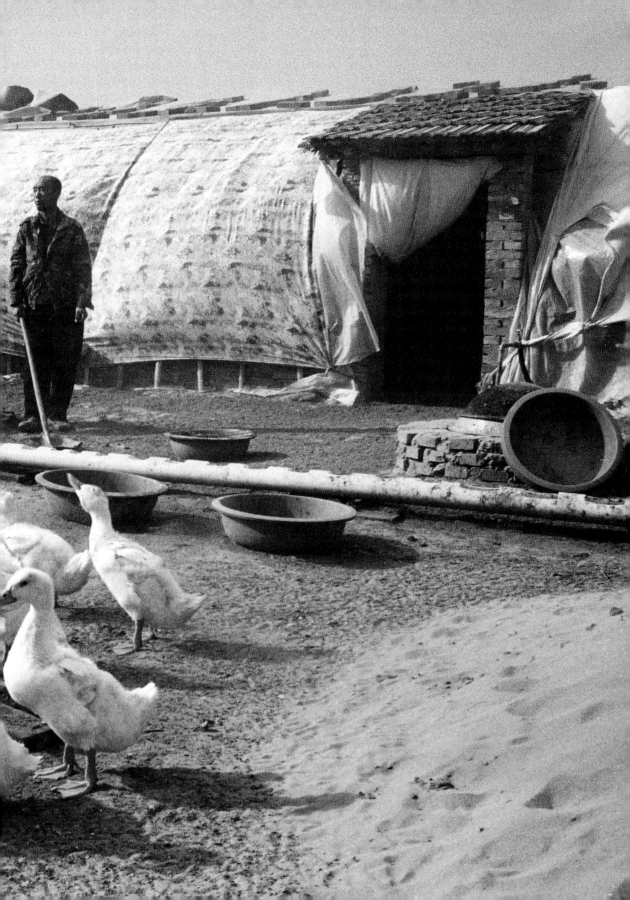

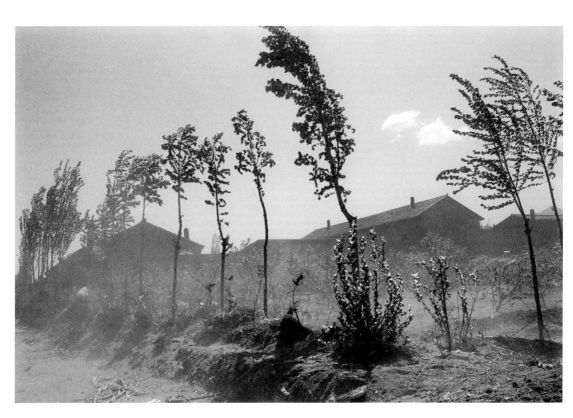

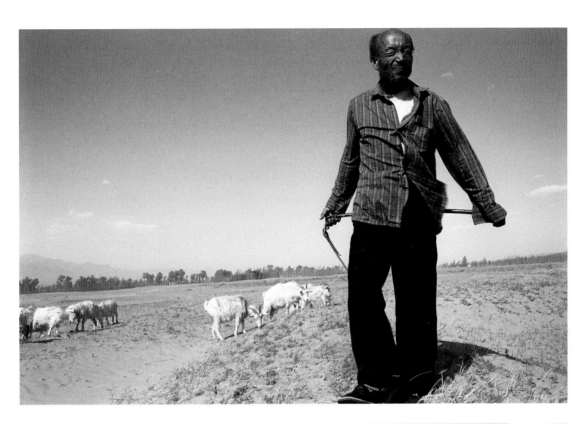

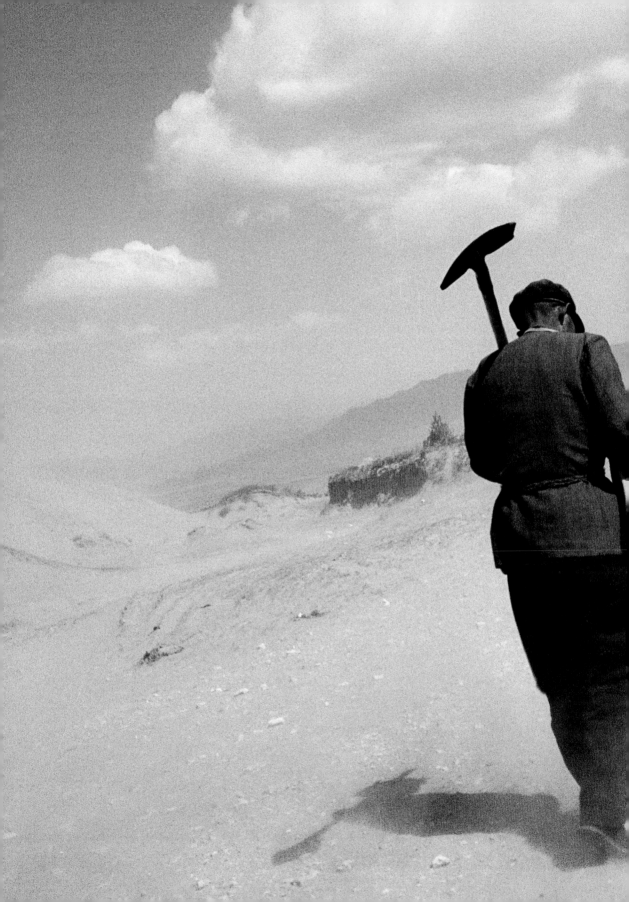

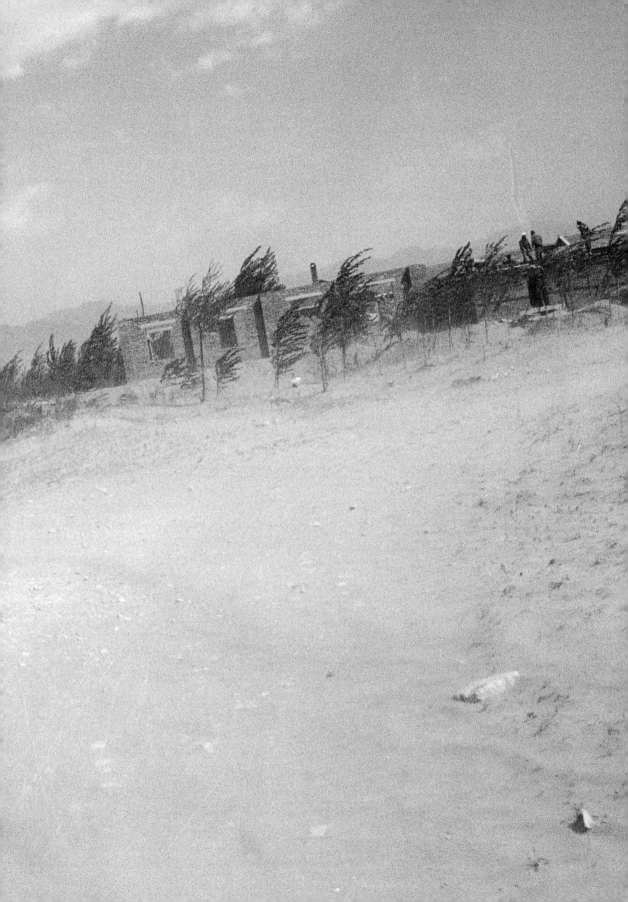

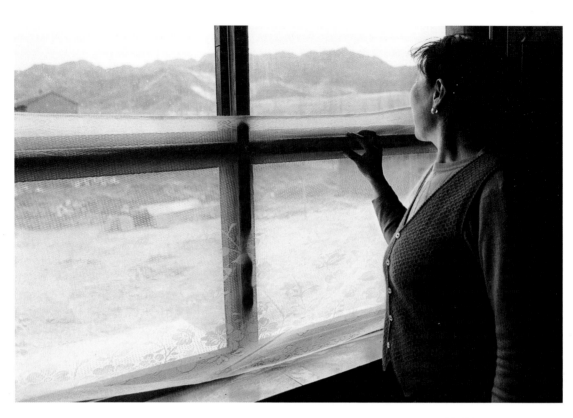

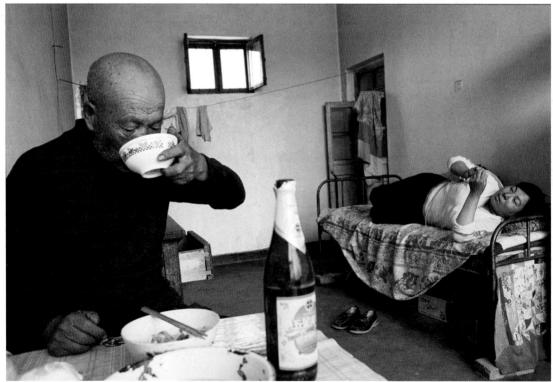

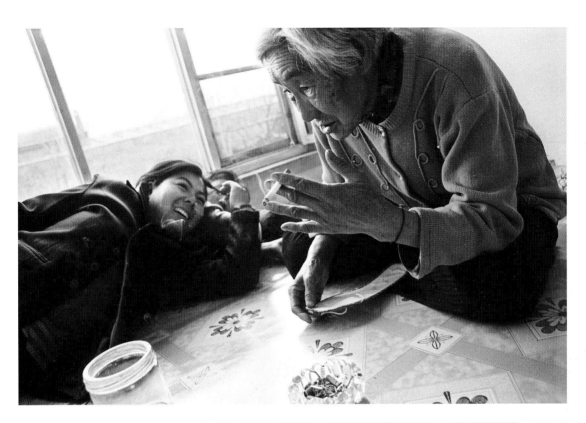

→ (Preceding pages) Beginning
in the month of March, huge
sandstorms hit Longbaoshan,
forcing livestock breeders and
farmers to abandon their
herds and fields. Like Dehai
Li, they wait out the storms in
their homes.

→ Eight-year-old Dang Guo Qing
Li's father went to work in
Beijing in 2002, and his
mother left to join him three
years later. His grandfather
takes care of him now.

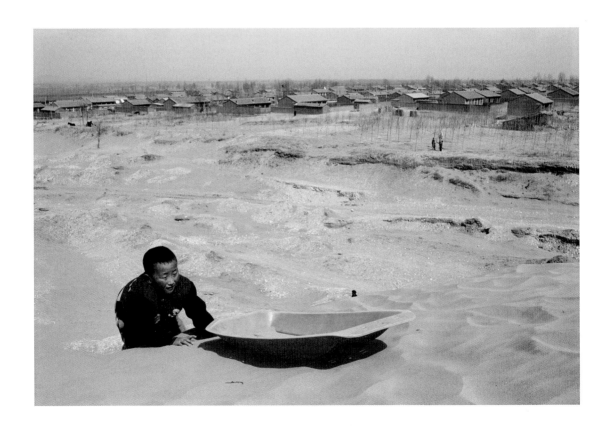

→ *The 30-metre-high sand dune is now less than 70 metres from the outermost houses of the village and is advancing by eight or nine metres per year, on average.*

→ *(Following pages) Another villager seeking exile in Beijing: Dang Jin Liang sets off for the capital in search of work.*

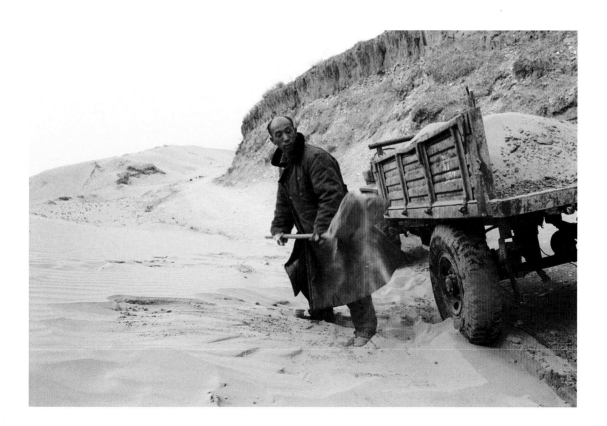

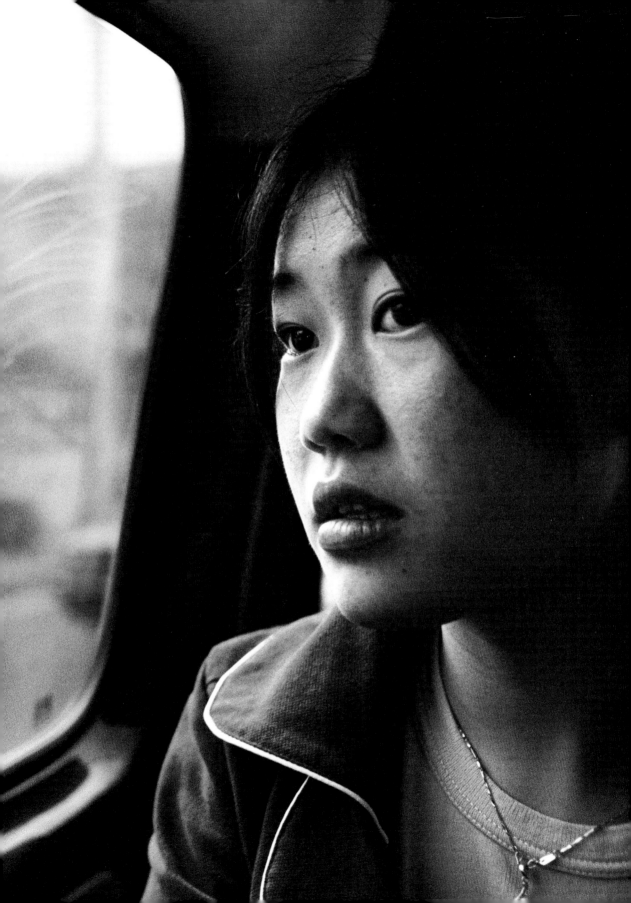

→ *Nightfall in Beijing. To help take their minds off their difficult working conditions and cramped living quarters, former Longbaoshan villagers come together to play mah-jong.*

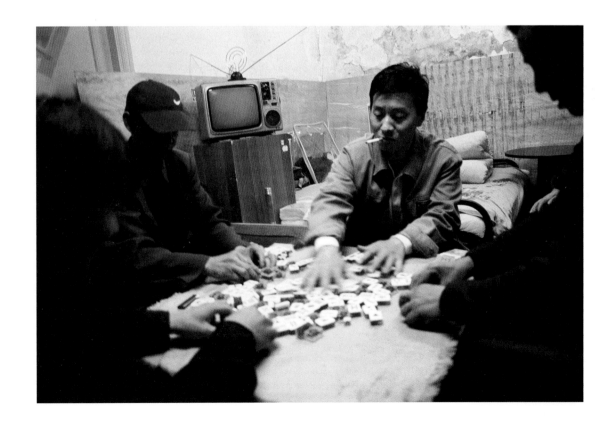

→ *Dang Jin Liang and her husband.*

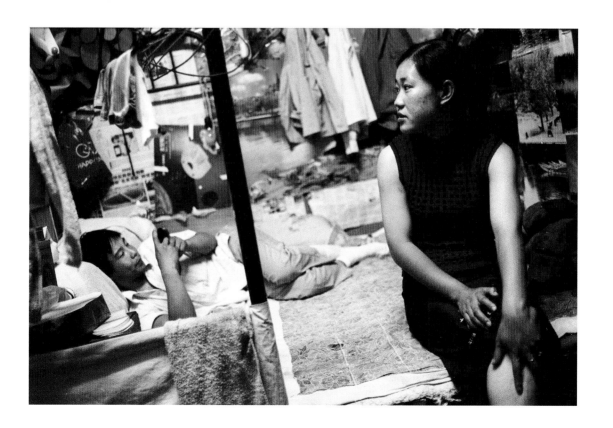

→ *Little Dang Guo Qing Li's*
parents work long hours at
restaurants and construction
sites in the city.

→ *(Following pages) Every
spring, storms sweep sand
from the Gobi Desert to
Longbaoshan and then
Beijing. For days on end, the
Chinese capital is covered in
a dense fog and experiences
dangerous peaks in pollution.*

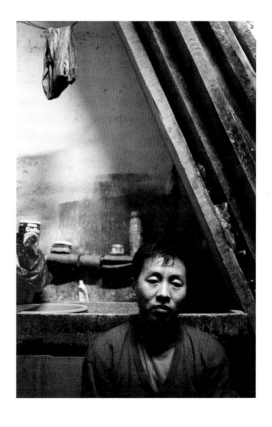

PACIFIC OCEAN

TUVALU (1 cm → 60 km)

PACIFIC OCEAN

Funafuti Atoll

Funafuti

Funafala

TEXT: DONATIEN GARNIER
PHOTOGRAPHY: LAURENT WEYL

PACIFIC OCEAN
Tuvalu, Polynesian requiem

1. A lesson in global warming

"Just look at Tuvalu on the map. It's this tiny country, this tiny speck in the ocean."
With a worried look, 30 or so 12-year-olds listen to Easter Molu, a teacher at the primary school in Funafuti, the capital of Tuvalu. This course on global warming, a recent addition to the curriculum, is just getting started. The cheerful, heavy-set teacher throws herself into the lesson, determined to take advantage of her powerful voice to captivate her young audience. There's no way she's going to let them doze off in the stifling heat, which is already making itself felt at the beginning of the day.

Photographer Laurent Weyl, who has been accompanying me for nearly three weeks, is as disoriented as I am. The map the teacher is showing her students is primarily blue – the ocean bordered by continents. It's not centred on Europe or the Greenwich meridian but on the Pacific Ocean. We obediently turn our gaze towards the end of the ruler, which the teacher has just positioned in the middle of the ocean to help us locate the Tuvalu archipelago among the myriad islands of the Antipodes – slightly south of the equator, a bit east of the International Date Line.

Using her teaching skills to best effect, Easter lets silence pervade for a few seconds; the only sounds are the low rumbling from the other classrooms and the

harmonic murmuring of the ocean. Funafuti is so narrow – only around 50 metres wide along nearly two-thirds of the 13-km-long island and 700 metres at its widest point – that the lapping of the crystalline lagoon merges with the constant humming of the ocean. Most of the time, the roar of the wind in the palm trees masks this soft sound, but a vibration persists as a constant reminder of the island's fragility. Why hasn't this minuscule territory of 26 square kilometres, comprising four reef islands and five atolls scattered over a watery expanse equal to the area of France and Germany combined – this coral 'confetti,' whose average elevation is only 2 metres above sea level – already disappeared into the foamy azure sea surrounding it? The mystery remains unresolved in 30 pairs of questioning, vaguely worried eyes.

"Just imagine that the sea level begins to rise – are you scared?" Curiously, the question dissipates the tension in the room as a conflicting chorus of *"yes"* and *"no"* rings out, mingled with laughter. With a solemn voice, Easter starts speaking again: *"I'm VERY scared. Over the past few years, during the spring tide, water has been seeping out of the ground and into my house. That's never happened before."*

We're not surprised at this revelation because we witnessed this strange flooding at the island's lowest points. What does surprise us is the students' reaction. They grew silent after the teacher spoke, although we had earlier seen them happily jumping in the newly formed ponds.
After the bell rings to signal the end of morning classes, we talk to the teacher about this issue. Her answer is half serious and half amused. *"They were born here and water is their element. They've always played in the ocean and in rain puddles. These floods are a new playground for them."*

We understand. They would have had fun in the Biblical flood as well. But why this silence in class just now? *"They know that one day they'll have to leave this country that they love!"* says Easter. *"You know, the December 2004 tsunami had a real impact on them. That disaster had nothing to do with climate change, but it gave them an idea of what they're facing with global warming."*

Something like a slow-motion tidal wave.

2. Bad weather report

A slow-motion tidal wave: that's similar to the description given to us by Helia Vavaï, a slender woman of 46 who directs Tuvalu's weather observatory, when we visited her a few days earlier. *"In 20 years, the temperature has risen by 0.4°C,"* she said. *"That's a huge increase! It leads to periods of drought as well as warming of the ocean surface, which contributes to the formation of devastating cyclones and could eventually result in the destruction of coral. But the most serious threat today is a recurrence of abnormally high tides – with disturbing consequences. The first we've seen is the appearance of large puddles of saltwater, which are pushed by ebb tides across the coral substratum to the island's lowest points. In other places, the water still doesn't rise to the surface but it sterilizes the soil underground and prevents cultivation of the island's two major root crops, taro and pulaka, which play an important role in our diet."*

At this point, Helia made an effort to contain her emotions. This was a far cry from the insouciance we thought we had detected in the nonchalant cheerfulness of her fellow citizens. *"The second consequence of these abnormal tidal ranges is coastal flooding, resulting from swells generated in the lagoon by west winds,"* she said. *"These winds have been increasing in intensity and duration during the rainy season. The flooding also contributes to coastal erosion. Have you noticed that there's only one beach left in Funafuti?"*

In fact, we were surprised to find, among the coconut trees and translucent waters, only a mixed bag of futile defences against the voracious sea: pointless cement-based structures, concrete blocks and scrap metal. Listening to Helia, we had the feeling that she was a harbinger of the anticipated sinking of the Tuvalu ship, powerless before her computer screens. Despite myself, I hastily voiced this concern, triggering a fresh response: *"At the end of the 1990s, I thought that our archipelago would become uninhabitable within a century. Everything has moved faster since then and I now think our country could disappear in 50 to 80 years."* This grim prediction, extrapolated from the forecasts of the Intergovernmental Panel on Climate Change (IPCC) and backed by daily observations of her sea-level country, did not, however, discourage the sensitive meteorologist. We must, she concluded, come up with all possible solutions to protect our fragile coral islands, even if it means filling in part of Funafuti Lagoon.

3. Siesta

In the stifling heat of early afternoon, while the 11 residents of Funafala, a small island located south of Funafuti Atoll and two hours away by speedboat, take their siesta, Helia's concerns seem far away. The strong west wind that had been blowing since our arrival in Tuvalu and had jeopardized our trip had finally stopped three days ago, so we're savouring our time in this sleepy hamlet where the population is nearly self-sufficient, as are most inhabitants of the 'outer islands' – the eight other islands and atolls comprising the Tuvalu archipelago.

We are now seated in the shade of a palm roof on the raised floor of the Akimo family's umu, which is a common area without walls that is generally separate from the house. From where I sit, I can easily observe the surrounding area: to the north-west, the blinding light of the lagoon; to the north-east, a small vegetable garden; to the east, a dense forest intersected by paths; and to the south, a maneapa, a type of umu where the community regularly gathers under the leadership of an elected chief. There are also coconut trees everywhere.

I glance at Elie Akimo, our host. He's lying fast asleep on a mat woven by his wife, with a coconut for a pillow. Slightly built, with an arm paralyzed since birth, he hardly has the imposing physique of the typical Polynesian man. With his face shrouded in sleep, you would never suspect this 53-year-old man's abundant strength and agility.

Like every morning, Elie had woken at dawn for the first of his three daily collections of kaleve (toddy), the precious sap of the coconut tree. Immediately on his toes, he stuck a sharp knife between his teeth, attached four empty bottles around his neck and nimbly bounded up his first tree. Clutching the tuft of leaves swinging from the tree, he then pruned and tied the growths that yield the acidic juice. Elie then slid to the ground while carrying full bottles, remembering to drop several coconuts on his way down. After tapping a dozen or so palm trees, he headed off to the lagoon, where Sekao, a sturdy young neighbour, was waiting to join him for a long, exhausting morning of fishing.

Faka Fetaï Akimo, Elie's wife, quickly interrupts Elie's nap. I see her powerful

arms feed a fire of coconut bark, which gives off a thick plume of smoke. A ro-bust-looking woman with an easy-going, generous nature, Faka Fetaï puts her heart into everything she does. She's now bringing the kaleve to a boil to turn it into a thick syrup that will be sold in the 'village,' namely Funafuti. The money will help pay her four children's school fees.

4. With the coconut tree, nothing goes to waste

Thanks to the knowledge passed down by their parents, the Akimos have become experts at taking full advantage of their island's every resource. So it goes with the coconut tree: from root to palm leaf (or frond) to trunk to coconut, every part of the tree can be put to use. The fronds serve as thatching for roofs, their central vein is used to produce brooms and their fibres make excellent fertilizer for growing taro and pulaka. The trunk, also bent under the prevailing winds, is highly prized as a building material. The coconut itself can be consumed at all stages of maturity, including germination, while its shell is used as tableware.

Elie sits up. The bickering of his three youngest children has woken him. Two of his sons, the mischievous Sene, 5, and the spirited Telefoni, 7, have come to join their little sister Sepa, 3, for the weekend. Normally, Sepa should go with her brothers every week to stay with their aunt and attend school in Funafuti, but things rarely turn out that way, explains her father with a tender expression, in his inimitable blend of English and Tuvaluan. *"Just when she's about to leave the island, she always manages to jump off the boat and we don't have the heart to make her go."*

Her parents understand, because they themselves are viscerally attached to their little island. Faka Fetaï has never really left it, and Elie, who originally came from an outlying island, can't imagine living anywhere else. His dark eyes light up when he tries to sum up his thoughts on the matter: *"I'm happy here because I lead a free life. I don't need money and I eat the food, always fresh, that nature provides."* Eating by gathering fruit from the earth and harvesting the ocean's many resources is like a scene from the Garden of Eden. Make no mistake, however: the Akimo family doesn't live a picture-perfect life. It's not easy living on the atolls, where life is a subtle balance between nature's generosity and human skill – much more so than in the spacious, fertile volcanic islands.

5. Noah returns

This balance is threatened by global warming. Is Elie aware of it? He has noticed that the sand beach near his maneapa is shrinking at a faster pace; he has seen erosion nibble away at the shore, and coconut trees fall; and he is clearly aware of the erratic seasons. He has, however, long denied the significance of these phenomena. During his Sunday visits, didn't the pastor keep saying that the Biblical flood had already occurred and that God had promised – symbolically reiterated in every rainbow – that it would never happen again? But the pastor himself has gradually changed his mind. His sermons, based on the omnipotence of divine love, have become ambiguous, no longer sufficient to camouflage a stubborn reality. So Elie no longer denies the possibility of major upheaval in his world. He does, however, need more evidence before he's ready to abandon his coral islet and coconut trees. *"If I see the sea level rise with my own eyes, I'll agree to leave, but that hasn't happened yet."*

A few programmes devoted to climate change, picked up at night between two series of soft hymns, on the only national radio station – and also perhaps the increasingly frequent visits over the past five years by scientists and journalists, with their repetitive questions – have nevertheless begun to convince him that he should at least think about finding a safe place for his children, but the contemplated solution remains hypothetical. *"If they do well at school, they'll go study abroad, maybe in Australia, and maybe they'll stay there,"* says Elie.

6. Roots in the sea

The weekend is over. Telefoni and Sene put on their turquoise and white Tuvaluan school uniform and kiss their mother goodbye, while Sepa hides under the umu. Two Funafuti fishermen whom we know well, Tehaki and Lupe, have come to take them to school after a night casting for flying fish in the atoll's channels. We decide to return with them. Funafala's silhouette, still dark, quickly fades in the wake of the speedboat and, while we watch the rising sun illuminate each individual colour in the lagoon, the two boys only have eyes for the large traditional scoops and a cap topped with a powerful electric spotlight stored at the back of the boat.

When we see their interest in these tools, we have a strong feeling that it's this way of life, true to their heritage, that these boys dream of – not going off to

study in faraway lands. Tehaki confirms what we suspected: that the boys' parents are highly skilled in the art of fishing. *"Faka Fetaï knows a lot of things,"* he says. *"She studies the stars, the shape of the clouds and the colour of the water, and knows where, when and what technique to use to catch this or that type of fish. Elie knows how to do everything: line, net, harpoon and cast-net fishing. These kids have it in their blood, like us."*

That reminds me of what we were told by Lupati, Tehaki's twin brother, before we left for Funafala: *"We live so close to the ocean that it's as if we were part of it. The place we live determines the way we live. Here, I see the ocean every day and that's what drives me, that's what gives me the strength and courage to go fishing. If I had to go far away from the ocean, I would lose my energy and motivation."*

We're approaching the end of our trip while silently chewing on the raw fish filets that Tehaki and Lupe offer us for breakfast. Alapi, Funafuti's last beach, soon comes into view. Seated on the fine sand or splashing about in the turquoise water, clusters of homemakers chat while waiting for the boat to arrive. Our boatmen are content; they know that their catch will soon be sold.

7. Culture and DVDs

After spending a few days in Funafala, we see Funafuti in a new light. It no longer seems like a large village of metal-roofed houses wedged between palm leaves and bushes under the shade of tall coconut trees, but truly the capital of Tuvalu: a small city with 5,000 residents, half the country's population. A 'micropolis' with a long runway, a university, a prison (without walls) and a nightclub open three days a week. A growing city that, due to its veneer of a Western lifestyle, is attracting an increasing number of young migrants from outlying islands.

We even wonder if, by the time rising sea levels force the population to evacuate the country, Tuvalu's citizens will already be fully acculturated to Western ways through the consumption of Australian chips and chicken and American and Chinese DVDs. This idea greatly amuses Iacopo Moloti, 38, an independent cameraman whom we visit upon our return from Funafala. We find him in his office, busy burning a series of DVDs for several merchant mariners who will be going

to sea for nine months. *"Aside from the latest news for the people they'll be seeing onboard, you know what they ask me for? Fateles."*

An old man explained the concept to us as follows: *"In Tuvaluan, fatele means 'doing or having a lot of something' – a lot of joy, a lot of noise, a lot of music, a lot of good fortune, a lot of dancing... Everyone participates; if you can't dance, you sing. If you can't sing, you clap your hands. If you can't clap your hands, you can still be there and have a good time."*

More specifically, fatele refers to large festivals in which Tuvalu's various island communities compete with each other in hotly contested dance competitions. The fateles symbolize a culture whose basic values are sharing and solidarity.

Since our visit to Iacopo, we've had an opportunity to talk to some merchant mariners about his DVDs. There are quite a few sailors in Tuvalu because a small maritime school is located on the islet of Amatu Ku, north of Funafuti. I ask them why they prefer dancing to their islands' scenery or other festive activities. Each in his own fashion gives pretty much the same answer: the landscapes are just images and we don't need videos to remember them, but what happens at the fatele represents the spirit of each island and each community. It's different every time. You can't memorize it; it has to be experienced.

We now realize that Funafuti's development has only had a superficial impact on Tuvalu's culture. As long as Tuvalu's communities and strange, nasal language remain alive, its culture will continue to exist and serve as a resource for humanity. It will disappear very quickly if its foundations are shaken, however, and that is bound to happen if the Tuvaluans are driven from their archipelago by rising sea levels and dispersed.

8. Diplomacy

As I enter Tuvalu's brand-new government building, funded by the Taiwanese, I think about the story we were told by Toaripi Lauti, the country's first prime mi-

nister, at the beginning of our stay. Recalling the first days of Tuvalu's indepen-
dence in 1978, he said that the government at that time operated out of a single
office – a room in his aunt's house. This made me think of the big companies that
started out in Silicon Valley garages. With its three floors, central patio and air-
conditioning, the building we have just entered bears witness to how far the
young country has come – at least from a diplomatic standpoint.

Pani Laupepa, 42, chief of staff at the Ministry of Foreign Affairs, is waiting for
us in his office. Barefoot, dressed in a sort of grey pareo – a flannel version of a
traditional sulu – he receives us with calm courtesy. We came to see Laupepa, be-
cause he is part of those for whom the country's fate is already a fact of life. Over
the long run, Tuvaluans will have no choice but to leave their islands. His role is
to immediately begin negotiating the future of his people so that they can be eva-
cuated under the best possible conditions – ideally by keeping them together in
a familiar environment and without loss of sovereignty.

The tiny nation lacks neither resources nor sang-froid when it comes to negotia-
tions. It has already stunned the world by announcing it would sue the major
greenhouse gas emitters – namely, the United States and oil companies – in inter-
national tribunals. It has since backed down, but is taking its fight to other are-
nas. The country has, for example, strengthened its alliances with other small
island nations, like the Maldives, and took its cause to the United Nations shortly
after becoming a member in 2000. It especially wants guarantees from its two
largest neighbours. *"We asked the governments of Australia and New Zealand to
acknowledge the concept of climate refugees,"* he says. *"They refused, saying that,
according to international law, refugees can only be people subject to persecution or
political, ideological, ethnic or religious pressure – a narrow definition that suits
them just fine."*

It's clear that acknowledging such a concept is not in the interest of those that
Laupepe calls 'the biggest polluters per inhabitant' as a way to further empha-
size Tuvaluans' minuscule contribution to global warming. Based on current
scientific knowledge, however, the existence of climate refugees may give rise
to the concept of 'environmental persecution' and thus responsibility for the
most vulnerable populations on the part of the major greenhouse-gas emitters.

That could be the beginning of climate justice in which 'the biggest polluters per inhabitant' would not be able to turn away Tuvaluans under the above-mentioned 'ideal' conditions. What impact would 10,000 Tuvaluans have on a country the size of Australia? *"Let's not forget that we're not the only ones threatened,"* said Laupepe. *"All low-lying islands around the world are facing the same threat, and that involves millions of people."*

With this change of perspective in mind, we take leave of the chief of staff. We have moved far beyond the irritation we couldn't help feeling at the beginning of our stay five weeks earlier. At that time, all we saw among Tuvaluans was a carefree attitude and a love of the easy life. As we got to know them, we discovered a pragmatic people fully aware of its inevitable fate and wanting to do everything in its power to stay on its land as long as possible, a people involved in a global struggle to negotiate its relocation under optimal conditions. Laupepe has brought to our attention the great strides made by this miniscule young country, this tiny democracy on the far margins of European maps that has managed, with few resources, to become a symbol.

We will leave Tuvalu worried – about our own indifference.

∫

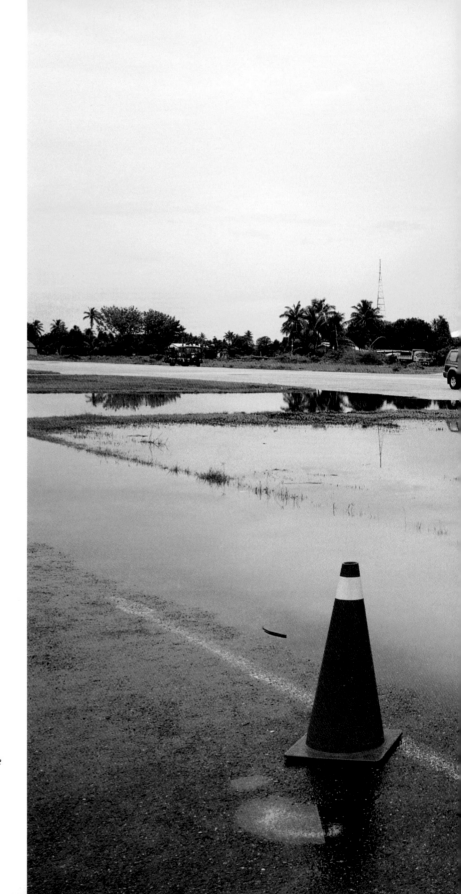

→ *Funafuti. When the spring tides roll in, large saltwater puddles form near the airport.*

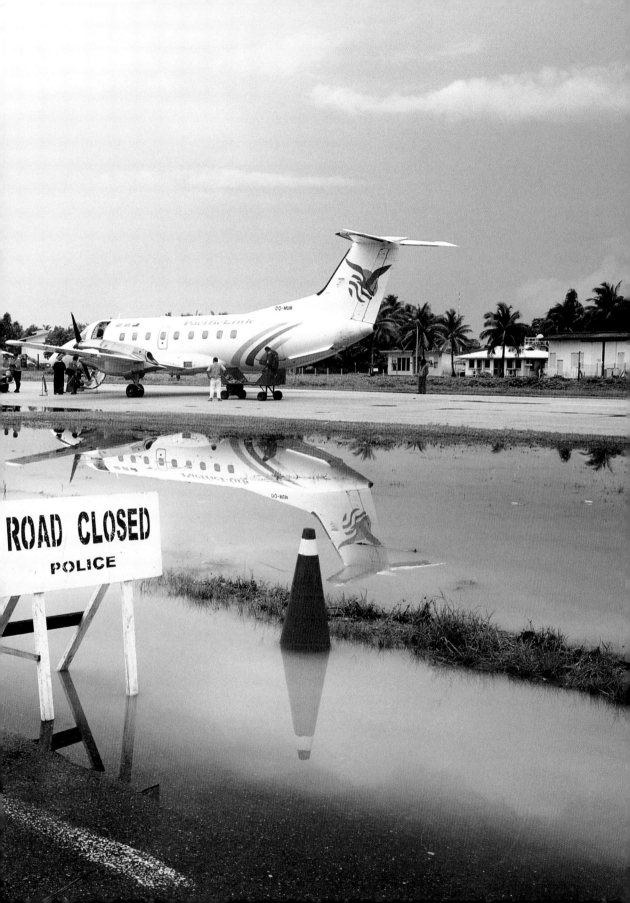

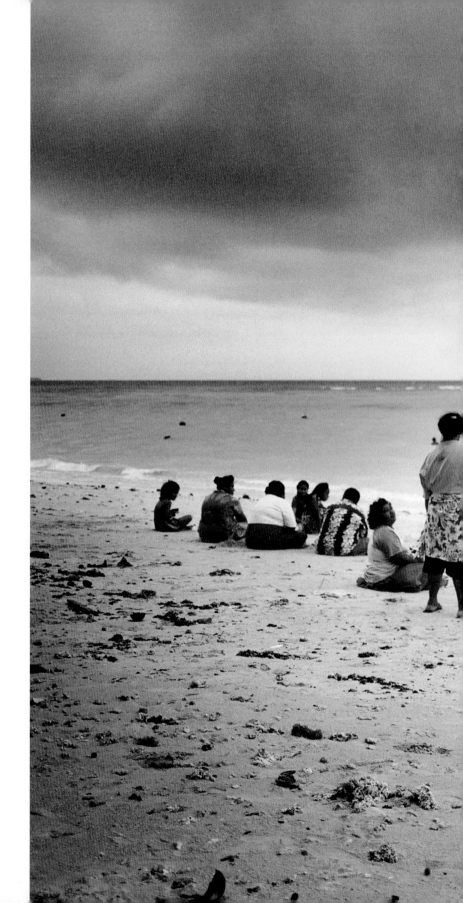

→ *Funafuti. On Alapi Beach, housewives shopping for fresh food wait for the fishermen to return.*

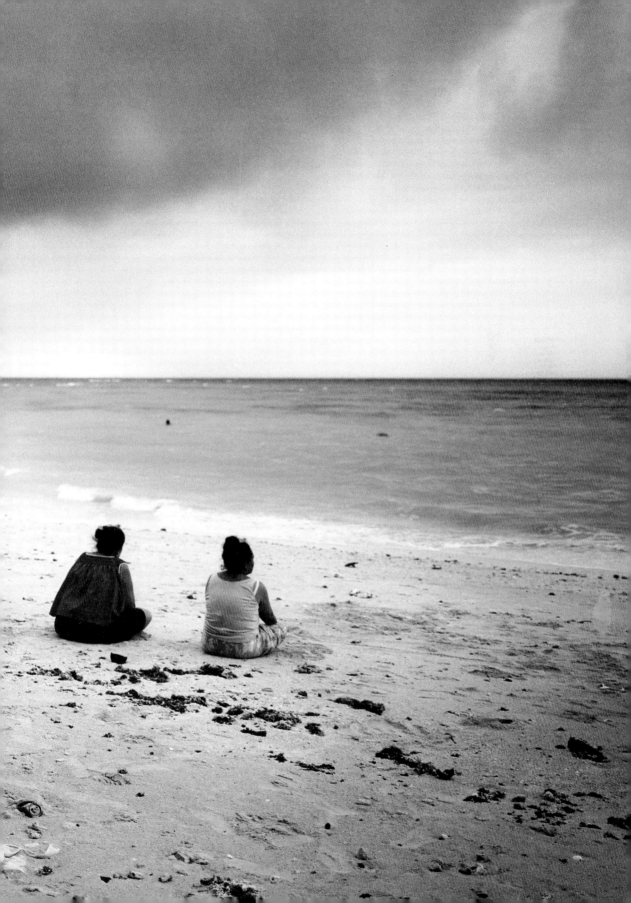

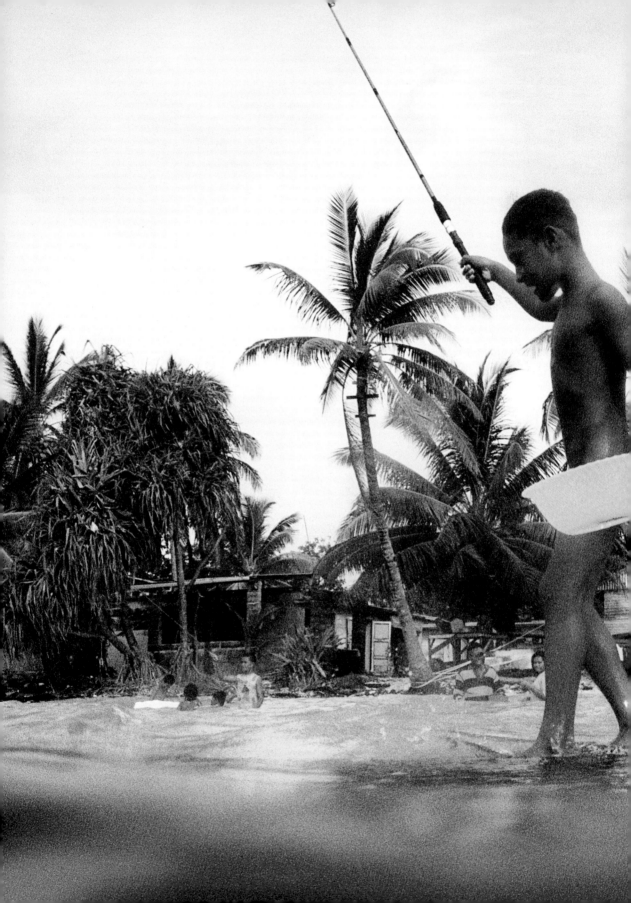

→ *(Previous pages) Funafuti. To have a snack, you first have to fish it out of the water.*

→ *Funafuti. The increase in ocean temperate endangers the coral and the entire ecosystem on which it depends.*

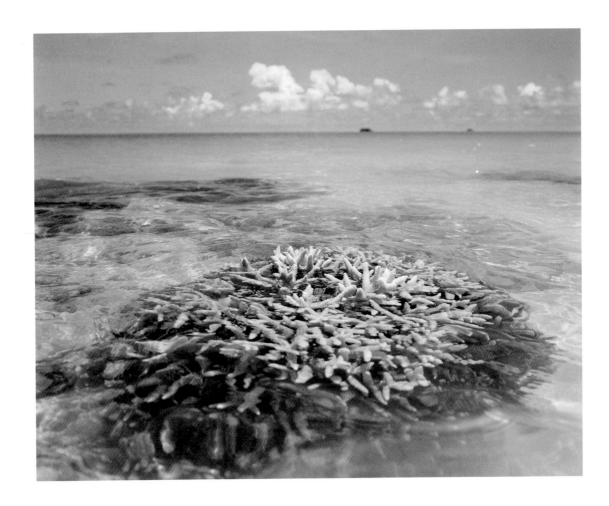

→ *Funafala. Falao, 66, fishing*
 with a fishgig in the coral reef.

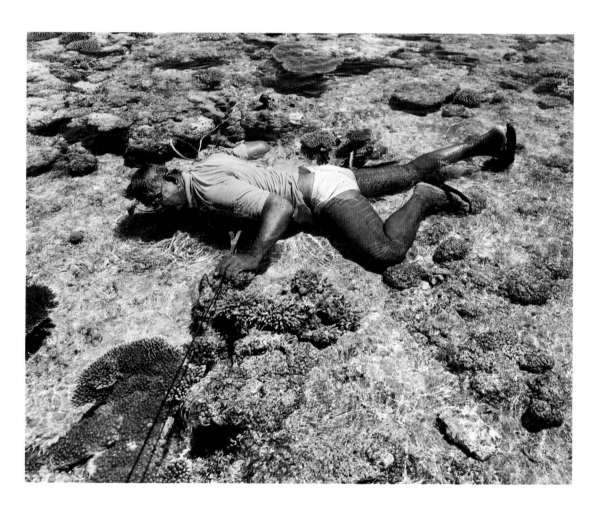

→ *Funafati. A structure built to fight erosion at the site of a former beach.*

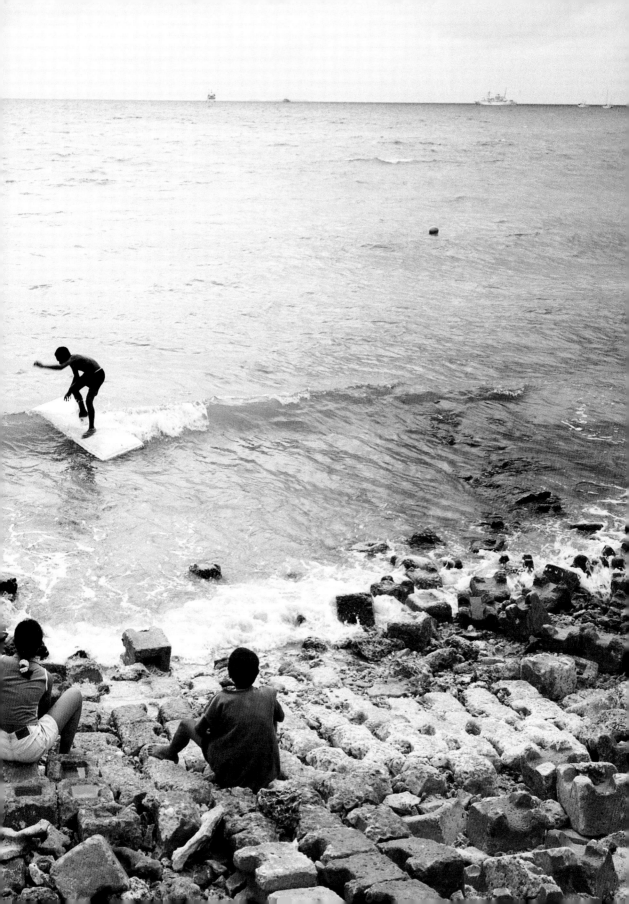

→ *Funafuti. Family fun after
Sunday mass.*

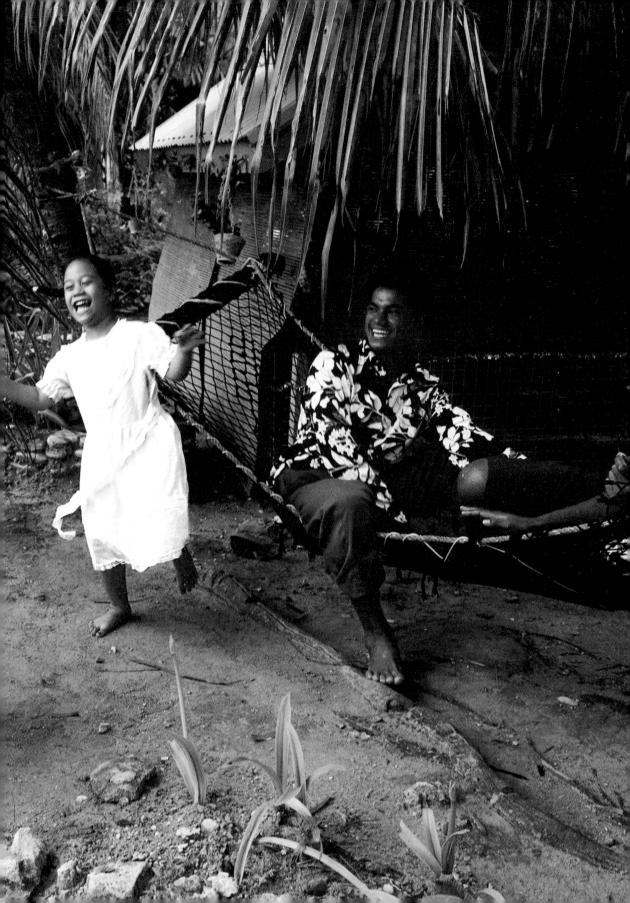

→ *(Previous pages) Funafuti. Though seen as troubling signs by adults, saltwater puddles that have appeared at the island's lowest points serve as playgrounds for children and teenagers.*

→ *Funafuti. Tuvuluans are very much involved in the life of their many –mainly protestant- churches. EKT, the most important one, did not recognize the hypothesis of global warming until 2005 and only admitted it was man-made in 2007.*

→ *Funafuti. A gathering*
 organized for Women's Day.
 Community life is one of the
 pillars of Tuvaluan society.

→ Funafuti. Laperouse
 School. Students sing a
 song they wrote about
 global warming: "Will we
 have to leave you? Oh!
 Tuvalu – beloved
 paradise."

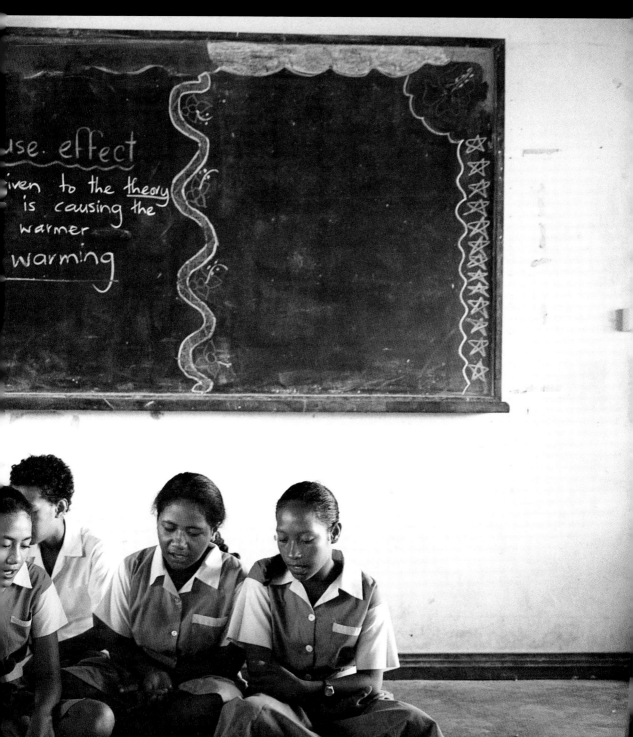

→ *Funafala. Sene, 5, and*
Telefoni Akimoa, 7, already
know how to skilfully
manoeuvre a prao.

→ *Funafuti. The lagoon is like
an infinitely huge lounge
where people gather in the
evening for a chat.the project
of building a seawall so as
to shield them from global
warming and to gather all
tuvuluans together is under
consideration.*

→ (Previous pages). Funafuti.
Combining the effects of
unusual winds and the rise in
sea level, swells are the major
reason for erosion and
shoreline flooding.

→ Funafuti. The shape of the
clouds, the colour of the
water and the location of the
stars indicate where, when
and how to fish. In Tuvalu,
scanning the horizon is of
prime importance.

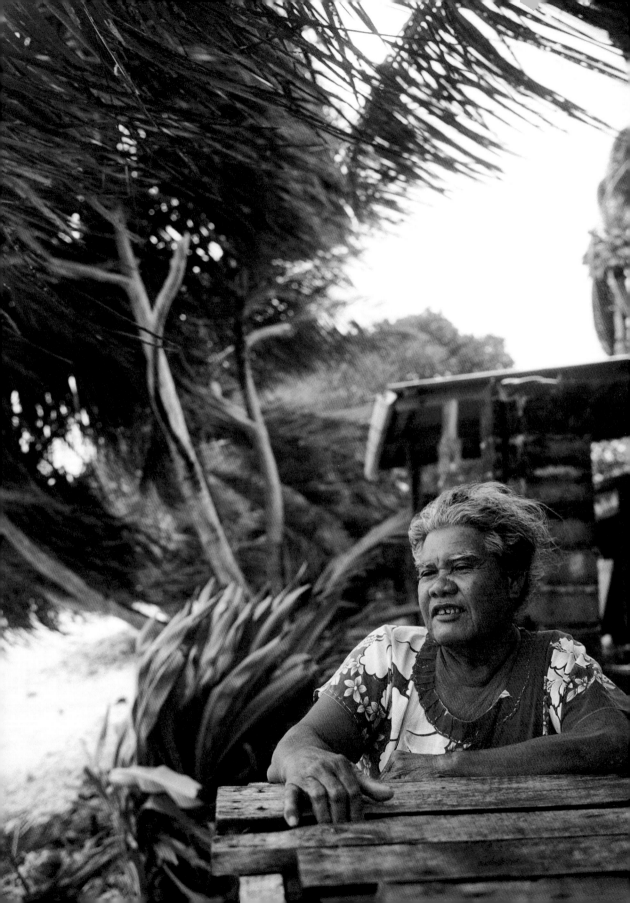

CHINA

NEPAL (1 cm = 6 km)
KHUMBU VALLEY

Island Peak (glacier)

Imja Tshu (lake)

Chukhung

Dingboche

Longponche (glacier)

Dig Tsho (lake)

Tengboche

Thame

Namche

Phakding

Ghat

Lukla

TEXT: AUDE RAUX
PHOTOGRAPHY: GUILLAUME COLLANGES

NEPAL
Himalayas, lost horizons

Pretty

One by one, the convicts enter the mountain dormitory, heads down, shoulders hunched and backs bent double. Another day spent breaking up rocks on the riverbank: piling the rocks onto wooden planks, securing them with rope and hauling them up to the entrance of Dingboche, a Khumbu Valley village perched 4,410 metres high in the Himalayas. Coming back down the narrow dirt path, made slippery by heavy monsoon rains, and then breaking, piling, roping and hauling once again, all the while waiting for the evening meal of dal bhat, a dish made with rice, lentil soup, a few potatoes and some cauliflower, washing it down with rakshi, a home-brewed rice alcohol. Then collapsing onto wooden platforms in the dormitory, where all eight men sleep side by side. On one of the room's otherwise bare walls hangs an eye-catching poster. *"I tacked that up because I thought it looked pretty,"* says Angat Bahadur Rai, the owner of the premises. *"See the mountain with the snow, the sun in the corner, sunbeams falling towards the earth, and then, down below, the river and the trees."* The title of this 'pretty' poster: *"Climate Change."*

Block of ice

On 4 August 1985, after an exceptionally mild July, the glacial lake Dig Tsho exploded. An enormous block of ice came loose from the glacier and splashed into the lake, which, thanks to global warming, was already bursting at the seams.

The water level shot up after the impact, causing the moraine – an unstable natural dam created by the glacier itself and composed of rock debris, sand and ice – to break. For over four hours, 6-10 million cubic metres of water, carrying stones, tree trunks, debris and mud, swept down through the Khumbu Valley. The flood eradicated everything in its path over about 90 kilometres. Some 30 houses were destroyed, hiking trails were washed away, a dozen bridges collapsed, entire herds of yaks were drowned, vegetable gardens and fields of corn, wheat and barley were devastated, and a hydroelectric power station was buried. Miraculously, only five people perished in the disaster.

Sky

"I saw water flowing under the sky" – Urgun Tsultrem, 87, a nun, describing the Dig Tsho explosion.

Blankets

In her little restaurant at the exit to the village of Ghat, Penpighen Rai is making dough for momos, dumplings that she stuffs with vegetables and meat, then drops into bubbling oil. Flames in the stove cast light onto her face, which takes on a pained expression as she begins speaking of the Dig Tsho explosion. It happened when she was eight years old. *"I had been sleeping, but woke up when the house started shaking like in an earthquake. My parents, little sister and I ran out of the house. I was naked, just wrapped up in some blankets. We saw the swollen river in the moonlight. The smell was very bad – a combination of yak dung and burnt rock. And there was this sound – dududu – like whirling helicopter blades. We took refuge up in the forest. We were crying. Once we had gotten to safety, my father wanted to go back down to get some food. Luckily, my mother stopped him. The next day, our house was gone. It had been washed away by the flood."*

Red dog

A legend has haunted the Khumbu Valley ever since the Dig Tsho explosion. Stories are told of a red dog that went into a yak herder's house to steal some cheese. The furious herder is said to have killed the dog and thrown its body into the lake, thereby angering the god of Dig Tsho. Here in north-eastern Nepal, every lake, mountain, peak and stone is protected by a divine spirit. To ensure the benevolence of these deities, the inhabitants of the Khumbu Valley – the Sherpa, who brought their Buddhist beliefs when they migrated from Tibet five centuries ago – hang colourful garlands of prayer flags from roofs, bridges, trees and religious monuments. Each colour symbolizes an element: yellow is for the earth,

green for the forest, blue for the sky and water, white for iron and red for fire.

One degree higher

Poles apart from this folklore, the scientific community is finally beginning to take a closer look at the effects global warming is having on the Himalayan mountain chain. For example, in a World Wide Fund for Nature (WWF) report produced in cooperation with the United Nations Environment Programme (UNEP), we read: *"Accelerated glacial melt is the most significant indicator of global warming. Since the mid-1970s, the temperature in the Himalayan region has risen by one degree Celsius."* According to Sandeep Chamling Rai, head of the climate change programme for the WWF in Nepal and a co-author of the report, one degree is a dramatic increase. *"The Himalayan glaciers are among the fastest-retreating in the world,"* he tells me during our meeting at his Kathmandu office. *"We estimate that there are about 200 glacial lakes in the Himalayas that may soon become engorged with water and explode. They pose a serious threat to valley residents, and there are 20 of these glacial lakes in Nepal alone."* [1] The same conclusions can be found in a report by the International Centre for Integrated Mountain Development (ICIMOD), an organization headquartered in Nepal's capital and funded mainly by the governments of Austria, Denmark, Germany and the Netherlands. *"The effects of climate change at global level are already being observed in the Himalayas, where glaciers and glacial lakes have been changing at an alarming rate over the past few decades... Glaciers are retreating by 10 to 60 metres per year... One of the effects of this melting is the growing number and size of glacial lakes."* [2]

Disappearance

If the predictions made by the Intergovernmental Panel on Climate Change (IPCC) prove correct, by 2050 temperatures will be two degrees higher and over one-third of the Himalayan glaciers will have disappeared completely. To learn more, I meet with Pradeep Mool, an ICIMOD specialist in remote monitoring of glaciers, at his workplace in the suburbs of Kathmandu. *"There's no doubt that this accelerated glacial melt is caused by global warming,"* he begins. *"Sooner or later, more lakes will experience these 'outburst floods,' but it's difficult to tell when this will happen or what the extent of flooding will be."* The uncertainty is due in part to the scarcity of funding provided for research by the governments of the nations bordering the Himalayas, which include Nepal, India, Pakistan and Bhutan. *"It was only four years ago that ICIMOD began making an inventory of these lakes with assistance from the Nepalese Hydrology and Meteorology Department.*

But without a budget directly allocated for this task, without the least sign of interest in the issue of global warming from the highest national authorities, it is very difficult to determine the exact level of risk," says Arun Bhakta Shrestha, an ICIMOD climate change specialist and head of various programmes dedicated to water, risks and the environment. This lack of funding means that specialists can currently monitor only one glacial lake in Nepal: Tsho Rolpa. Thanks to funds from the Netherlands, they were able to install a pumping system that has lowered the lake's level by 3 metres. Only 17 more metres and the lake will no longer be a threat.

Space

The situation isn't made any easier by the large number of glaciers and the difficulty of accessing them – there are about 15,000 spread out along some 33,000 square kilometres of mountains. To overcome these obstacles, the French Development Research Institute, in association with the National Centre for Scientific Research, has launched a large-scale space observation project. The first satellite images published early in 2007 revealed evidence of 8 to 10 metres of melt in a 915-square-kilometre test area between 2000 and 2004.

Roof

"There was a roof floating on the river" – Ang Maya Sherpa, describing the Dig Tsho explosion in the village of Thame.

Clouds

Mingma Sherpa steps out of his tea shop, walks a few paces, takes a look down the road, goes back in, stirs up the flames of the fire, boils some water, drops a tea-bag into a Thermos, and adds a few spoonfuls of powdered milk and then some sugar. He steps out again, squints into the distance, and goes back into the single room with the smoke-blackened walls. Finally, there's a sound: his wife, for whom he has been waiting a day and a half, appears in the doorway, her feet wrapped in mist, their 18-month-old daughter bundled on her back underneath a large shawl. He wipes their streaming faces, takes Teshitawa in his arms, encloses her tiny fingers in his large hands and brings them closer to the fire to warm them. Purdigi gave birth to their daughter in this very same room. *"It was in November,"* she recalls. *"The 16th, I believe. It was so cold."* Their village, Chukhung, is at an elevation of 4,730 metres. It's the very last settlement before Imja Tsho.

Walking

According to the ICIMOD report, Imja Tsho is Nepal's most dangerous lakes. At

5,010 metres, it towers over Khumbu, the most populous high mountain valley with close to 5,000 inhabitants. And because its hiking trails lead to Mount Everest, it's also the region most visited by tourists. The valley now gets most of its revenue from tourism: no less than 27,000 foreigners passed through here in 2006. To reach Imja, we board an old-model Yeti Airlines plane at Kathmandu Airport. We fly through a sky full of 'potholes' of turbulence and bump down onto a tiny mountain-ledge landing strip at 2,840 metres. After a steaming mug of tea, we begin our ascent. Up here, distances are still expressed in days of walking. We hike five to six hours each day for four days. The oxygen becomes increasingly meagre as we get higher. We soon leave a jungle setting and enter a lunar landscape – there are no trees above 4,000 metres. Altitude sickness begins to set in, accompanied by seasickness each time we cross a suspended bridge swaying at dizzying heights above the torrents. Whenever we start to tire and fall behind, the sight of the porters we pass – men with callused feet, stoically bearing loads of up to twice their own weight – motivates us to quicken our pace and catch up to the others. The porters carry large wicker baskets packed with some 90 kilos of provisions such as beef, bottled water and bags of rice. From time to time they take a break, propping up their baskets with long, thick wooden sticks to rest their backs. Our guide, Buddhi Rai, keeps our energy high with his cheerful conversation, laughter and songs. The scent of pine needles, mint leaves and flowers mix and mingle in the amazingly pure air. A wild deer strays onto the hiking trail and stands there for a moment, its vacant eyes staring into ours. Along the way we try to catch a glimpse of a Himalayan monal, Nepal's national bird, a pheasant with multi-coloured feathers. We come upon stupas, magnificent mound-like Buddhist structures made of earth that must always be passed in a clockwise direction. Inside them are prayer wheels – cylinders containing paper scrolls and pieces of cloth printed with the mantra aum mani padme hum. One spins the cylinders for the prayers inside to be heard. Finally, we see Mount Everest, which towers 8,848 metres over all creation. It was first conquered in 1953 by Sir Edmund Hillary and Tenzing Norgay, who are regarded as living gods in the Khumbu Valley. The Tibetan name of the world's highest mountain is Chomolungma, meaning 'divine mother of the universe.'

Melting

Pradeep Mool of ICIMOD tells us that, should Imja Tsho also explode, *"It would be an even worse disaster for the valley dwellers than Dig Tsho was."* According to ICIMOD's latest statistics, which date from 2002, Imja Tsho is six times larger than Dig Tsho, covers an area of almost a square kilometre and contains 35.8 mil-

lion cubic metres of water. This water is supplied by Island Peak, a melting glacier that, according to observations from 2001 to 2006, is retreating at the record rate of 74 metres per year. We learn this lake's astonishing history from Om Ratna Bajracharya, head of the Hydrology and Meteorology Department: *"The lake didn't exist 40 years ago. It was formed at the end of the 1980s from a number of small pools created during the 1960s when Island Peak began melting more rapidly. Since the 1990s, the lake has been growing at a remarkably fast rate. This is of course due to global warming and, more specifically, the sharp rise in temperatures that we've been seeing at this altitude. Glaciers are very sensitive to this phenomenon. They're like climatic record-keepers."*

Black

"The feeling you get when you look at Imja Tsho is not good at all. Maybe because of its black colour" – Ang Nima Sherpa.

Pollution

"I don't know who's responsible for global warming. Maybe people like you, in the rich countries! It's not us, in any case. We're respectful of nature; we keep it clean. If you create a lot of pollution with your factories, temperatures will rise and God will not be happy. He doesn't like pollution. The entire world should think about that and help us. Nepal is an international territory, a world heritage site" – Tenzing Tashi Sherpa, social worker and Khunde Valley resident.

Mask

Tsering Teshi is putting on his stage costume: a frightening dragon mask, boots decorated with embroidery and a long grey cape, which he drapes over one shoulder. It's Friday, 6 July – the Dalai Lama's birthday. This year (2007) he's turning 73. To wish him a long life, over 300 Sherpa have gathered in the small courtyard of the Namche monastery. A crossroads for business and tourism, this village at 3,440 metres in elevation is the site of the largest market in the region. Every Saturday, the Sherpa hurry there to sell and buy yak butter, incense flowers and counterfeit North Face jackets. After placing sacred white scarves with a few banknotes tucked carefully inside them in front of the holy man's photo, the people who've come to join in the celebration find seats on the risers. Percussionists begin beating their drums, kicking off a long day of singing, dancing, play-acting and the sampling of such delicacies as biscuits, sour candies, savoury rice dishes and Tibetan tea, a horrid-tasting (to us) salty concoction made with yak butter. Waiting in the wings is Tsering Teshi, a young man born in Namche who now

studies science in Kathmandu. He speaks to us of his concerns: *"The mountain used to be covered with snow; the Khumbu Valley looked just like Switzerland. But now, because of global warming, the summer sun is very hot, so the snow melts, causing the lakes and rivers to swell. When I was little, that mountain facing us had snow on its peak all the time – it never melted. But now, in the middle of July, look at it...for the past five years it's been just a mountain of rock, a dead mountain."* A bell rings. The young performer hides his face with the mask and steps out onto the stage.

Fighting

Very few of the Sherpa in the Khumbu Valley have heard of global warming, despite three glacial lakes exploding in the recent past: Dig Tsho in August 1985, Chubung in July 1991 and Sabai Tsho in September 1998. Although they've all noticed the changes in their mountains, there's no reason they would make the connection – living in a remote region as they do – between melting glaciers and a rise in temperatures caused by greenhouse gas emissions. A nurse we met in Tengboche tells us her own theory: *"The snow and ice are melting because too many tourists come here to climb as high as they can, in a spirit of competition, with no respect for the mountain gods – so the gods become angry and cause floods."* To help raise awareness of the true causes, the WWF office in Kathmandu has assigned a member of its Namche team the task of organizing seminars. Since March 2007, Dil Bahadur Margar has been giving talks all over the Khumbu Valley. In his view, these informational sessions are *"the first step in the fight against global warming, because it's crucial, above all else, to know what we should be fighting."*

King

"I hadn't heard that Imja Tsho might explode. What if the king – or God himself – didn't know? How, then, could I know?" says Dorje Sherpa, 84, the village elder. Looking at his face, we see mountain erosion, furrows etched by monsoons, eyes faded by snowfield glare, skin chapped by icy winters, and a halo – formed by the clouds among which he's spent his whole life, up here above 4,500 metres.

Notebook

At the bottom of the valley, on the banks of Dudhi Koshi, a river supplied with water by Imja Tsho, is the village of Phakding. This morning one of its residents, a pretty 14-year-old girl with braids and a shy smile, is getting ready to leave for school with two of her classmates. For the past three years, Dolma has been living at her aunt's lodge. Her parents are only peasants, too poor to continue providing

for their eldest daughter. Dolma gets up every day at 6 am, makes breakfast for customers, waits on them, does dishes, washes potatoes, fetches wood, sweeps the floors and leads the herd of cows out onto the hill. At 9:30, she finally changes into her school uniform: a red sweater over a white shirt and a wrinkled blue skirt. A small photo of the Dalai Lama hangs from a red string around her neck. She grabs her book bag and is off, arm in arm with Ramila and Bamila, the three of them sheltering from the monsoon rains under her umbrella. When they reach their pine classroom, they find Dil Bahadur Margar about to begin his talk. On the wall is the WWF climate change poster depicting snow-capped mountains, a river and some trees, the sun casting its beams over the scene. For two hours, the pupils listen attentively, taking notes as Margar defines global warming, gives some statistics and explains its causes and effects. He points out the examples of incidents that have occurred in the area – from the 1985 Dig Tsho explosion to the danger Imja Tsho represents for valley residents, in particular the Phakding families living so close to the river. Dolma discusses the issue with her girlfriends as they make their way back home at 4 pm on a precipitous path. *"This is the first time we've ever heard about global warming. I didn't know that pollution was making the world get warmer, or that this is why snow and ice have been melting faster. If Imja Tsho explodes too, that will be very dangerous for us. I can't even imagine it."* Dolma dreams of becoming a teacher. She's decided to keep her notebook for the future so that she may one day teach her own pupils about global warming.

Witness
A Sherpa is taken far from his mountains, across continents and oceans, to bear witness before groups of Westerners. When Sandeep Chamling Rai of the WWF travels to participate in international global warming summits in places like Kyoto and Berlin, he sometimes brings along a villager from the Khumbu Valley – a 'climate witness,' as he's dubbed them.

White
"The Himalayan Mountains were once white. Now they have become black" – Chuki, a nun.

Water
The Himalayas are the world's water tower. According to a second ICIMOD report, also published in June 2007,3 this mountain chain is the source of the nine largest rivers in Asia, in particular the Ganges, the Mekong and the Yangtze,

which provide water to some 1.3 billion people. For example, Himalayan snow- and ice-melt contributes 70% of the Ganges' flow during the spring dry season prior to the arrival of the monsoon rains. According to Arun Bhakta Shrestha and the report's other authors, *"The Himalayan region is the most critical region in the world [with regard to] melting glaciers [having] a negative effect on water supplies in the next few decades."* Not only do rising temperatures cause accelerated glacial melt, but they also shorten the periods during which glaciers are able to form. With winter coming later in the year, snow no longer has enough time to become ice; similarly, certain elevations where only snow used to fall during the monsoon season now receive rain. As a result, while at first this melt will increase the flow of the rivers, leading to occasional severe floods that will devastate the villages along their banks, over the long term these large Asian rivers will no longer receive any meltwater from the Himalayas. They'll be dry in winter, have a reduced flow in spring and won't swell with water until the summer monsoon season. At their April 2007 meeting in Brussels, IPCC scientists cited the difficulties of water provision linked to the accelerated melt of the world's largest freshwater reserve as one of global warming's most serious consequences. If nothing is done, nearly 2 billion people – one-third of the earth's population – could be affected by water shortages in 50 to 100 years.

Solitude

Men, women and children, their arms loaded with food, tea, mattresses, pillows, incense and prayer flags, are heading up into the mountain towering over Dingboche. They'll stay for four days and four nights with a hermit monk who's been living in seclusion in a monastery there since the month of January. They'll celebrate the Buddhist holy day of Niumi with him. Then they'll make their way back down, leaving the lama to his meditations. *"From the moment the first shred of wisdom came to the mind of man, he has aspired to solitude,"* explorer Alexandra David-Néel wrote in her travel journal, In the Heart of the Himalayas. It's a very silent solitude in this case – every summer in mid-July, the village of Dingboche shuts down. The owners of the 19 lodges and 12 houses in the village lock their doors and leave the area for a month and a half. *"According to a popular and ancient belief, the village must be evacuated during this time; otherwise, the smoke from the chimneys would prevent the barley and potatoes from growing,"* explains Mingma Sherpa, one of the village administrators. And so the men, women and children of Dingboche leave. Their temporary exile foreshadows another departure if Imja Tsho should explode – a departure with no return.

Paradise

A plane crashes in the Himalayas. Its passengers are taken in by a group of kind villagers living in an idyllic valley sheltered from the rest of the world, a place untouched by time. It's the story of an endangered paradise – like the Khumbu Valley – and a 1937 Frank Capra film, Lost Horizons.

[1] *"An overview of glaciers, glacier retreat and subsequent impacts in Nepal, India and China,"* March 2005.

[2] *"Impact of climate change on Himalayan glaciers and glacial lakes,"* June 2007.

[3] *"The Melting Himalayas. Regional challenges and local impacts of climate change on mountain ecosystems and livelihood,"* June 2007.

∫

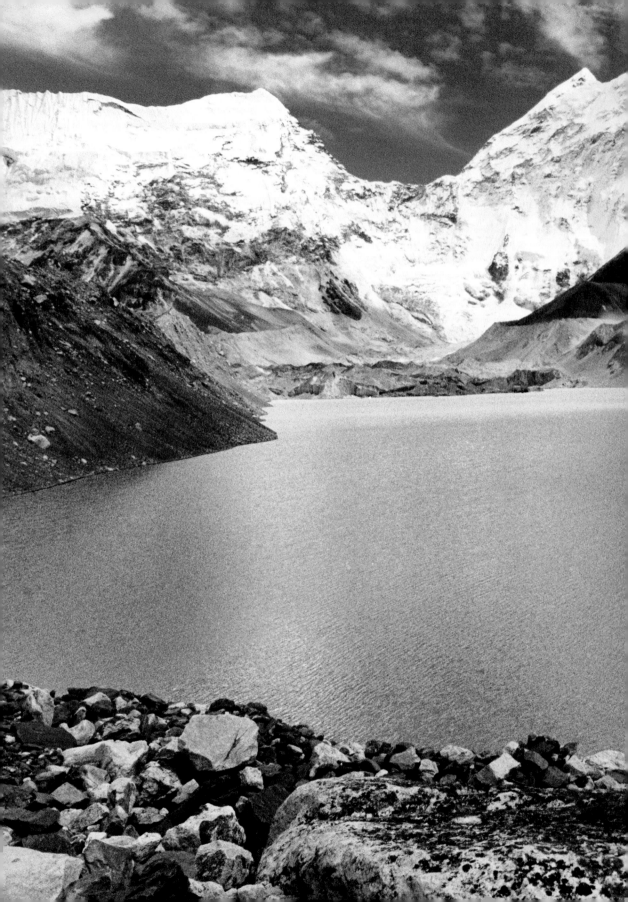

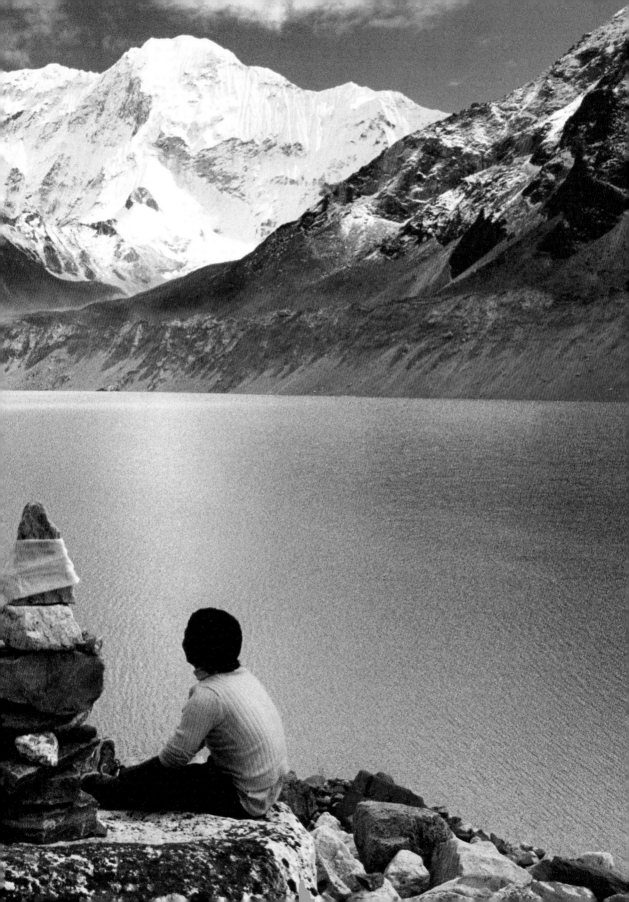

→ *(Preceding pages) Accelerated glacial melt is the most significant indicator of global warming.*

→ *Over the past 30 years, the temperature in the Himalayan region has risen by one degree Celsius.*

→ With its 35.8 million cubic
metres of water threatening
to flood through the Khumbu
Valley, Imja Tsho (elevation:
5,010 metres), is the most
dangerous lake in Nepal.

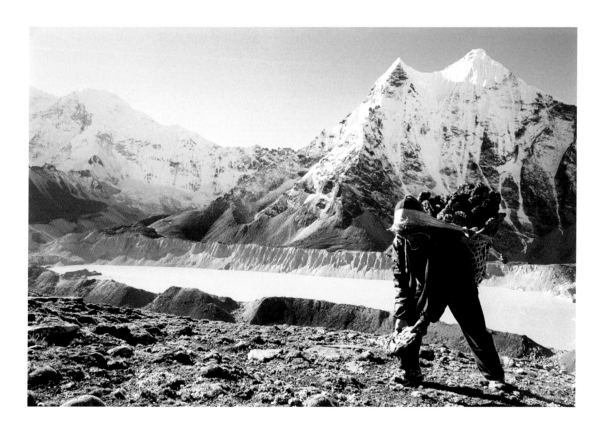

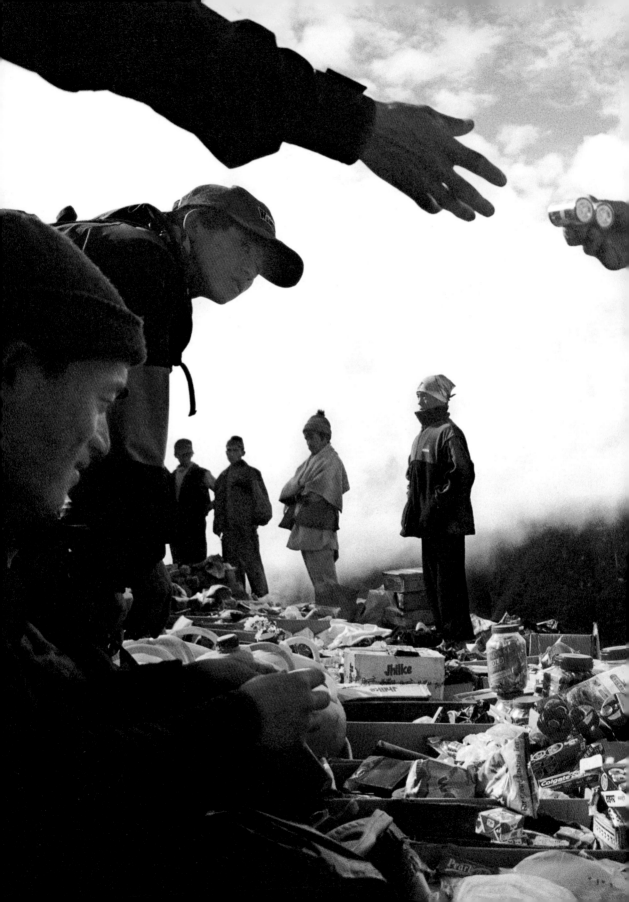

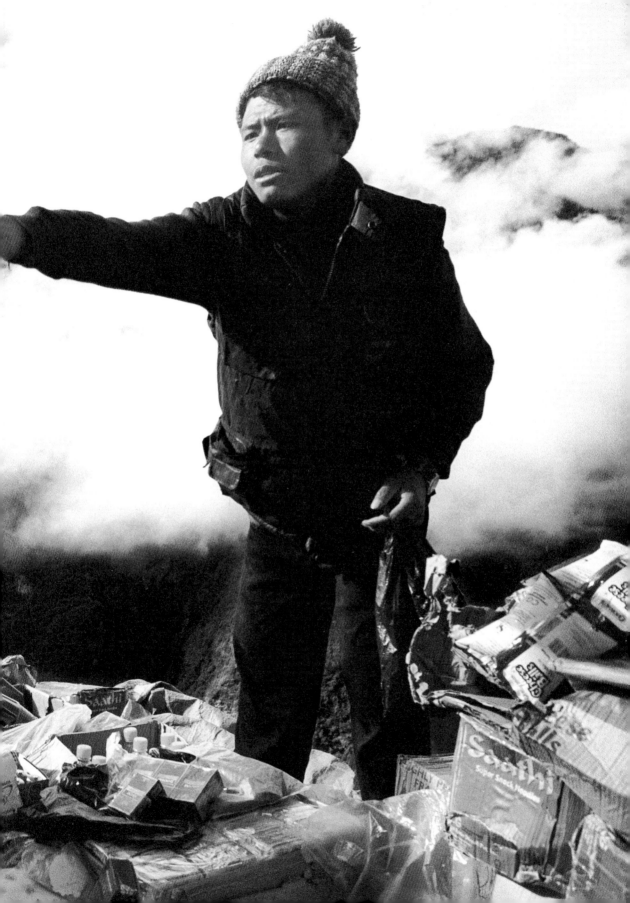

→ (Preceding pages) Every Saturday, residents of the valley and its surrounding areas hurry to the large market in the village of Namche. Thousands of tourists pass through this area every year.

→ Due to accelerated glacial melt, over 20 glacial lakes in Nepal may soon become dangerously swollen with water. The natural dams retaining the water can give way under the pressure, as with the Dig Tsho explosion of 1985.

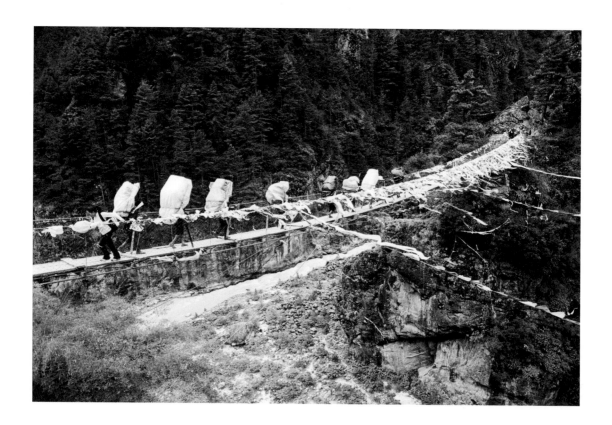

→ *When glacial lake Dig Tsho
exploded on 4 August 1985,
6-10 million cubic metres of
rock-laden water swept down
through the Khumbu Valley,
destroying everything in its
path.*

→ *Perched at an elevation of
4,410 metres, Dingboche will
be the first village destroyed
if Imja Tsho explodes.*

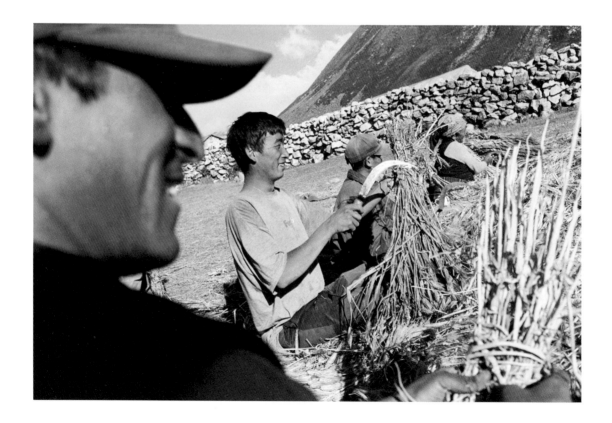

→ *If the glacial lake flooded through the valley, vegetable gardens and fields would be devastated, houses destroyed, hiking trails washed away, bridges demolished, yak herds drowned and hydroelectric power stations buried.*

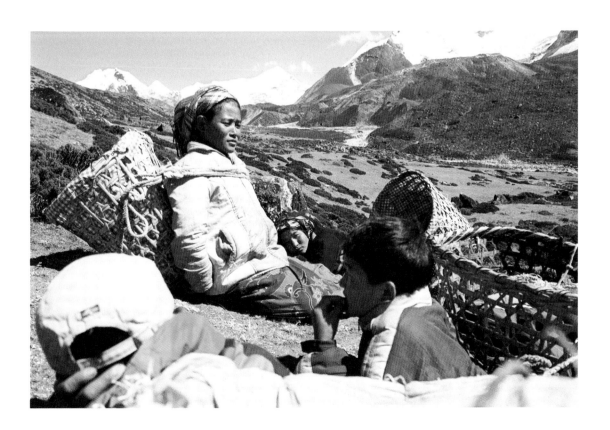

→ *Despite the danger and the lake explosions that have occurred in the recent past, very few Sherpa in the Khumbu Valley have heard of the effects global warming is having on the Himalayas.*

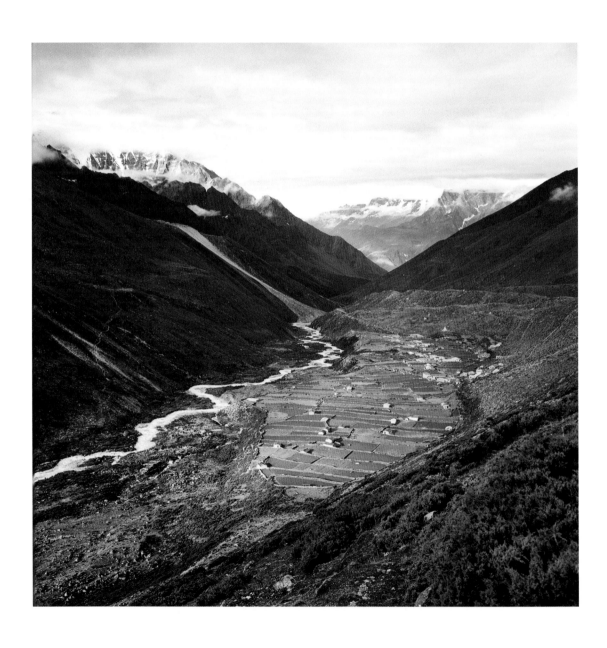

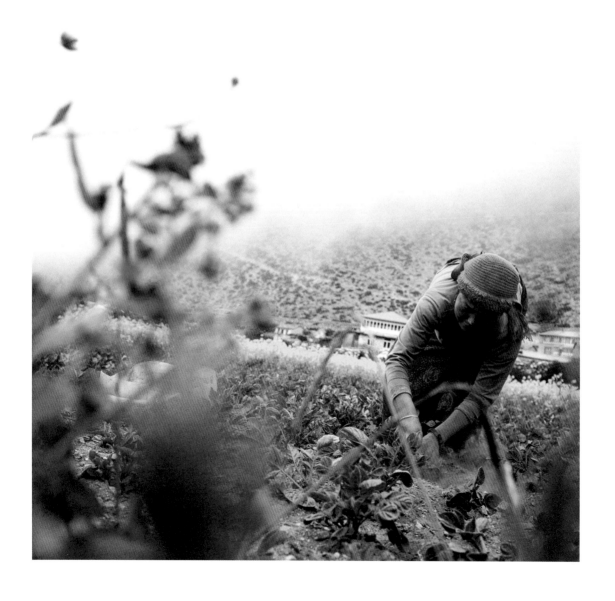

→ In spring, melt-water from
 the Himalayan mountains –
 which have been referred to
 as "the world's water tower" –
 feeds nine of Asia's largest
 rivers, including the Ganges,
 the Mekong and the Yangtze.
 If glacial melt continues at
 this pace, close to 2 billion
 humans – one-third of the
 earth's population – may
 experience water shortages in
 50 to 100 years.

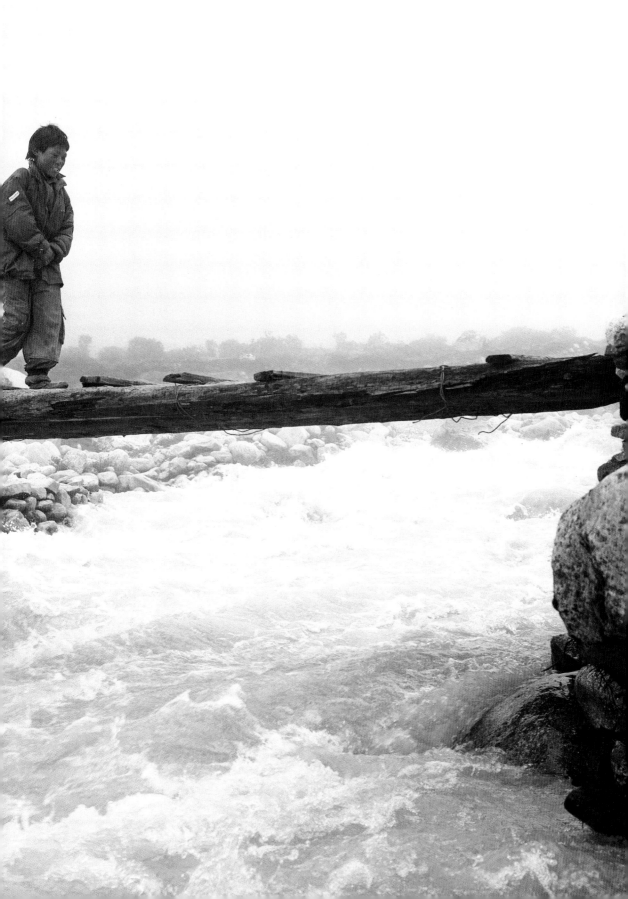

→ *Dolma and Ramila, two friends from the village of Phakding at the bottom of the valley, make their way to the schoolhouse to attend a talk on global warming organized by the World Wide Fund for Nature*

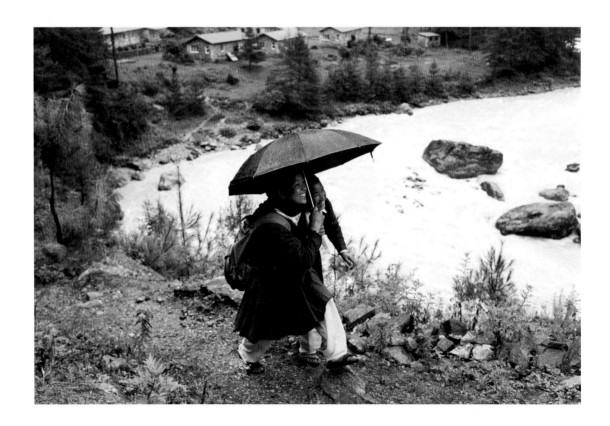

→ *According to Buddhist beliefs,*
each mountain, peak and rock
is protected by a deity.
To ensure their benevolence,
the Sherpa build religious
monuments out of stone.

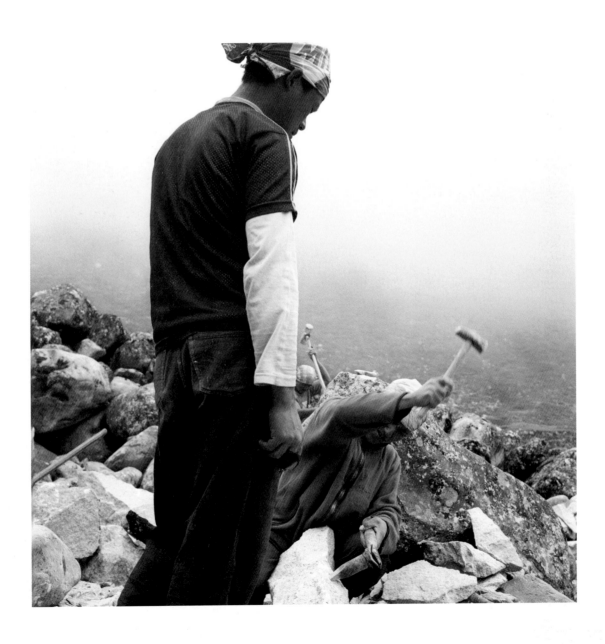

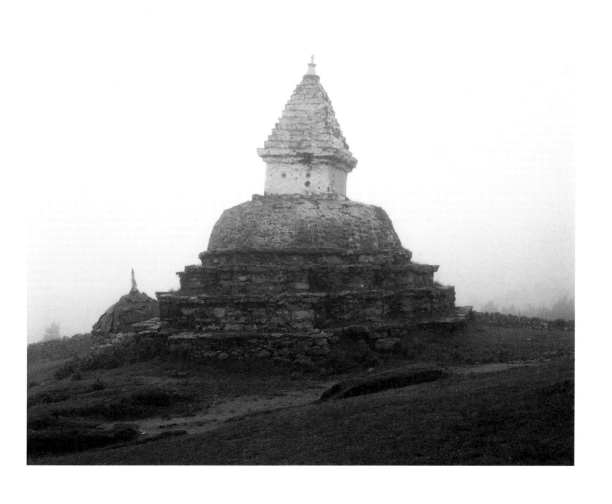

→ *To help his parents meet the*
family's needs, Rames Rai
spends three months of the
summer on his own, looking
after a herd of 22 yaks.

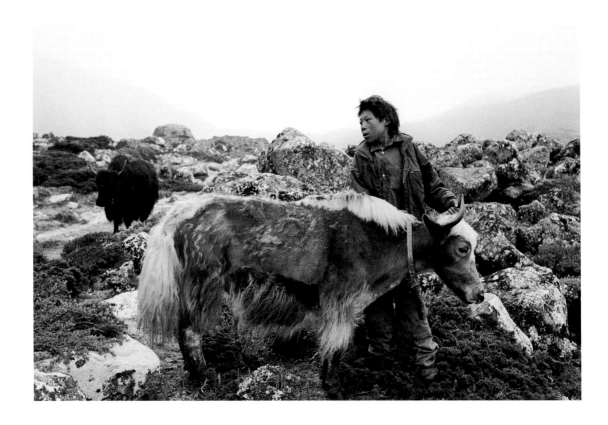

→ *Mr and Mrs Pa and their five children live close to the menacing river channel.*

→ *(Following pages) The Khumbu Valley's living memory: Urgun Tsultrem, 87, a nun, and Dorje Sherpa, 84, the village elder in Dingboche.*

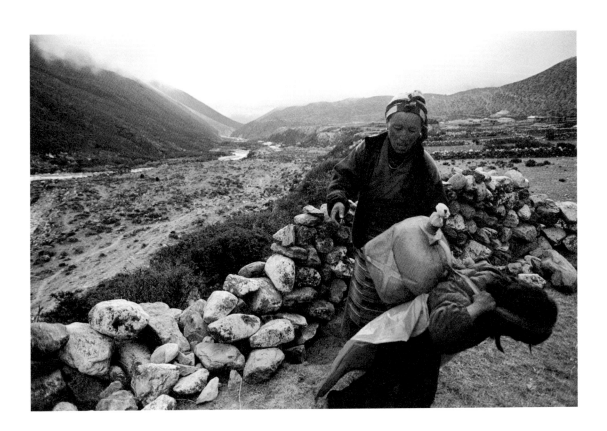

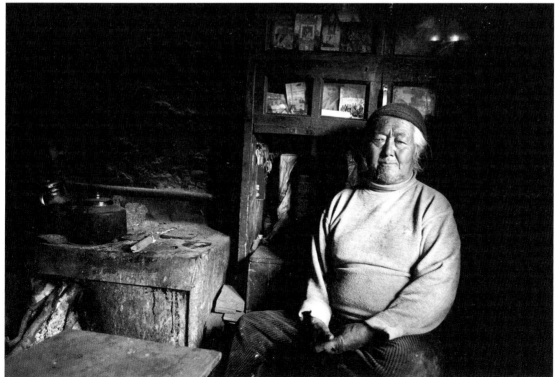

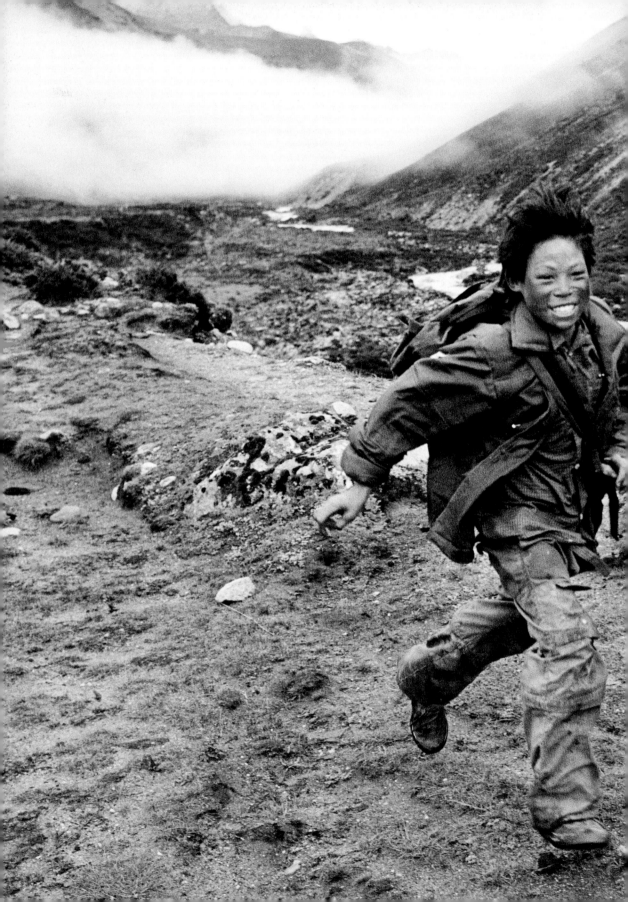

→ SOURCES

- *Atlas de la Menace Climatique*/Éditions Autrement
- *Climate Change 2007: Fourth Assessment Report*/IPCC
- *L'Effet de Serre: Allons-Nous Changer le Climat?*/Hervé Le Treut and Jean-Marc Jancovici/
 Édition Flammarion
- *L'Avenir Climatique: Quel Temps Ferons-Nous?*/Jean-Marc Jancovici/Édition du Seuil
- *Le Climat: Jeu Dangereux*/Jean Jouzel and Anne Debroise/Édition Dunod.
- *L'Homme et le Climat: Une Liaison Dangereuse*/Édouard Bard/Édition Découvertes Gallimard
- *L'Homme Face au Climat*/Édouard Bard/Édition Odile Jacob
- *Les Réfugiés Écologiques: Quelle(s) Protection(s), Quel(s) Statut(s)?*/Christel Cournil/
 Revue du Droit Public No. 4-2006
- *National Security and Threat of Climate Change*/Report by the CNA
 Corporation: securityandclimate.cna.org
- *Human Tide: The Real Migration Crisis*/Report by the Christian Aid NGO
- *Conventions and Protocols Relating to the Status of Refugees* (UNHCR)
- *Menaces Climatiques sur l'Ordre Mondial*/Jean-Michel Valantin/Édition Lignes de Repères
- *Environmental Refugees: An Emergent Security Issue*/Norman Myers/Green College,
 Oxford University/Session, 13th OSCE Economic Forum, Prague, 23-27 May 2005
- *The Economics of Climate Change*/Report by economist Nicolas Stern

→ FOR MORE INFORMATION

- French Environment and Energy Management Agency (ADEME): *http://www.ademe.fr*
- Intergovernmental Panel on Climate Change: *http://www.ipcc.ch*
- Institut Pierre Simon Laplace: *http://www.ipsl.jussieu.fr*
- Jean-Marc Jancovici, consultant: *http://www.manicore.com*
- Greenpeace: *http://www.impactsclimatiquesenfrance.fr*
- Climatologist blog: *http://www.realclimate.org*
- Alofa Tuvalu organization: *http://www.alofatuvalu.tv/*
- United Nations University : *www.unu.edu*
- Cop 15 Copenhagen : *http://en.cop15.dk/*
- Forum humanitaire mondial : *www.ghf-geneva.org*
- Secrétariat international permanent. Droits de l'Homme et gouvernements
 locaux (SPIDH) : *www.spidh.org*
- Environmental Change and Forced Migration Scenarios : *www.each-for.eu*
- Living Space for environmental refugees : *www.liser.org*
- Global Governance project : *www.glogov.org*
- Environment Forced Migration And Social Vulnerability : *www.efmsv2008.org*

→ BILAN CARBONE™ (carbon-balance method)

According to the assessment method recommended on the www.CO2solidaire.org website, the Argos collective emitted 104.2 tonnes of carbon dioxide into the air during its research for the nine articles in this book. In order to compensate for these emissions, Argos decided to help finance a solar energy and rural development programme in the Indian Himalayas, a project run by French non-profit organization GERES (Groupe Énergies Renouvelables, Environnement et Solidarités).

THANK YOU to **Yves Leers** for his confidence and very precious support; **Alice Audouin; Yann Arthus-Bertrand and the 3P grant** (Photographers ProPhotography); **Cyril Drouhet; Philippe Gassmann; François George; Marie Jaudet; Jean Jouzel; Jean-François Leroy; Jean-Luc Marty; Claudine Maugendre; Alain Mingam; Sylvie Rebbot; Hubert Reeves; Guillaume-Olivier Robic; and Hélène Tesson.** ∫ ALASKA For Kigiqtaamiut and Shishmaref's schoolchildren; **Jimmy the great hunter and Wella; Joe Braach** (see you in Montana); **Floyd Baldry** (cheers!); **Koozye; Carol and Kelly Ningeucook; Mina Weyiouanna; Clifford and Shirley Weyiouanna; Johnny and Roberta Weyiouanna; Jimmy Nayopuk; John Sinnuk; Jonathan and Barbara Weyiouanna; Bea Stough; Susie, Tony and Fanny Weyiouanna; Clarence, Daphnée and Junior; Frances and Franck; Luci Eningowuk and Peter McKay; Frances H. Eutuk and Frank Ongtowasruk; Jimmy Seetomona; Curtis Nayokpuk; Edna Senunjetuk; Bill Nayopuk and Mary Huntington; Bessi Sinnuk; Margie Ningeulook; Mollie Ningeulook; and Dennis Sinnuk.** ∫ BANGLADESH **Mohond Kumar Mondol** (Gana Unnayan Sangstha/GUS); **Mohammad Tihami Siddiquee; Shihab Uddin Ahamad** (Action Aid); **Arifa S. Sharmin** (CARE); **A. Atiq Rahman** (Bangladesh Centre for Advanced Studies/BCAS); **Mozaharul Alam**

(BCAS); **Ashan Uddin Ahmed** (Bangladesh Unnayan Parishad/BUP); **Serena Campo Grande** (Terre des Hommes Italia); **A. K. M. Mamunur Rashid** (United Nations Development Programme/UNDP); **Anindya Mustafa; Mannan Mola and family**; all the residents of Pankhali; **Nasimul Haque** (United Nation Office for Project Services/UNOPS); **Ashraf Mahmmood Dewan** (University of Dhaka); **Maudood Elahi** (Jahangirnagar University); **the Alliance Française staff in Dhaka; and Gaëlle Le Goff.** ∫ CHINA The residents of Longbaoshan and former residents living in Beijing: **Ze Zhen Wang; Dehai Li; Jian Li; Weifengying Li and family; Chsengzhen Chang; Mme Li; Facai Shi; Jian Bing Li; Dang Jin Liang; Dang Guo Qing Li; Dang Li Yuan; Wang Yaxiang;** the schoolchildren and their teachers; **Sun Baoping,** professor, Beijing forestry college and adviser, Ministry of Water Resources; **Wang Tao,** director general, Cold and Arid Regions Environmental and Engineering Research Institute, Chinese Academy of Sciences; **Michel Ayrault,** researcher, CNRS (French National Scientific Research Centre); journalists **Tristan de Bourbon-Parme, Richard Prost, Alain Lewkowicz and Mickaël Sztanke; and Michèle Aulagnon.** ∫ THE HALLIGEN **Fiede and Anelore Nissen; Ark Boysen; Hanke and Britta Johannsen; Jan Niemann; Theo Steinmann; Mr. and Mrs. Olk; and Hanke, Britta, Ose, Niels and Lasse Johanssen.**

∫ THE MALDIVES Saffah Faroog; Jamba; Mohamed Ali; Shaahina Ali; Ali Rilwan; Abdulla Mifthah; Mohammed Shahid; Abdullahi Majeed; Mariyam Mastar; Mohammed Zahir; Ali; Ali Nassir; Abdul Aziz; Mohammed Manik; C. J. Jos; Stéphane Pillon; Lorenzo Felici; and Bernard Genier. ∫ NEPAL Buddhi Rai, our guide during two reporting trips; Potom, our porter in October, and Tampa, our porter in July; the residents of the Khumbu Valley: Angat Bahadur Rai; Urgun Tsultrem; Penpighen Rai; Ang Maya Sherpa; Ang Nima Sherpa; Tenzing Tashi Sherpa; Tsering Teshi; Dorje Sherpa; Dolma; Mingma Sherpa; Purdigi and Teshitawa; the nun Chuki; Mingma Sherpa and Ramès Rai; Sandeep Chamling Rai, director, WWF's climate change programme in Nepal; Pradeep Mool, expert in remote detection of glaciers at Icimod; Om Ratna Bajracharya, director, government department of hydrology and meteorology; Dil Bahadur Margar, WWF coordinator, global warming awareness workshops, Namche; Arun Bhakta Shrestha, climate change specialist at Icimod and programme coordinator, water resources, risks and the environment; and Lacchu Sankar Rai, director, Khumbu Alpine Conservation Council in Dingboche. ∫ GULF COAST Aksam and Maria Mershed; Ride Hamilton; the Bailey family; Lisa and Errol Donahue; Catheryn Longino; Denise Bishop (American Red Cross);

Kim Paul; Ebony Bolding; Eric Willis; Emmanuel Kerry; Kyron Lewis; Ruel Douvillier; and Dorothy Stuks (Acorn). ♪ CHAD The fishing community on Blarigui Island: **Didina Diathé; Moussa Gao and Samuel Ngargoto; Al Hadjil Kanë,** village chief of Blarigui; **Babanguida Chari,** representative, Patriotic Salvation Movement; **Zara Mahamat,** restaurant owner; the children of the island; **Sali Oumar,** author of a fishery survey for the Ministry of Environment and Water; **Zakara Anza,** fishery expert, **CBLT** (Lake Chad Regional Commission); **Jacques Lemoalle,** hydrobiology expert, Research Institute for Development and international expert on Lake Chad; **Koundja Mbatha,** CBLT topographer known as "the old monkey"; **Abakar Diguira,** CBLT driver; former Grand Sultan of Bol, member of parliament and traditional chief **Djerakoubou Dando,** responsible for implementing the Mambi project; and Dara Laobeul, fishery and aquaculture expert, Ministry of Environment and Water. ♪ TUVALU **Gilliane Le Gallic and Fanny Héros** (Alofa Tuvalu); **Susy Kofe; Iacopo and Asita Moloti; Helia Vavaï; Pani Laupepa; Silafonga Lalua; Siaosi Finiki; Tanese Tusitala; Elie and Faka Fetaï Akimo; Elie Ala and Lupeti; Tehaki Tapu and Lupati Iacopo; Faatasi Malologa; Easter Molu and the teachers at the Lapérouse school; and Toaripi Lauti.**

To Armand and Chloé; Catherine,
Mila and Adrien; David and Olivia; Elliott; Gaëlle; Karine,
Théodore and Anatole; Marie, Justine and Robin;
Mathilde, Emile and Suzanne; and Catherine,
Sarah and Gabriel.

∫

Printed and bound by
Tien Wah Press, Singapore
in February 2010
on EuroBulk 115 grs paper

PEFC

PEFC/06-38-69

COLLECTIF ARGOS
40 Rue Orfila
75020 Paris, France
+33 (0)1 43 58 31 16
www.collectifargos.com
collectifargos@collectifargos.com